Louis C.

TIFFANY

and the Art of Devotion

This catalog accompanies the exhibition
Louis C. Tiffany and the Art of Devotion on display
at the Museum of Biblical Art from October 12,
2012–January 20, 2013.

© 2012 Museum of Biblical Art

First published jointly in 2012 by GILES
An imprint of D Giles Limited
4 Crescent Stables, 139 Upper Richmond Road
London SW15 2TN, UK
www.gilesltd.com

and

Museum of Biblical Art
1865 Broadway (at 61st Street)
New York City
NY 10023, USA
Phone: 212-408-1500
Fax: 212-408-1292
info@mobia.org
www.mobia.org

Louis C. Tiffany and the art of devotion/ edited by
Patricia C. Pongracz; contributions by Elka Deitsch,
Alice Cooney Frelinghuysen, Lindsy R. Parrott,
Patricia C. Pongracz, Elizabeth De Rosa, Jennifer
Perry Thalheimer, Peter W. Williams, and Diane C.
Wright.. –1st edition.

 p. cm.

This catalog accompanies the exhibition Louis
C. Tiffany and the Art of Devotion on display at
the Museum of Biblical Art from October 12th,
2012-January 20th, 2013.

Includes bibliographical references.

ISBN 978-1-907804-02-1

1. Tiffany Studios (New York, N.Y.)--Exhibitions.
2. Tiffany Studios (New York, N.Y.). Ecclesiastical
Dept.--Exhibitions. 3. Church decoration and
ornament--United States--Exhibitions. 4. Synagogue
art, American--Exhibitions. I. Pongracz, Patricia C.,
editor of compilation. II. Museum of Biblical Art, host
institution.

NK2192.U64T54 2012

726.5'29097471--dc23

 2012012349

ISBN: 978-1-907804-02-1

The exhibition was curated by Elizabeth De Rosa;
Lindsy R. Parrott, Director and Curator of the
Neustadt Collection of Tiffany Glass, Long Island City,
New York; Patricia C. Pongracz, Director of Curatorial
Affairs, Museum of Biblical Art, New York; and Diane
C. Wright.

Copy-edited and proofread by Sarah Kane
Designed by Alfonso Iacurci
Produced by GILES, an imprint of D Giles Limited
Printed in China

All measurements are in inches and centimeters;
height precedes width.

Major support for MOBIA's exhibitions and programs
has been provided by American Bible Society and by
Howard and Roberta Ahmanson.

AMERICAN BIBLE SOCIETY

Louis C. Tiffany and the Art of Devotion is made possible
by the generous support of the Henry Luce Foundation
and the Elizabeth Morse Genius Foundation.

This program is supported, in part, by public funds
from the New York City Department of Cultural Affairs
in partnership with the City Council and the New York
State Council on the Arts with the support of Governor
Andrew Cuomo and the New York State Legislature.

Front cover illustration: Frederick Wilson, Tiffany
Studios, New York, *The Righteous Shall Receive
a Crown of Glory* (Brainard Memorial Window for
Methodist Church, Waterville, New York), detail,
ca. 1901, leaded glass, Corning Museum of Glass,
Corning, New York

Back cover illustration: Tiffany Glass and Decorating
Company or Tiffany Studios, New York, sample of a
mosaic column possibly for St. Michael's Episcopal
Church, New York, ca. 1900–20, detail, glass tesserae
and plaster, Chrysler Museum of Art, Norfolk, Virginia

Louis C. TIFFANY *and the Art of Devotion*

Edited by Patricia C. Pongracz

Contributions by Elka Deitsch, Alice Cooney Frelinghuysen, Lindsy R. Parrott, Patricia C. Pongracz, Elizabeth De Rosa, Jennifer Perry Thalheimer, Peter W. Williams, and Diane C. Wright

MUSEUM OF BIBLICAL ART
MOBIA

Museum of Biblical Art, New York, in association with D Giles Limited, London

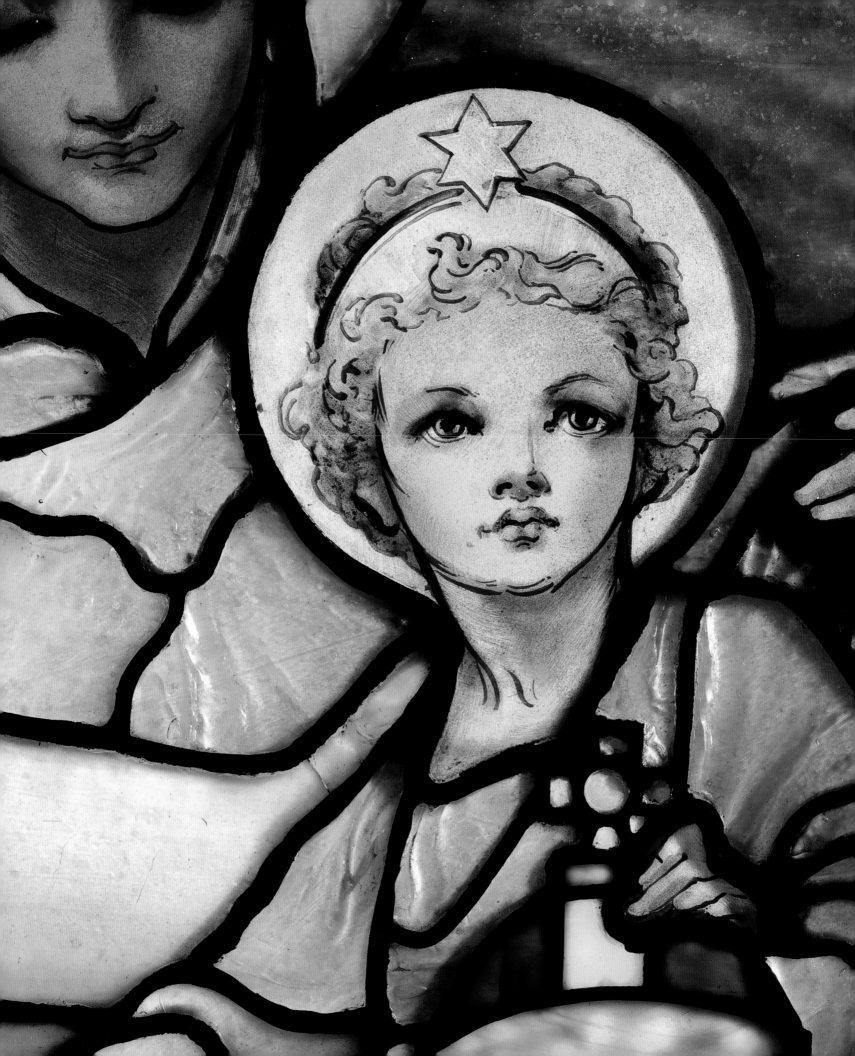

CONTENTS

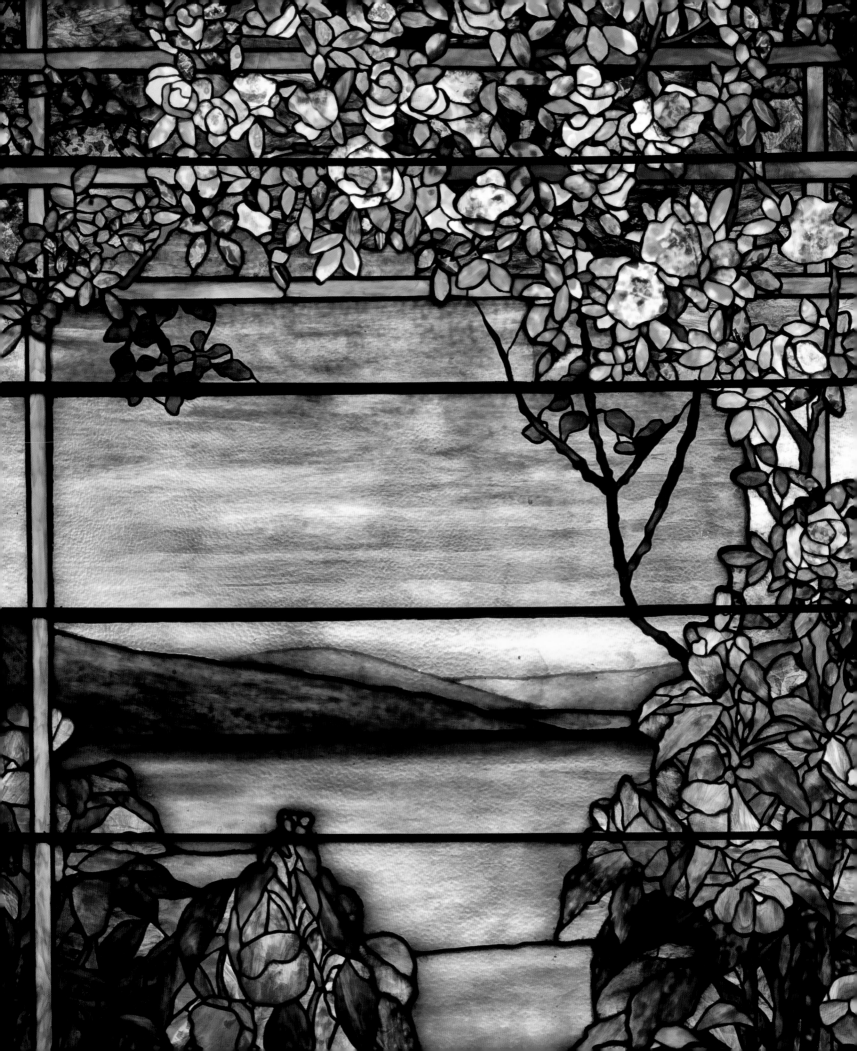

DIRECTOR'S FOREWORD
Ena G. Heller, Executive Director, MOBIA

Louis Comfort Tiffany, the quintessential American artist/businessman, seems always to be in the public eye. Since 2005 there have been at least seven different Tiffany exhibitions in the U.S., two of them traveling to multiple venues and two of them in New York City. Most came with fully illustrated catalogs, while at least a handful of other books on the artist and his milieu were published during this time. And yet, until now, there has not been an exhibition or a volume that focuses exclusively on the work created for America's churches and synagogues—although religious works represented a majority of Tiffany Studios' commissions.

The Museum of Biblical Art exhibition, to which this book is the companion, sets out to correct that hard-to-believe fact. It is the first exploration of Tiffany Studios' religious commissions in a systematic, contextual manner, against the backdrop of the religious building boom that started in the 1880s. While the building boom created an opportunity, Tiffany Studios positioned itself as the firm of choice for all liturgical needs within those newly erected buildings. Tiffany defined himself—through a thoroughly modern mixture of artistry and marketing genius—as the maker of taste, as well as of religious and cultural identity. While a majority of its clients were Protestant, varied other religious groups went to Tiffany for their commissions precisely because Tiffany works conferred a certain status— in the case of Catholic and Jewish communities, for example, reinforcing their status as acculturated Americans.

So as we examine superb examples of Tiffany glass, mosaics, liturgical implements, and furniture, we also sketch a history of religious sentiment and religious commissions in the Gilded Age. For lifting the curtain on this essential yet little-studied facet of the American Decorative Arts movement, I thank the co-curators of the exhibition, Elizabeth De Rosa, Lindsy R. Parrott, Patricia C. Pongracz, and Diane C. Wright. Their amazing knowledge is matched only by the passion with which they embraced this project, and their indefatigable search for Tiffany gems that have stayed hidden from the public eye. We were extremely lucky that scholars Elka Deitsch, Alice Cooney Frelinghuysen, Jennifer Perry Thalheimer, and Peter W. Williams came alongside the co-curators and added their insights to the catalog, helping it become a comprehensive look, not only at the artist and his collaborators, but also at the period during which their art—and business acumen—flourished.

As always with exhibitions, there are so many other people who made this project happen, and made it successful. Special thanks go to the church congregations, individual and institutional lenders who parted with treasures in order to make this exhibition possible. For believing in the importance of this exhibition early on, we thank the Henry Luce Foundation, whose American Art Program generously funded us; the Elizabeth Morse Genius Foundation; and David Specter, President, and the Board of Directors of the Neustadt Collection of Tiffany Glass for supporting the exhibition's conservation goals. Additional funding came from the New York City Department of Cultural Affairs, the New York State Council on the Arts, and our long-time supporters, Howard and Roberta Ahmanson, and American Bible Society. To all of them, our most sincere thanks. MOBIA is still a young museum, and the confidence that so many generous donors have put in us for this extremely ambitious project has given us wings. Last, but certainly not least, I thank our partners at D Giles Ltd., co-publishers of this handsome volume, and my superb staff. I am grateful for the team at MOBIA, a team who believes that we can make a difference, one exhibition at a time.

ACKNOWLEDGMENTS
Elizabeth De Rosa, Lindsy R. Parrott, Patricia C. Pongracz, Diane C. Wright

An exhibition is always the work of many people. *Louis C. Tiffany and the Art of Devotion* owes its realization to the institutions and individuals who have supported this project since its inception. Research for the show has afforded the curators opportunities to meet with people who share an interest in—and in many instances a passion for—the Tiffany Studios' work for America's churches and synagogues. We have had the good fortune to see objects rarely on view and even to discover some that were little known. This has been a gift.

We are grateful to the lenders who made their works available to us for study and display, for their belief in the project and their trust in us. We thank Micki and Jay Doros, Allen Michaan, and Eric Streiner who generously loaned from their collections. We are grateful to the congregations who agreed to lend objects despite the exhibition's scheduling during the Christmas season, and we thank those who facilitated these loans including: Doug Fiero and the Prudential Committee at the Arlington Street Church, Boston; Reverend Ronald T. Lau and Deacon Anthony Bowen of Christ Church Cobble Hill, Brooklyn; Reverend David M. Carter, Lora Erskine, Caroline Sloat, and Linda and Jim Goodwin of Christ Church, Pomfret, Connecticut; Reverend Edward Chapman of Emmanuel Parish of the Episcopal Church, Cumberland, Maryland; Pastor Doug Madden and Helen Brink of First Presbyterian Church, Bath, New York; Alan McFarland, John S. Payne, and Jerry Guerin of St. Andrew's Dune Church, Southampton, New York; and Reverend Monica Styron of the United Presbyterian Church, Binghamton, New York.

We thank the institutions who supported our loans and the colleagues who worked with us to facilitate them including: Dr. Laurence Ruggiero, Director and David McDaniels, Chief Preparator at the Charles Hosmer Morse Museum of American Art, Winter Park, Florida; Kelly Conway, Curator of Glass and Molly Marder, Registrar at the Chrysler Museum of Art, Norfolk, Virginia; Gail S. Davidson, Curator and Head, Drawings, Prints, and Graphic Design Department and Jackie Killian, Curatorial Assistant, Drawings, Prints, and Graphic Design Department at the Cooper-Hewitt, National Design Museum, Smithsonian Institution, New York; Tina Oldknow, Curator of Modern Glass, Jane S. Spillman, Curator of American Glass, Warren Bunn, Collections and Exhibition Manager, and Stephen Koob, Chief Conservator at the Corning Museum of Glass, Corning, New York; Carol Johnson, Curator of Photography at the Library of Congress, Washington, D.C.; Arlie Sulka at Lillian Nassau LLC, New York; Drew Anderson, Associate Conservator, Sherman Fairchild Center for Objects Conservation at the Metropolitan Museum of Art, New York; Susan Greenbaum, Conservator and Elizabeth Donsky, Office Manager at the Neustadt Collection of Tiffany Glass, Long Island City, New York; Diane Dolbashian, Head Librarian, Nive Chatterjee, Processing Archivist, Gail Bardhan, Reference and Research Librarian, Beth Hylen, Reference Librarian, Regan Brumagen, Outreach and Education Reference Librarian, Tracy Savard, Cataloguing Specialist, Artwork and Books at the Rakow Library at the Corning Museum of Glass, Corning, New York; Joyce Lee at the Richard H.

Driehaus Museum, Chicago, Illinois; and Rolf Achilles, Curator at Smith Museum of Stained Glass Windows, Chicago, Illinois.

Over the last two years our research has put us into contact with many who share our interests and we thank those who took the time to discuss our progress, help us along, draw our attention to something new, and help us understand more fully the subject at hand. Thanks to: Sheldon Barr; Tony Benyon; Ettore Christopher Botti of Botti Studio of Architectural Arts, Inc.; Marilyn and Rick Cloran and Chris Trahan at St. Stephen's Episcopal Church, Lynn, Massachusetts; Peter Cormack; Jack Cushen; Paul Doros; Richard Goodbody; Edward and Jeanne Hewett; Jeffrey Rush Higgins; Mary Clerkin Higgins, Clerkin Higgins Stained Glass Studio, Brooklyn, New York; H. Tom Küpper; Monica Obinski, Assistant Curator of Decorative Arts, Art Institute of Chicago; Deirdre Pontbriand; Virginia Raguin; Roberto Rosa of Serpentino Stained Glass, Needham, Massachusetts; Jeni Sandberg; Albert M. Tannler; Barbara Veith; and Reverend David Westcott of Bowne Street Community Church, Flushing, New York.

We acknowledge those whose contributions resulted in this catalog. Dan Giles, Allison Giles, Sarah McLaughlin, and Pat Barylski at D Giles Ltd took our essays and loose images and turned them into a volume of which we are immensely proud. Elka Deitsch, Senior Curator, Herbert & Eileen Bernard Museum of Judaica, Temple Emanu-El, New York; Alice Cooney Frelinghuysen, Anthony W. and Lulu C. Wang Curator of American Decorative Arts at the Metropolitan Museum of Art, New York; Jennifer Perry Thalheimer, Curator and Collection Manager at the Charles Hosmer Morse Museum of American Art in Winter Park, Florida; and Peter W. Williams, Miami University, Oxford, Ohio and Bexley Hall Seminary, Columbus, Ohio, generously shared their work so that we all may have a deeper understanding of Louis Comfort Tiffany the designer, Tiffany Studios' participation in the development of a unique American liturgical aesthetic, and the period during which the firm exerted its influence.

A number of students assisted with research on various aspects of the exhibition. We are grateful for the work of those enrolled in the Smithsonian-Mason Master's Program in the History of Decorative Arts, Washington, D.C. during the spring and summer of 2011: Renee Corbino; Margaret Powell; Michelle Powell; Juli Schmidtchen; Samantha DeTillio; and Natalie Zmuda. We also thank Lindsey Jochets and Michelle Jackson enrolled in the Master's Program in the History of Decorative Arts and Design, Parsons The New School – Cooper-Hewitt National Design Museum, New York. Ruth Ballester, MOBIA's curatorial intern during the fall of 2010, made our lives infinitely easier by converting Tiffany Studios' Partial List of Churches into a searchable database.

Finally, we thank MOBIA for its steadfast support of this project. Dr. Ena G. Heller, Executive Director, was unwavering in her belief that this exhibition could and would be presented and for that we are most grateful. We also owe our gratitude to MOBIA's staff. Without all of their efforts, the exhibition simply could not have been realized. Adrianne Rubin, Assistant Curator and Registrar, negotiated all the loans and insured that they arrived in a timely and secure manner; Kate Williamson, Curatorial Assistant, worked tirelessly to secure images for our catalog and kept the publication on track; Dean Ebben, Exhibition Designer and Lead Preparator, turned curatorial concepts into elegant reality; and Kara Van Woerden, Graphic Designer, gave the exhibition its distinct graphic identity.

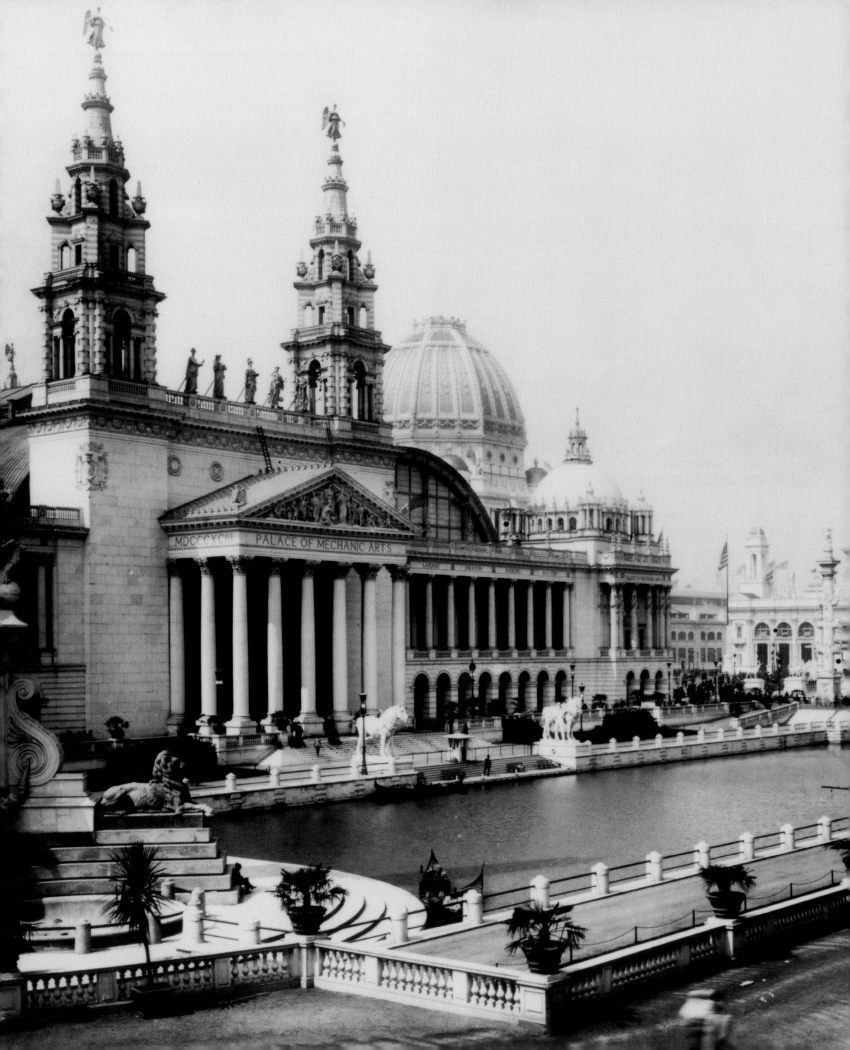

American Religion
in the Age of the City, 1880–1915

PETER W. WILLIAMS

Palace of Mechanic Arts and lagoon, World's
Columbian Exposition, Chicago, 1893
Photograph

The years between the Civil War and the "Great War" were ones in which the United States was thoroughly transformed by a convergence of powerful forces that changed what had been a predominantly rural nation into one in which the city clearly held pride of place. In 1880, slightly over one quarter of a population of about fifty million were urbanites; by 1920, over half of America's 106 million dwelt in cities. During these four decades, New York City grew from roughly 1,200,000 to 5,620,000; Boston from 363,000 to 748,000; and, most spectacularly, Chicago from 503,000 to 2,700,000.

This vast demographic shift was the result of a number of factors. The railroads had become a means through which a continental network of manufacturing, shipping, and sales could integrate the nation into one vast interconnected marketplace, with cities—including new ones, such as strategically placed Chicago—at the nodes of production and distribution. Cities, especially the burgeoning ones on the Great Lakes, also grew dramatically as industries dependent on new technologies proliferated: steel in Cleveland, meat-packing in Chicago and, eventually, automobiles in Detroit.

These cities rapidly became magnets for another major source of urban transformation: immigration. The foreign-born population doubled during this period, from about 6,700,000 in 1880 to nearly fourteen million in 1920. (American entry into World War I in 1917 closed the oceans to immigrants, and Congress subsequently imposed highly restrictive quotas favoring northwestern Europeans.) The middle decades of the nineteenth century had already brought vast numbers of Catholic Irish, fleeing the ravages of the potato blight, as well as German-speakers from across the religious spectrum, seeking religious and political liberty as well as economic opportunity.

The "New Immigration" that followed the Civil War shifted to the central, southern, and eastern areas of Europe. Yiddish-speaking Jews fled the "Pale of Settlement"—the vast tract of western Russia in which they were compelled to live—seeking refuge from czarist pogroms as well as a chance at a better life. They were accompanied by Eastern Orthodox Christians from Russia, Ukraine, Romania, Greece, and the Balkans, as well as Roman Catholics from Lithuania, Poland, Hungary, Slovenia, Croatia, and Italy. Unlike the Irish, who found it economically difficult to leave their East Coast ports of entry, and Germans, who frequently were skilled artisans and farmers, these largely peasant newcomers gravitated towards markets for unskilled labor, which was to be found in the emergent industrial cities on the Great Lakes. Through chain migration, families, neighbors, and their clergy followed the urban pioneers and founded ethnic neighborhoods such as those that still make up significant parts of Chicago, Detroit, and Cleveland.

This shift in demographics was rapidly reflected in the changing urban religious landscape. Understanding this context allows us greater insight into Tiffany Studios' work for religious communities. Communities of newcomers usually regarded religion as central to their now-threatened cultural identities, and were quick to erect houses of worship wherever they congregated. The styles of their buildings echoed the traditions of their homelands. Greek Orthodox churches, for example, were

distinguished by a central cross plan with a rounded dome, while Russians and Ukrainians favored their distinctive onion-shaped domes. Roman Catholics drew on a variety of historic styles, especially the Romanesque and Gothic that had arisen during their centuries of religious hegemony in much of Europe prior to the Reformation. Catholic churches, with their accompanying parish plants—elementary schools, convents, rectories—were frequently built on the scale of cathedrals, dominating the neighborhoods which they anchored, and frequently sited within a few blocks of other Catholic churches serving different ethnic constituencies. Catholic churches, which were frequently decorated with elaborate arrays of liturgical art, provided good markets for European religious goods—stained glass from Munich and statuary from the Saint-Sulpice neighborhood in Paris—until local producers began to provide competition.

German Jews assimilated easily and often grew prosperous in fields such as the garment industry and retail dry-goods, opening stores that might grow into chains such as Saks. Many were attracted to the progressive Reform variety of Judaism that had originated in Germany in the eighteenth century, and erected houses of worship of considerable grandeur, such as the richly ornamented Plum Street Temple in downtown Cincinnati. Since there was no firmly established tradition of synagogue architecture, these structures were often eclectic in style, incorporating Gothic, Romanesque, and Moorish (Iberian Muslim) elements. "Russian" Jews—a generic term for Yiddish-speakers from the old Russian Empire—were usually, when religious, Orthodox in persuasion, and Manhattan's Lower East Side abounded with dozens of their larger or smaller *shuls*.

13

Fratelli Alinari, Florence, Italy
View of the Main Square of the World's
Columbian Exposition, Chicago, 1893
Photograph
Museo di Storia della Fotografia

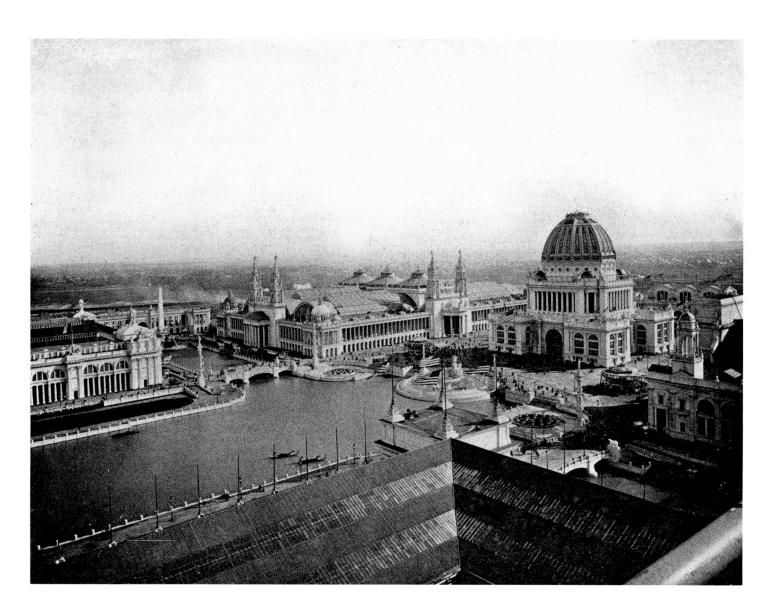

After Reconstruction, most African Americans still lived in the South, no longer formally enslaved but bound to the land as sharecroppers and deprived of civil rights through "Jim Crow" legislation. They possessed an informal but powerful religious tradition comprised of a Christian frame of reference and African worship rhythms, practiced often in small rural frame churches. Most belonged to some variety of the Baptist, Methodist, or "Sanctified" (Holiness-Pentecostal) traditions, though compelled to adapt these for use in segregated congregations and all-black denominations. Their presence was also felt in northern cities in enclaves such as Manhattan's Harlem. Here one might find representatives of "mainline" denominations, such as St. Philip's Episcopal—a spin-off from Trinity, Wall Street—as well as those of black traditions such as Abyssinian Baptist, both dating from the early 1800s. Philadelphia's Mother Bethel AME (African Methodist Episcopal) was founded in 1794 by Richard Allen and other free blacks who had been denied full rights by a white Methodist Church, and became the basis for the first of the nation's black-led denominations. Larger urban churches also began to appear in black neighborhoods in southern cities, such as Ebenezer Baptist in Atlanta, home to the Martin Luther Kings, Sr. and Jr.

White Protestants also began to gravitate and adapt to the new urban landscape. By this time, the denominational system that had arisen from the distinctively American circumstances of religious freedom and pluralism had taken on the contours of the broader social structure. Lutherans, primarily of German and Scandinavian birth or descent, were concentrated in the Great Lakes and upper Midwest region. Many of the former settled in the "German Triangle" defined by Milwaukee, St. Louis, and Cincinnati, along with their Catholic and Jewish compatriots. Methodists were most abundant in the states comprising the "south of the North and the north of the South;" though British in origin, their tradition was adopted by others of various ethnic origins, primarily middle class in status. Congregationalists— the denominational descendants of the New England Puritans—had spread from that region westward, through upstate New York, into the Great Lakes region (the "Old Northwest"), and eventually to northern California and the Pacific Northwest, reproducing the neoclassical and Greek revival styles of the region as they established new communities. Unitarians, their liberal spin-off, were small in number and predominantly well-educated urbanites. Baptists, who with Methodists and Presbyterians had divided along sectional lines with the coming of the Civil War, were more likely to be found among the working classes, and also established ethnic congregations in many northern cities. The upper reaches of society tended to frequent Episcopal or Presbyterian churches, both slower to evangelize than their Baptist and Methodist counterparts, and particularly well represented in fashionable urban neighborhoods.

In addition to the varieties of Christianity and Judaism, the Victorian era saw a number of religions that were much newer, whether in actual origin or introduction into North America. The Latter-day Saints (Mormons) had consolidated their

settlement in the Utah territory, but had to abandon their distinctive and highly controversial practice of plural marriage in 1890 before political recognition as a state. Christian Science, on the other hand, was an eastern urban phenomenon, introduced by New Englander Mary Baker Eddy through her book *Science and Health*, first published in 1875. In it Eddy claimed to have discovered a "key to the scriptures" that enabled her followers to overcome disease and other afflictions through a proper understanding of the illusory character of matter and the power of spirit. Spiritualism, the quest for communication with the deceased, was a popular movement that attracted fervent believers and equally fervent skeptics. Theosophy was an attempt to apply teachings derived from Asian religions in a form accessible to middle-class Americans. Its sources, Hinduism and Buddhism, were introduced to Americans at the World's Parliament of Religions (1893), convened in Chicago in the wake of the World's Columbian Exposition, and featuring articulate spokesmen for traditions of which most Americans had never seen a living representative.

The result of burgeoning immigration and the rise of the city during these decades was an impressive increase in the number of congregations—and their houses of worship. The following are some comparative statistics for the number of congregations in 1890 and 1906 respectively:

	1890	1906
Christian Science	638	221
Congregationalist	4,808	5,713
Episcopal	5,018	6,845
Jewish	533	1,769
Lutheran	8,595	12,703
Methodist	51,489	64,701
Presbyterian	15,506	13,471
Roman Catholic	12,482	10,239
Unitarian	461	421

This time of the "Gilded Age" and Progressive Era were both exciting and stressful for American Protestants, by far the largest group for whom Tiffany Studios designed, who were being forced to confront new intellectual as well as social change. The earlier part of the nineteenth century had thrust two closely related challenges into the American academy, especially its theological branch: Darwinian evolution and German biblical criticism. Darwinism, which posited the evolution of humans from common ancestors shared with other primates, cast into doubt human uniqueness as well as the static version of creation derived from the literal reading of Genesis that still held sway in most Christian circles. Biblical scholars, who applied the emergent German model of "objective" scientific research to humanistic and religious studies as well, utilized tools of historical and critical analysis to postulate that the Genesis narrative was in fact a work of multiple and complex authorship written in language that was more poetic than scientific. Similar analysis concluded that the Christian Gospels

Palace of Mechanic Arts and lagoon, World's
Columbian Exposition, Chicago, 1893
Photograph

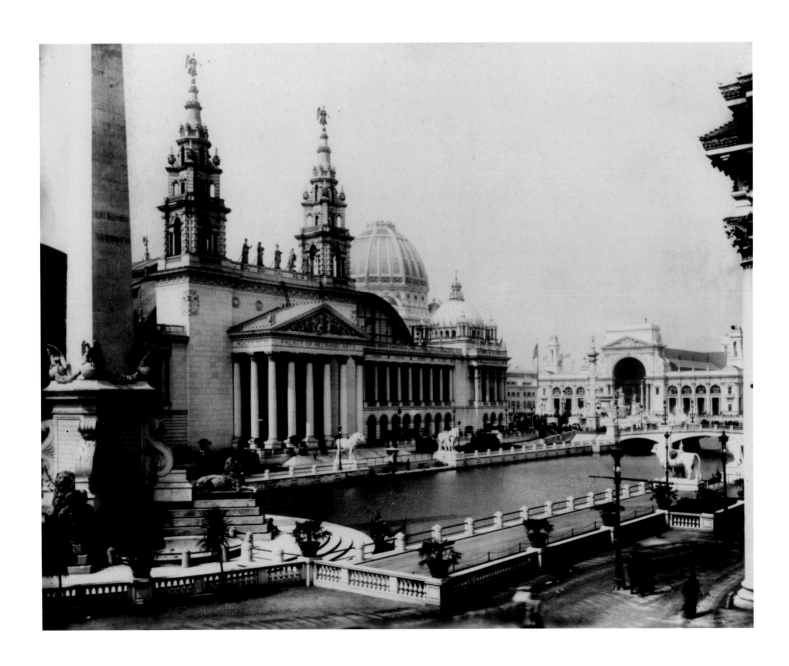

were also cut-and-paste creations, compiled from the protean narrative attributed to Mark as well as pieces of a lost oral collection of Jesus' sayings known as Q (from the German *Quelle*, "source.") Darwinism and biblical criticism had two major commonalities: they employed a schema of historical development rather than an assumption of stasis, and they could easily be read as undermining the assumption that scripture was literally true.

Such ideas had little impact on some areas of the nation—especially the culturally isolated evangelical South—but made rapid headway in northern universities and Protestant seminaries, such as the divinity schools at Harvard, Union (New York), and the newly established University of Chicago. What had previously been a shared interdenominational set of assumptions about biblical truth now began to shatter, as factions emerged especially in the Baptist and Presbyterian denominations. In 1910, a series of booklets defending traditional teachings began to be published under the title *The Fundamentals*, giving a name to the conservative movement that would henceforth be known as "Fundamentalism." Fundamentalism—in later times a major component of the "Religious Right"—emerged as a harder-edged version of traditional Evangelicalism, antagonistic to the loosely constituted theological movement known as Protestant Liberalism or Modernism. Liberals among Protestants of various denominations allied themselves with the new intellectual forces, arguing that if biblical and scientific findings seemed to clash, the problem lay in an inadequate methodology for reading the Bible—

that is, literalism. Liberalism, though still affirming the centrality of Jesus and scripture, downplayed traditional teaching such as original sin, predestination, and the vicarious atonement, and stressed instead the exemplary character of the life and work of Jesus and the potential goodness of all humans. In more radical versions of Modernism, the centrality of Christian revelation was further downplayed, and the value of any religion lay—in pragmatic philosopher William James's phrase—in its fruits rather than its roots.

The overall response of the American Christian churches to the challenges of the American city can be viewed collectively under the heading of "Social Christianity," but that category includes a wide spectrum of assumptions and approaches. Roman Catholic leaders had until late in the nineteenth century been preoccupied with dealing with the material as well as spiritual needs of the vast numbers of immigrants who shared their tradition. In addition to churches, parochial elementary schools, and housing—convents and rectories—for staff, this enterprise included the development of a vast institutional complex—secondary schools, orphanages, hospitals, asylums, cemeteries—at a time when civic authorities were unable to provide social and medical services and Protestants often all too eager to proselytize potential converts. A major breakthrough took the form of Pope Leo XIII's 1891 encyclical letter *Rerum Novarum*—"Of New Things"—which departed from traditional papal defensiveness against social change. Leo instead argued that Christian moral teaching demanded that workers be treated as spiritual beings rather than economic units, and paid

a "just wage" that would support a worker and his family with a measure of dignity. American Catholic bishops and scholars would rapidly turn this teaching into an entire social program, which ultimately influenced Franklin Roosevelt's New Deal.

The American Protestant response to the new urban industrial social order was more complex. Evangelicals, for example, generally held to the traditional laissez-faire economics to which they had given theological legitimacy for much of the century, and believed economic issues to be essentially questions of individual character. The key to worldly success lay in personal conversion, a major watchword of Evangelicalism from the Great Awakening of the 1740s to the present day. Responses to the urban scene and its dysfunctions were innovative in means but directed toward traditional ends. These included the Gospel Mission, located in poor neighborhoods and designed to help the poor with an offering of food, a clean bed, and a good dose of prayer and evangelism. (The Salvation Army, which featured street-corner musical ensembles to attract attention, was an English innovation that exported its message and tactics to the United States.) The YMCA and YWCA movements, with origins in the Civil War era, were aimed at young people, often new to the cities, who could be sheltered from urban temptations with inexpensive lodging, recreation, and religion.

Perhaps the most dramatic of evangelical responses to the city was the new form of revivalism pioneered by evangelist Dwight L. Moody. Revivalism had been a staple of American Evangelicalism since the Great Awakening a century and a half earlier, but its tactics had changed in response to the new challenges of succeeding eras. Moody, who had begun as a shoe salesman and used dynamic Chicago as a base of operations, applied modern techniques of organization and publicity to religion, and enlisted many wealthy businessmen to finance and do the advance work for his large-scale revivals, providing vast "tabernacles" as preaching halls. Moody's innovations included a musical director—Ira D. Sankey—to stir up his auditors' emotions, and the altar call—"hitting the sawdust trail"—an event at the climax of his sermon in which potential converts came forward to shake his hand and accept Jesus as their personal savior. Moody's message focused entirely on the conversion of individuals, and he made no public reference to reform in the social realm. His best-known successor, Billy Sunday, was more negative in tone, attacking liberal theology, "booze," and various other social sins and theological errors with dramatic abandon and helping to lay the moral groundwork for Prohibition.

At the opposite end of the theological spectrum were the theologians and pastors who believed that the Christian Gospel was not simply about individual salvation and conduct, but was aimed at the social, political, and economic orders as well. The chief theorist of this "Social Gospel" was Walter Rauschenbusch, a German-American Baptist who experienced the evils of contemporary urban life at first hand in Manhattan's "Hell's Kitchen." Rauschenbusch then went on to write *Christianity and the Social Crisis* (1907) and other works calling upon Christians to help usher in the Kingdom of God, eliminating the systemic inequities of the social

order through reforms aimed at bettering the lot of working men (as well as women and children). Richard T. Ely, a lay Episcopal economist, launched a scholarly attack from his base at the University of Wisconsin on laissez-faire economics, favoring a positive role for the state on the German model. More specific calls to practical social reform emanated from the pulpit and pen of Washington Gladden, a Congregationalist based in Columbus, Ohio, who wrote dozens of books with titles such as *Working People and their Employers* (1876) and *Christianity & Socialism* (1905). A few Social Gospel advocates such as Boston Episcopal priest W. D. P. Bliss actually advocated a form of Christian Socialism, but most stayed within the safer parameters of reform on the lines of the Progressive movement.

Another innovation of urban Protestantism was the auditorium church, a large structure designed to showcase the preacher as celebrity. These churches were favored by a spectrum of denominations— especially Baptist, Congregational, Methodist and Presbyterian— and enjoyed prominent locations, either downtown or on axial avenues. In style they might be Gothic, Richardsonian Romanesque, or some combination of these and other styles that have come to be known as Victorian eclectic. Their interiors resembled one another and were modeled on a secular institution, the theater, featuring sloped floors, "opera seating" (rows of individual seats rather than pews), a prominent pulpit, and a platform with seating for officiants and a choir or other musical ensemble. Stained glass was a frequent mode of ornament, usually confined to decorative patterns or biblical scenes. Ministers were expected to

prepare elaborate sermons as the core of the service, and to deliver them in an arresting style. Among the "princes of the pulpit" who enjoyed celebrity status were Henry Ward Beecher and Lyman Abbot of Plymouth Church, Brooklyn; George Angier Gordon of New Old South, Boston (all Congregational); and Phillips Brooks at Boston's Trinity Episcopal Church. The auditorium-style worship space was often part of a broader complex known as the "institutional church," an expansive plant that also included rooms for Sunday school and adult educational programs, kitchen and dining facilities, recreational apparatus such as bowling alleys and basketball courts, and other strategies for attracting the younger generation especially.

It was Phillips Brooks who in some ways can be considered the epitome of the Victorian American clergyman. A celebrity both in North America and Britain, where he preached frequently in Anglican churches, Brooks's charismatic presence attracted not only the Boston "Brahmin" upper class who were the Episcopal Church's typical constituency; he also reached out as well to the new middle class drawn to the city by rapid commercial expansion with a message of self-improvement through the personal appropriation of his optimistic message of moral uprightness and purity exemplified in Jesus. Trinity Church, which had called Brooks to Boston in 1869, had recently purchased a new site in the emergent fashionable neighborhood of Back Bay. During the next decade Brooks engaged in an extensive collaboration with the architect Henry Hobson Richardson and painter John La Farge in fashioning a new Trinity in which the whole spectrum

Detroit Publishing Company
Postcard of Trinity Church, Boston, Massachusetts,
70000 series, ca. 1910
Offset photomechanical print
Stephen A. Schwarzman Building / Photography
Collection, Miriam and Ira D. Wallach Division of
Art, Prints and Photographs, MFY 95-29

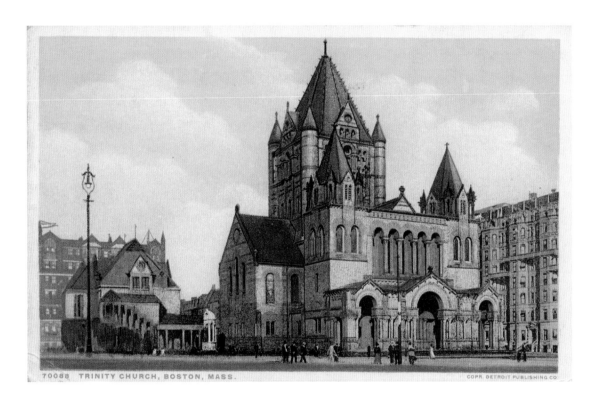

of the arts combined to provide a showcase for Brooks's pulpit oratory. Brooks kept a distance from the growing Anglo-Catholic movement within the Episcopal Church, which favored the Gothic revival style, an elaborate physical apparatus for worship, and an embrace of Roman Catholic practices such as the veneration of the saints. He himself selected the Romanesque revival mode, of which Richardson was becoming a master interpreter, as a style closer to that of early Christianity and thus appropriate for distinctively Protestant worship. Trinity became a showcase for a variety of liturgical arts, including stained glass with biblical themes— some provided by English Pre-Raphaelite artists—as well as mural painting and wood-carving. Brooks and Trinity thus provided a precedent and a legitimation of the visual and material arts as suitable for Protestant worship, as well as a venue for pulpit oratory as popular entertainment and a focus for any number of outreach

programs to poorer Boston neighborhoods. Trinity was a new kind of church, and the epitome of what a new urban middle class craved as a place of worship that was at once traditional and *à la mode*. It provided a paradigm for religious building in which the various arts were not simply ornamental, but integrated components of a larger aesthetic and liturgical ensemble—one that Louis C. Tiffany most likely would have known.

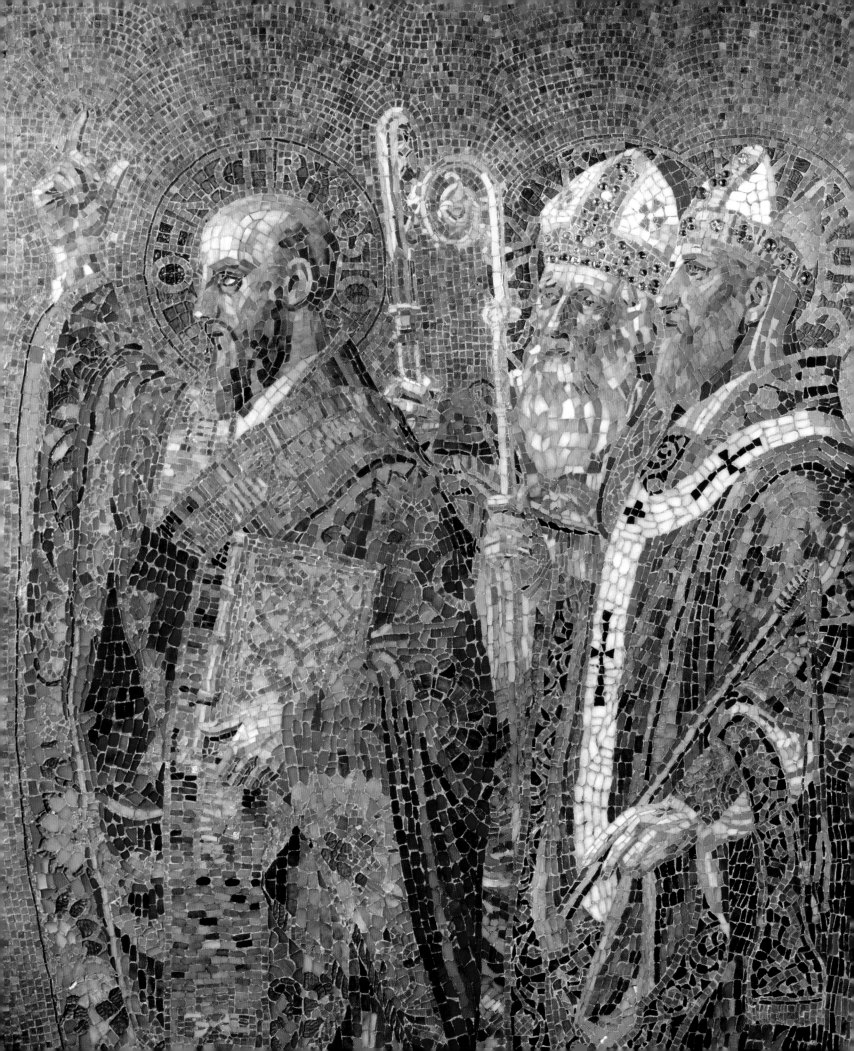

Louis Comfort Tiffany's Gospel of Good Taste

JENNIFER PERRY THALHEIMER

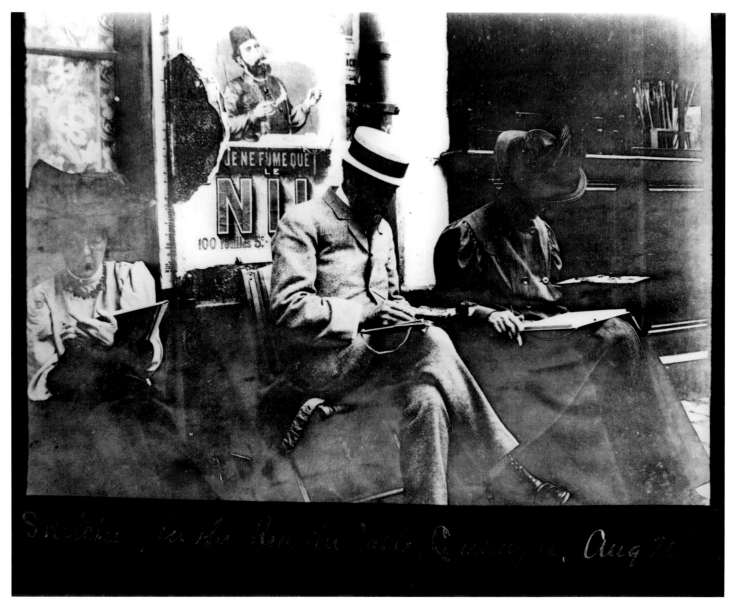

Fig. 1
Dr. Parker Cairns McIlhiney (1870–1923)
Sketching in the Rue du Salle, Quimper: Clara
Driscoll, Louis C. Tiffany, and Agnes Northrop,
August 20, 1907
Collection of Michael John Burlingham, New York

For more than 150 years the Tiffany name has been synonymous with luxury goods. Louis Comfort Tiffany (1848–1933), like his father Charles Lewis Tiffany (1812–1902) who founded Tiffany & Co., intended Tiffany Studios to meet and often set current taste.[1] Unlike his merchant father, however, Louis Tiffany was first and foremost an artist in quest of beauty. He was Tiffany Studios' motivating force and art director. Tiffany's aesthetic vision—a published overview of which was titled "The Gospel of Good Taste"— ultimately determined the nature, character, and quality of the artwork produced by Tiffany Studios.[2]

Tiffany's artistic approval was his workers' primary objective when designing or producing work. To stimulate and shape their creativity, designers were invited to Tiffany's homes and gardens, and often to travel with him (Figure 1). In addition to this primary study, Tiffany provided a crucial resource for his workers in the form of a vast archive of images which he assembled as a guide for his vision. A large part of this photographic archive survives today and provides a unique insight into Tiffany Studios' oeuvre.[3]

Recently there has been great interest in exploring the individual roles of Tiffany Studios'

designers. This long-overdue study is essential to the development of the full context for the body of work that earned Tiffany Studios international acclaim. A disproportionate amount of primary source material from specific workers, however, has led at times to a distortion and to Louis Tiffany, by implication, being miscast as a megalomaniac. No compelling evidence supports this view. In fact, close study of Tiffany's life, his role in the studio, and the nature and function of the photographic archive he developed suggests his active participation in Tiffany Studios' production. Tiffany provided the imaginative guidance and supportive hand which, through a complex management system including both formal and informal collaboration with his staff of designers, chemists, artisans, executives, and technicians, defined Tiffany Studios. He is ultimately responsible for the character and extent of its celebrated identity.

FORMATION OF MAN AND BUSINESS

One lifetime was not enough to carry out Mr. Tiffany's creative experiments. He had the rare combination of executive and artistic ability, the financial resources and the will to carry out his ideas through to realization.[4]

Louis Comfort Tiffany (Figure 2) began his career as a painter, quickly became successful and was admitted at an early age to the National Academy of Design. Well-travelled throughout Europe and North Africa and with a great sensitivity to color and light, he developed thematic and formal preoccupations early on that would characterize his personal work and that of Tiffany Studios. These predilections allowed for a perfect transition from canvas to glass, a material which intrinsically captured color and light. This natural attraction to glass—its ability to so totally transform light and both amplify and shape color—drove Tiffany's tireless efforts to exploit its effects and to minimize the standard use of enamel on windows.

Tiffany had been experimenting with glass at independent glasshouses since the mid-1870s when he was in his twenties, and now, with his new undertaking, he "took up chemistry."[5] Significantly, he seems from the beginning to have realized his goals with and through an organization of his design. Tiffany sought the help of preeminent glassworkers and chemists and attempted to open a glasshouse to satisfy his desire to produce flat glass with "richer, finer" color (Figure 3).[6]

In the early 1880s Candace Wheeler recalled of her time at Tiffany's Fourth Avenue studios in New York City that:

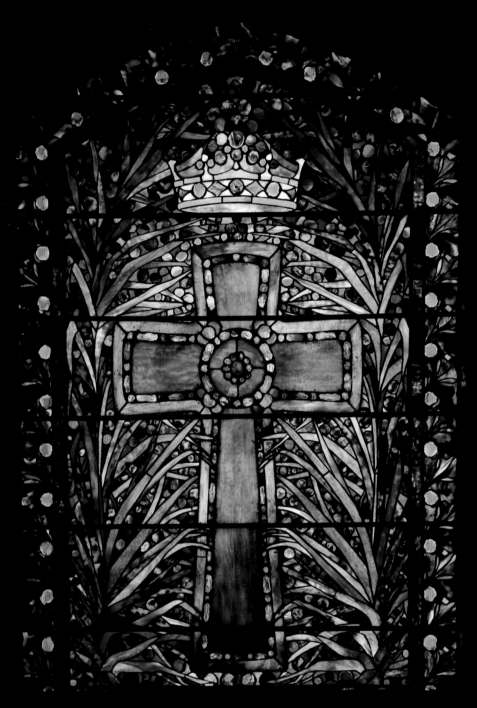

IN MEMORIAM

ALMY TOWNSEND HICKS.
BORN MARCH 4,1795 ✦ DIED DECEMBER 18 1862.
CHARLOTTE BREVOORT HICKS.
BORN OCTOBER 13 1798 ✦ DIED DECEMBER 31 1882

[A]t the top were the glass rooms where Mr. Tiffany's experiments in color went on and where he was working out his problems from bits of old iridescent Roman vases which had lain centuries underground; or finding out the secrets of tints in ancient cathedral windows, and the proportions of metals and chemicals which would produce certain shades of color. The actual melting and mixing was done in the laboratory underneath his own apartments, far up on Fifth Avenue, but the results of the study and effects of juxtaposition were tried in the "glass loft."[7]

Tiffany later focused his attention on enamelwork and was only forced to discontinue experimentation at his New York residence after a chemical explosion. Hands-on experimentation attested to Tiffany's natural curiosity about materials that probably originated with his close ties to Tiffany & Co. Tiffany's uncle, George McClure, the head gemologist at Tiffany & Co. from 1852 through 1879, no doubt exposed Louis to the wonders of the natural world. Tiffany's interest was further cultivated by McClure's successor George Frederick Kunz, who was so admired by Louis that he was later asked to advise the young artists studying at the Louis Comfort Tiffany Foundation. Exposure to the most precious materials at such an early age only served to heighten Tiffany's desire for perfection in all objects he created.

Tiffany began to transition into more practical applications for his talents by June of 1878 when he opened his first business. The venture successfully established him as a premier interior decorator completing artistic designs for notable domestic, civic, and ecclesiastical interiors, even designing stage sets for theaters.[8] He was interested in the big picture and used the compositional skills and color principles he had acquired as a painter in his work as an interior designer. He described his sense of the delicate balance of atmosphere:

> We must have a combination of the physical and mental in fine art decoration—the objective and subjective must be married and intimately blended by the subtle employment of color, as the composer employs the moods of music.[9]

Ultimately, Tiffany channeled his style as an architect, a photographer and a designer of wallpaper, textiles, ceramics, furniture, enamels, and jewelry in addition to glass lamps, windows, mosaics, and vessels, into a cohesive company image.

An optimistic Tiffany presented his first incorporation as "going after the money there is in art, but the art is there, all the same."[10] The dissolution of many of his earliest companies through bankruptcy, however, illustrates the unrealistic nature of this statement; his focus on the pursuit of beauty may have taken much needed attention away from the business side of things. Early company instability led Tiffany to establish a fundamental management system of checks and balances that eventually forged a successful marriage of art and merchandising. Tiffany established the vision for his company and set creative standards while relinquishing to managers the day-to-day

Cat. 1
After Joseph Lauber (1855–1948)
*Chapel Exhibit by Tiffany Glass and
Decorating Company, 1893 World's
Columbian Exposition in Chicago,*
ca. 1893

business of developing product lines that could be both commercially successful and cost-effective.[11] Dividing the artistic and commercial entities permitted Tiffany to pursue his primary artistic objectives and ensure Tiffany Studios' solvency.

The name of Louis Tiffany—and indirectly that of his father—fed the reputation of Tiffany Studios. The Tiffany name was a decided advantage for the young artist since it enabled Louis to receive prime booth locations at the various world's fairs always side-by-side with the well-established Tiffany & Co. Louis capitalized on the Tiffany name, including it in almost all corporate incarnations. "Tiffany" linked his firm's production with the marketability, quality, and stability that came through association with his father's prestigious retail firm.

Tiffany Studios' original building was located on Fourth Avenue and Twenty-sixth Street in the heart of New York's artistic community—centered largely between Fourth and Fifth Avenues, and Fourteenth and Twenty-sixth Streets. His business was just blocks away from the National Academy of Design, major art galleries such as O'Brien's, Moore's and Kurtz, and clubs like the Lotos, University, and Union League, as well as theaters like the Lyceum, Hudson, and Madison Square. Tiffany's large circle of social and professional associates was located in this community as well. Wealthy patrons and their places of worship offered Tiffany Studios many opportunities for sales and marketing. Tiffany followed this cultural hub as it migrated uptown. In 1905 he relocated his studios to the former Knickerbocker Athletic Club on Madison Avenue and Forty-fifth Street.

By this time his glasshouse in Corona, Long Island, had been established as well.

Ecclesiastical works had been part of Tiffany Studios' repertoire since the company's foundation. By 1889, demand from churches for decorative art was so great that Tiffany designated an entire department at Tiffany Studios for the creation of "all forms of church decoration and *instrumenta ecclesiastica*."[12] This division boldly advertised its "large and practical knowledge of religious art…" and the claim that it was

> well-equipped to undertake both the design and execution of all forms of church work in glass, fresco, metal, stone or wood. In addition to ecclesiastical glass work, this department embraces metal work altars, candlesticks, crosses, desks, railings, etc. Also in wood or stone altars, panels, symbols, figures of saints, mural decorations, medieval needlework, medieval tiles, liturgical books from the press of the Society of St. John the Evangelist, and all manner of ecclesiastical supplies.[13]

Tiffany Studios' commissions varied from complete church interiors to single objects. This department's great success ultimately resulted in its outliving all others at Tiffany Studios.

By the time Tiffany exhibited at the World's Columbian Exposition in 1893, his studio had established itself as the premier ecclesiastical design firm. Intentionally appealing to this burgeoning market, the company installation at the Chicago world's fair

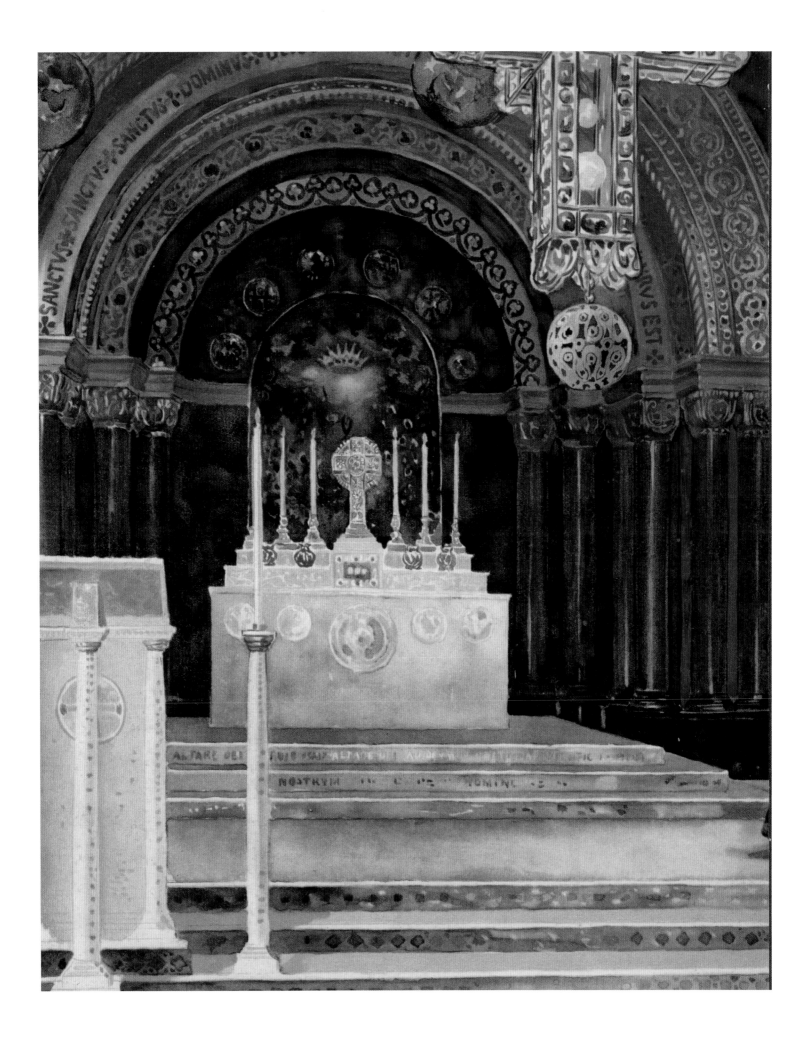

Fig. 4
Tiffany Glass and Decorating
Company, New York
Entombment window, ca. 1892
Leaded glass
104 × 73 inches
The Charles Hosmer Morse Museum of
American Art, Winter Park, Florida (58-012)

concentrated heavily on religious works—windows, liturgical garments and accessories, and even a fully fitted Romanesque-inspired chapel (Catalog 1). Entirely designed by Louis Tiffany, and "executed under his personal supervision," the chapel had been constructed with a plaster foundation since it was intended to be a temporary structure.[14] It was such a success however that, as Patricia C. Pongracz discusses in this volume, it was subsequently reinstalled in Tiffany Studios' showroom in New York City.[15]

While still on display there in 1895, Tiffany simultaneously opened a loan exhibition of religious art in the rooms adjoining the chapel. The show included celebrated examples of European religious paintings and icons from the fourteenth through the sixteenth centuries from prominent private collections. In addition to the praise lavished on the historical masterworks, Tiffany's show was reviewed as "richly illustrative of modern religious art."[16] The joint exhibition was not coincidental—Tiffany intended to attract admirers of both the old and new using the treasures from history to elevate his work.

Ecclesiastical windows exhibited in the chapel at the World's Columbian Exposition demonstrated the broad stylistic reach of Tiffany Studios. Designs showcasing a variety of historical precedents were introduced in order to appeal to every style and belief. An original window design by Tiffany called the *Entombment* (Figure 4) was heavily influenced by the High Renaissance and specifically the painting *The Lamentation over the Dead Christ*, 1495, by Pietro Perugino (ca. 1446/50–1523.) The window was a deeply

Fig. 5
Tiffany Glass and Decorating Company, New York
Head of Joseph of Arimathea window, 1892
Leaded glass
21 × 20 ½ inches
The Charles Hosmer Morse Museum of American
Art, Winter Park, Florida (85-005)

personal depiction for Tiffany as he modeled the head of Joseph of Arimathea on his father's likeness. In order to perfect this character's depiction, the Studios constructed a study for the saint's head (Figure 5). The complex system of plating, or layering the glass, which allowed for a lifelike perception of depth in the face, also integrated the natural properties of glass to communicate textural effects like the hair and facial features. Tiffany presented this study in exhibitions as an example of the successful use of glass to convey depth and modeling with the limited application of enamels.[17]

By contrast, the *Madonna and Child* window (Figure 6) directly copied the Renaissance painting by Sandro Botticelli (ca. 1445–1510), *Virgin and Child with Seven Angels Bearing Tapers*, 1485–87. No doubt the illuminated depiction was intended as a statement of the superiority of the new opalescent glass. By 1908, however, Tiffany had set a strict policy restricting historical reproductions, except by his express consent.[18] The practice had apparently served its purpose, and the goals of the Ecclesiastical Department had shifted to the production of original designs.

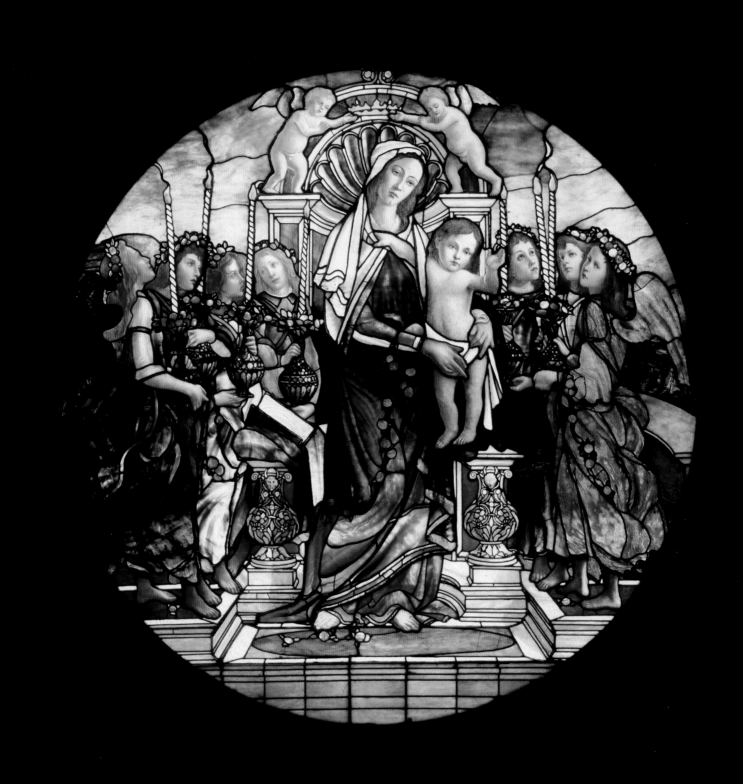

A PROGRESSIVE LEADER
OF A TRADITIONAL ARTISTIC STUDIO

Louis Tiffany created Tiffany Studios according to his personal design theory. In addition to his own designs, he oversaw all levels of work, allowing individuality to flourish but within the parameters of his artistic style. Siegfried Bing described Tiffany Studios' organization in 1895 as

> a large factory, a vast central workshop that would consolidate under one roof an army of craftsmen… all working to give shape to the carefully planned concepts of a group of directing artists, themselves united by a common current of ideas.[19]

It was this "current" that Tiffany passionately pursued. Tiffany Studios' brochure for their exhibit at the Paris Exposition Universelle in 1900 clearly defines the overall company ethos, stating that "… in speaking of the Studios, let it be understood that the personality and individuality of Louis C. Tiffany pervades the entire establishment…."[20]

As Tiffany's businesses grew, so did the numbers in his employ and the amount of their output. Despite this expansion, he was diligent in the supervision of artistic production. As the Studios' art director, Tiffany drove all creative production, thematically and materially. An early article describes that the artistic operation "is so skillfully organized, that it allows for the personal interest on the part of the worker, as well as obedience to the inspiration from the fountain head."[21] Tiffany's signature denoted the authorization of design drawings, and he reinforced his ultimate approval during weekly visits through various departments and to the furnaces in Corona. He even monitored business practices and intervened when he felt they compromised the creative endeavors of the company.[22]

Dependent upon fresh perspectives, varying styles, and excellent artistic eyes, Tiffany sought the most prominent designers of his day. Despite modern speculation, it was well documented in period papers that Tiffany had designers who worked for him. Designers, regardless of their gender, were publicly credited for their work. In the self-published brochure produced for Tiffany's most public showing up to that date, *A Synopsis of the Exhibit of the Tiffany Glass and Decorating Company… at the World's Fair, Jackson Park, Chicago, Illinois, 1893*, designers Frederick Wilson (1858–1932), Jacob Adolphus Holzer (1858–1938), F. S. Church (1842–1924), Joseph Lauber (1855–1948), Edward Peck Sperry (1850/51–1925), Will H. Low (1853–1932), Lydia Emmett (1866–1952), and Louis C. Tiffany himself are all credited beneath pictures of their designs.[23]

The acknowledgment of workers actually became standard in the course of the company's official showings at exhibitions, in company brochures, and in the liberal access to the workshops granted to the press. Acknowledgment in newspaper coverage, however, was not as easily controlled as material produced by Tiffany Studios. Enthusiasm by the reporter to identify with the cachet of the Tiffany name often overshadowed the accurate details of attribution.

Tiffany Studios encouraged designers to specialize according to their strengths. The design process was described in 1894 with the recognition that "individual and peculiar talents have a great deal to do with the making of a successful window."[24] These talents were cultivated, and may account for the variety in style within Tiffany's standard range. Frederick Wilson, who specialized in ecclesiastical design, was known for the subtle motion he achieved in his graceful figures. Agnes Northrop (1857–1953) was recognized for "flowers and conventional designs" and applied this specialty to carpets and silks as well as windows.[25] Designers also freely collaborated on works, to create the best finished product. Northrop, for example, created the background for a window made by Frederick Wilson in memory of Jay Gould.[26]

Like any studio workshop throughout history, a hierarchy of artists and artisans worked on a commission from initial design through to the final article. Tiffany intentionally modeled his workshops to function as an apprenticeship system, much like William Morris had done in England.[27] Traditionally a work would be attributed to the artist responsible for the original rendering, but it was understood that his achievements were not without skilled assistance. In addition to the designers there were assistants, selectors, and a multitude of workers who completed the works—each mindful of Tiffany Studios' overall design parameters. Describing the complex relationship between artist and artisan, Tiffany noted that "to produce a successful work of art… [a] hundred little details at all stages of the production require the constant attention of the artist,

and in order that he may be understood the artisan must be in sympathy with him."[28]

This level of collaboration required close proximity physically as well as creatively. An 1896 building inspection inventory described the adjacent work areas for designing and fabrication: "[T]he building in the middle of the avenue as a store on the first floor, offices on the second, a workshop and drafting room on the third, a 'lead glazing workshop' on the fourth and metal workshop on the fifth."[29] Even the second-tier workers were recognized:

> [T]he beginner—cutting out patterns and glass jewels… —to the worker in her own alcove, surrounded by the design she is copying, cartoons and great boxes of glass of every description—fitting with an artist's hand and perception this bit of glass here and that there into an artistic whole that will convey the impression of the water-color beside her.[30]

Artists and artisans typically worked together on the same projects. Published examples of this collaborative working style can be found for designers such as Northrop and Wilson "entrusting" their designs to be carried out by assistants like Miss Stoney and Miss Egbert.[31] Further evidence establishes the division of labor in the creation of the rose window for the "Tiffany Chapel" at the 1893 World's Columbian Exposition (Figure 7), where "the entire work was carried out by women, except the original design, which was by Mr. Tiffany."[32] Particularly noteworthy is the fact that tiers of workers are publicly acknowledged in these news

35

accounts and that employment at the Studios was described as "always notable for progressive spirit."[33]

Division of labor at Tiffany Studios was clear: upper-level designers, with Tiffany at the head, led the studio, and many mid- and lower-level workers assisted as needed. It is likely that this organizational structure was not unique to Tiffany Studios' window manufacture, but spanned the many departments under the firm's name. As the many mentions and credits suggest, Tiffany recognized and encouraged his workers' talents.

CODIFYING A VISION
Tiffany Studios' Study Photograph Collection

Probably the most tangible evidence of Tiffany's overall vision exists in a design file comprised of photographs to provide guidance and inspiration for Tiffany Studios' employees. This visual archive cultivated an aesthetic vision within which the designers worked. Over the course of his career—as early as the 1870s through the end of his life—Tiffany accumulated photographs which eventually found their way into an ever-growing image catalogue organized by subject matter.

Each photograph was affixed to a cardboard mount of a heavy stock to endure handling and use. The collection was divided by an alpha-numeric system for easy reference.[34] They were typically registered with an ink stamp identifying a Tiffany company,[35] while some were affixed with an applied label, and others were either marked with a collector's stamp "Louis C. Tiffany" or

had Tiffany's name written in ink.[36] It appears that the images signed by Tiffany were the earliest and were perhaps the nucleus of a collection that grew over time, across companies and product lines.

Photography was central to Tiffany's design process. His various travels were rich opportunities for artistic inspiration and he often recorded them through sketches and photographs (Figures 8, 9). An 1876 letter from Mary Tiffany to Mr. and Mrs. Robert de Forest notes that "Louis is working very hard, painting, drawing and photographing."[37] These efforts occurred concurrently and continued throughout his career, as is reflected in the image Dr. McIlhiney took in France in 1907 (Figure 1). Though Tiffany's artistic photography appears to have most directly related to his painting pursuits, the abundance of images naturally fed his burgeoning interest with regard to the decorative arts. Many original images in the archive provided a continuing stream of guidance, direction, and inspiration for his creative staff.

In 1904 Tiffany opened his Long Island country estate, Laurelton Hall, and his library and archives to Tiffany Studios' designers. He encouraged them, as he eventually would young artists of the Louis Comfort Tiffany Foundation, to come be inspired by his vision, his selection of works, and his principles of unity, light, color, and beauty.[38] Tiffany made Laurelton Hall into an expression of his personal aesthetic and philosophical vision. Objects of his own design, including architecture and gardens, and artwork he collected made his aesthetic ideas palpable. Significant religious works such as icons, vestments, and crucifixes had been integrated into his collections and were on display on the balcony

Fig. 8
Louis Comfort Tiffany (1848–1933)
Rheims, 1889
Watercolor and graphite
13 × 10 ¼ inches
Yale University Art Gallery, 1974.57.1,
Gift of Louise Platt

Fig. 9
Louis Comfort Tiffany (1848–1933)
Senlis, 1891
Watercolor and graphite
13 ¼ × 8 ¾ inches
Yale University Art Gallery, 1974.57.2,
Gift of Louise Platt

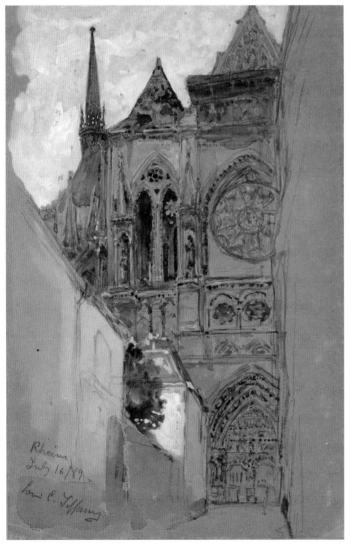

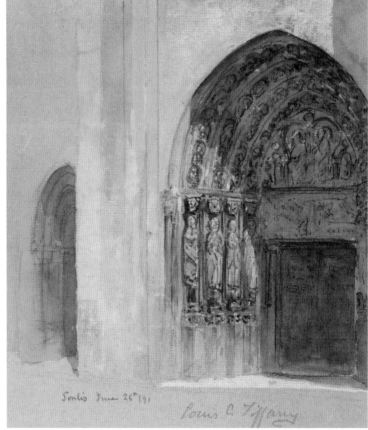

Fig. 10
David Aronow
Detail of the balcony display
cases at Laurelton Hall, ca. 1925
Gelatin silver print
The Charles Hosmer Morse
Museum of American Art, Winter
Park, Florida

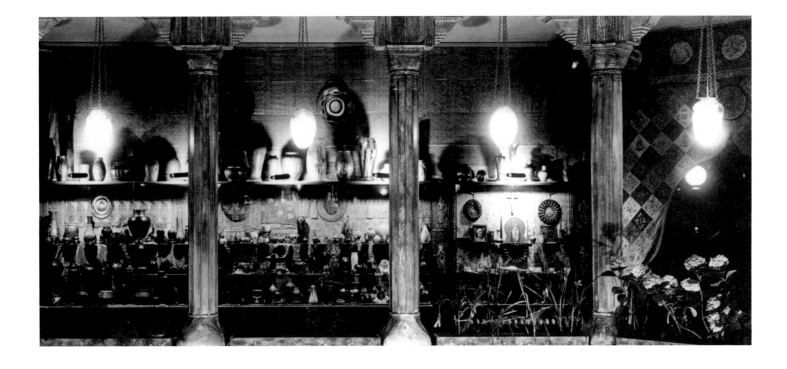

Fig. 11
Deroche & Heyland (active in Italy, 1865–73)
Madonnina, Milan Cathedral, ca. 1865
Albumen print mounted on board
14 × 10 inches
The Charles Hosmer Morse Museum of American Art,
Winter Park, Florida (65-030:0303)

overlooking the reception hall (Figure 10). Artists and designers were given access to this material, the photographic archive, a collection of plaster casts, and were granted use of a photographic darkroom—all in an effort to feed and form their aesthetic development.[39]

The majority of images in the archives were acquired through shops in New York City or abroad and used as precedents on which workers were encouraged to base their designs. In the late nineteenth century, European landscape and architectural scenes were sold as souvenirs and collectibles. Tiffany, like other artists, accumulated them for his study files. Known photographers such as Francis Frith and George Washington Wilson created images that were considered the next best thing to personal experience and often substituted for travel to the various areas.[40] They provided accurate images of archaeological objects from museums around the world, buildings and architectural details, decorative arts, figural studies, animal and plant studies, a study of every material (wood, metal, stone), carvings, paintings, landscape, and vestments, and complemented the artistic images and studio photography done at Tiffany Studios.

An early filing system at the studios defined certain images that were particularly emblematic of a general style. An image of a spire labeled as "Gothic 19" on the mount (Figure 11) served as a model for patterning that appears on candlesticks made in this style (Catalog 2). However, not all images were so overtly categorized. An image of a twelfth-century vase (Figure 12) complete with complex wirework and inset cabochons shows a style commonly employed at Tiffany Studios (Catalog 3).

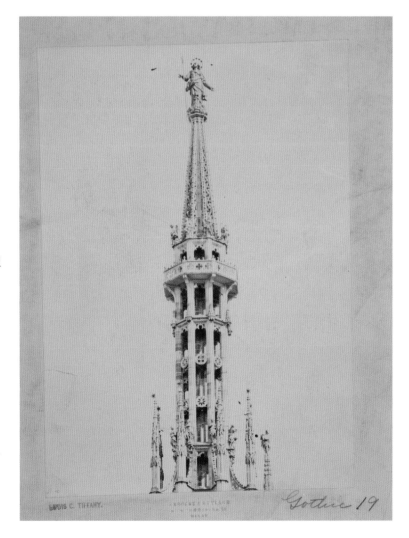

Cat. 2
Tiffany Studios, New York
Pair of candlesticks, ca. 1916

Fig. 12
Adolphe Giraudon (French, 1849–1929)
The Eleanor Vase from the Treasury of Saint-Denis, ca. 1892
Albumen print mounted on board
14 × 10 inches
The Charles Hosmer Morse Museum of American Art,
Winter Park, Florida (2006-005:012)

Fig. 13
Tiffany Studios study image (unknown photographer)
Study of cloud formation, ca. 1902
Albumen print mounted on board
8 × 10 inches
The Charles Hosmer Morse Museum of American Art,
Winter Park, Florida (2007-002:195)

for which glass could be selected based on the pattern or deliberately prepared to reproduce the design.

Upper-level designers like Wilson often maintained their own personal scrapbook in keeping with the photographic image file at the Studios. The latter, however, was available as a visual aid to the entire workforce who differed in education and life experience, thus ensuring that upper-level designers could rely on the artistic understanding of and potentially also a higher level of workmanship from even the lowest-level company artisan. This was important since the structure of the organization depended on the seamless interaction of all levels of work; the file appears to have been a widely used tool, since the photographs bear notations on their heavy-weight, cardboard mounts. Dimensions are often noted along the side of the mount, in one case: "6 ft 1 in from top to toe."[42] On other examples the image is overlaid with a pencil grid suggesting a scale drafting from the image. Occasionally a subject is actually embellished with supplementary details such as the addition of a crown.[43]

Markings also provide information on the way images were integrated into the design process. Looking to contemporary French ecclesiastic design, Tiffany supplied photographs offering one suggested style guide for depicting biblical figures in a series of sketches

The historical significance was apparent only on a caption below the photograph, and is filed under the number "18" on the mount by Tiffany Studios apparently offering a general reference to vessels.

Some of the study photographs depict trees, plants, waterfalls, hills, and other natural elements essential to the growing need for designs depicting landscape. In fact, Tiffany was very proud of the fact that "one can get in glass effects one can never obtain with pigments, such as nearer approach to the brilliant and peculiar subtile [sic] color of the sky itself."[41] Several photographs portraying cloud formations (Figure 13) likely served as reference images in designs (Catalog 4)

41

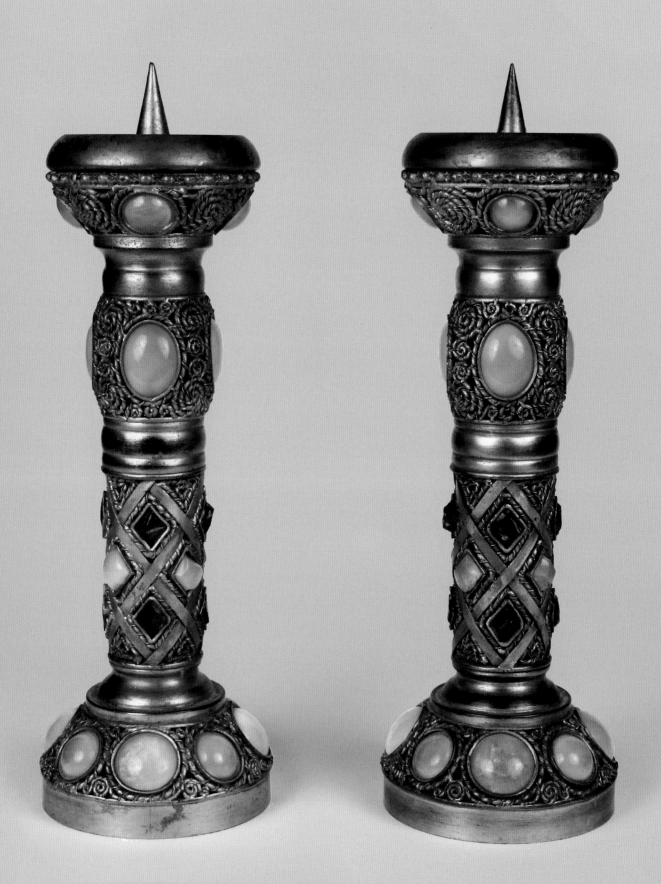

Cat. 3
Tiffany Studios, New York
Pair of candlesticks, after 1902

Cat. 4
Louis Comfort Tiffany (1848–1933)
Design for a window for All Saints
Church, Atlanta, Georgia, late 19th–
early 20th century

Fig. 14
Adolphe Giraudon (French, 1849–1929)
Sketch for *Moses* by Jean-Hippolyte
Flandrin (1809–1864) in Saint-
Germain-des-Prés, Paris, ca. 1890
Albumen print mounted on board
14 × 10 inches
The Charles Hosmer Morse Museum
of American Art, Winter Park, Florida
(65-030:0821)

was an attractive incentive for patrons who desired a Tiffany window's quality of design and material, but had limited resources to purchase a completely original work. In 1908, however, Tiffany adjusted the policy and limited production to "two repeats of any original design for a stained glass window, these repeats to be made at great distances and the owner of the original window, together with the owner of each repeat, to be informed of the name of the Church and the location of the same, in which the copy is placed."[46] Tiffany was protecting the character of the artwork by setting these parameters for the manager negotiating the deals.

The conflict between the artistic and commercial interests at Tiffany Studios developed around the 1890s and intensified through the eventual dissolution of the company. Discovery of Clara Driscoll's (1861–1944) correspondence as well as notebooks from the Nash family allow rare insight into the day-to-day workings of the company, workers' perspectives of the Studios, and the perceived place of the latter in the company structure.[47] Driscoll in particular struggled with her role in the management of a commercial department at Tiffany Studios that was overseen mainly by business managers. She envied the fortune of other designers in what she referred to as "little arcadia," stating: "They never hear the word cost, and are quite untouched by the hurry and worry of the commercial world. Mr. Tiffany whose only idea is Art comes to see them two or three times a week."[48] As Driscoll accurately described it: "Their work is practically the private enterprise of a rich man, and they never consider anything but the question of beauty while I

from Jean-Hippolyte Flandrin (1809–1864). One figure that appears to represent Moses (Figure 14) is labeled on the back of the mount as another figure, David, and on the front of the mount as a third figure, St. Matthew. These notes suggested that the main figures could be used interchangeably to depict each character.[44] Designs by Edward P. Sperry filed with the copyright office for the figures of *Job* and *Moses* (Catalog 5) reinforce this form of figural adaptive reuse. This method was practical since the price of a window could double depending on the degree of work required by a designer.[45] Using cost-efficient stock figures in a drawing

Fig. 15
Tiffany Glass and Decorating Company, New York
Miter from the World's Columbian Exposition,
Chicago, ca. 1893
Albumen print mounted on board
11 ½ × 7 ½ inches
The Charles Hosmer Morse Museum of American
Art, Winter Park, Florida (65-030:0014:01:01)

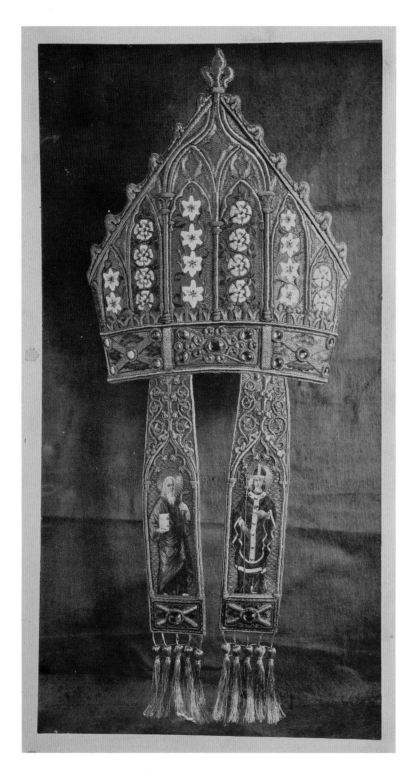

have to consider the cost of production at every step—beside being interrupted in my work by all manner of things relating to business rather than Art....".[49] This balance of art and profit was constantly tilting, but was necessary for the long-term health of the company.

The breadth of the Studios' production is evident in a collection of glass plate negatives taken at Tiffany Studios. Objects such as lamps, metalwork, furniture, monuments, windows, mosaics, interiors, rugs, exhibition pieces, nature studies, and even window designs were photographed. Images made from these negatives were often used for promotional purposes and placed in the study file for future reference. The fact that even Tiffany Studios' work was available for review suggests that these pieces were considered to be successful and worthy of recreation.

Several liturgical garments exhibited at the 1893 World's Columbian Exposition in Chicago were documented in the Tiffany Studios' photographic file. A needlework and appliqué miter (Figure 15) was advertised as "a form... which was in vogue during the best periods of church art and in every respect conforms with the rules of the Congregation of Rites for precious mitres."[50] Perhaps to highlight the enduring legacy of fine ecclesiastic vestments, Tiffany Studios also created a monumental mosaic depicting the early Church Fathers in resplendent robes (Catalog 6). The careful attention paid to the figures' garments suggests Tiffany's familiarity with historic mosaic work, like the sixth-century program at San Vitale in Ravenna, as well as the firm's ability to translate designs from one medium to another. An antependium, or lectern frontal, cloth

(Figure 16) especially designed for the Chicago fair was similarly described as an "entirely new design, but upon strong ecclesiastical motives...."[51] This textile served as the model for a window (Catalog 7). The plush of the crimson velvet is communicated through irregular, delicately striated glass, while the gold embroidery was translated into rich, glowing jewels. Tiffany was known to celebrate preferred or personal designs by reproducing them and often by transforming them into an alternate material.[52]

TIFFANY
Name Above All Names

Louis Tiffany's employees understood the firm's dynamic. His companies were, as Clara Driscoll noted, "the private enterprise[s] of a rich man."

Tiffany's insatiable pursuit of beauty was best portrayed in a theatrical performance called the *Quest of Beauty* staged at the Tiffany Studios in honor of the designer's sixty-eighth birthday. The leading character of the performance unquestionably revealed from Tiffany's point of view the story of his transformation from merchant's son to artist: the fictional Tiffany represented by Genius was, at first, "... eager-eyed, a youth, to whom had come a yearning to create the beautiful...."[53] As a result of his great sensitivity, Beauty is awakened:

> [S]he smiled and turned her face to the artist...
> Under the influence of her gaze he opens his
> eyes and beholds... the radiant goal of his

aspirations. To Beauty he pledges himself—The Quest of Beauty will thenceforth be his purpose and desire in life. For this service Beauty will give into his hands native metals and minerals... glass and clay... gems and precious stones and all the colors for the painter's needs....[54]

Allegorically portraying the awakenings Tiffany experienced through his artistic pursuits, the performance articulates the obvious passion with which he approached them.

Tiffany's passion accounted for nearly fifty years of continuous production from Tiffany Studios. He developed and nurtured the Studios' aesthetic through diverse means like his photographic archive and a successful management system permitting commercial and artistic balance. As the company's director, Tiffany won numerous esteemed commissions and facilitated award-winning showings at exhibitions worldwide. These accomplishments were the mainstay of Tiffany Studios' reputation during his lifetime and of its enduring legacy to this day.

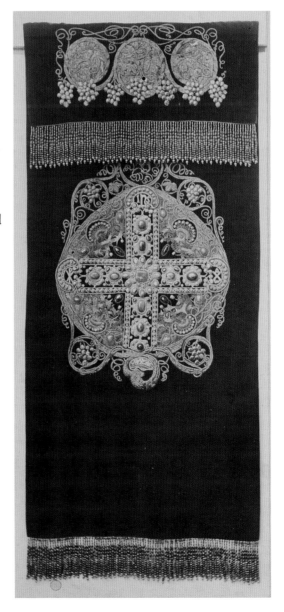

Tiffany Studios' Business of Religious Art

PATRICIA C. PONGRACZ

Tiffany Studios, New York
Liturgical suite, ca. 1916
Christ Church Cobble Hill, Brooklyn,
New York
View of Cats. 2, 21, and 22 *in situ*

Cat. 8
Tiffany Studios, New York
Design for St. Paul's Episcopal
Church, Paterson, New Jersey, n.d.

When we think of Tiffany Studios' work, we most often call to mind the intricate lamps, desk sets, and other objects made for the home. The bulk of Tiffany Studios' commissions—its bread-and-butter so to speak— were actually religious. Throughout the period under discussion, 1880 to 1915, houses of worship were integral to American civic life. The period reportedly saw a boom in church building counting at one point 4,000 churches under construction.[1] Tiffany Studios was one of the top American firms to cater to liturgical decorative needs at this time, guiding and influencing American ecclesiastic style in a way that cannot be underestimated.

Tiffany Studios' distinctive style, formed during a period known as the American Renaissance, was born of Tiffany's active engagement with the history of art and architecture, in particular the major medieval and Renaissance monuments in Italy, France, and Spain. Tiffany continued the grand tradition of religious art, taking cues from both Western and Eastern decorative styles to create an aesthetic embraced by America during the Gilded Age. In addition to the memorial windows for which Tiffany Studios is perhaps best known, the firm had an active trade in ecclesiastic furniture, objects, and decorative interiors. Tiffany Studios offered a range of decorative services allowing a community to commission a fully integrated interior, like those at First Presbyterian, Bath, New York (1897); St. Michael's Church in New York City (1895); St. Paul's Episcopal Church, Paterson, New Jersey (ca. 1897) (Catalog 8); All Hallows' Church in Wynecote, Pennsylvania (ca. 1896); and Christ Church Cobble Hill, Brooklyn (1916) (see page 50). A patron could also commission a single

memorial window, baptismal font, pair of candlesticks, cross, or some combination thereof. Offering a range of decorative services on a sliding scale enabled Tiffany Studios to cultivate a broad customer base.

Tiffany Studios was not shy in its marketing efforts. As J. B. Bullen notes, Louis C. Tiffany saw his creative ventures first and foremost as businesses. Discussing the establishment of the Associated Artists, Tiffany stated that the firm "is the real thing, you know; a business, not a philanthropy or an amateur educational scheme. We are going after the money there is in art, but the art is there, all the same."[2] The firm's most remarkable marketing coup took place at the World's Columbian Exposition held in Chicago in 1893. In a structure erected within the Manufacturers and Liberal Arts Building, the Tiffany Glass and Decorating Company created an evocative liturgical environment in which mosaics, windows, candlesticks, textiles, crosses, and sanctuary lamps—known as electroliers— produced especially for church interiors, took pride of place. So successful was the Tiffany Chapel, as this installation came to be called, that contemporary reports noted "men removing their hats" as they entered what they perceived to be a "sacred" space in the midst of the tumult of this World's Fair spectacle.[3]

Now on view at the Charles Hosmer Morse Museum of American Art in Winter Park, Florida, the chapel was certainly a favorite of Tiffany's and provided a wealth of marketing material that the firm used continuously after its initial display in Chicago in 1893.[4] Tiffany Studios capitalized on the chapel's success in the winter of 1895 by reinstalling it in the firm's showrooms

at 335–41 Fourth Avenue in New York City. From March 25 through April 6, 1895 the chapel was displayed as part of an exhibition of religious art held to benefit the chapel at St. Gabriel's in Peekskill, New York. The chapel was enough of a draw to be included in the show's discursive title, which read "Loan Exhibition of Religious Art for the benefit of the Chapel at Saint Gabriel's, Peekskill, New York. Held in the rooms adjoining the Tiffany Chapel at 335 to 341 Fourth Avenue, New York…." The *Lexicon and Catalogue*, listing the objects on view, is particularly notable for the works it lists as on loan from the Tiffany Glass and Decorating Company.[5] These liturgical objects and photographs belonging to Tiffany's archives, discussed below, suggest just what models inspired the firm's distinctive style.

The *Lexicon and Catalogue* reveals a number of lenders to the show, including other notable names in the field of churches and church decoration. In addition to the Tiffany Glass and Decorating Company, J. & R. Lamb Ecclesiastical Art Workers of 59 Carmine Street in New York City loaned three alms-basins, and the architect Stanford White loaned "an altar-card in a carved and gilt frame" as well as several figures of the Madonna.[6] The exhibition, and in particular the churches and firms lending to it, indicate that much of the work in churches during this period was inspired by art of the past. Not only were the choices of church leaders and congregants influenced by the historic objects they collected, but the firms catering to them actively collected and developed a style undoubtedly informed by major monuments and objects from the history of art and architecture.

The chapel, inspired by early Christian, Byzantine, and medieval art and architecture, together with the exhibition, set within Tiffany's showrooms, was an expert marketing tactic. Through loans the firm encouraged the participation of the very congregations to whom it wished to advertise. Many of the works came from either clergy or area churches including St. Agnes's Chapel in New York, for which Tiffany Studios would design a monumental mosaic pulpit and east end. Enlisting the partnership of competing New York area firms like J. & R. Lamb and W. H. Colson & Co., through both loans and advertising (their firms' advertisements, together with that of Tiffany Glass and Decorating Company, at the back of the catalog, most likely paid for its publication), demonstrated publicly the shared philosophy of looking to the past for models, while allowing Tiffany's firm to stand out as an innovator. The display was, after all, advertised as "in the rooms adjoining" the wildly successful 1893 chapel and in the showrooms of the Tiffany Glass and Decorating Company.

The timing of the chapel's display in Chicago in 1893 and again in New York City in 1895 was itself a wise promotional strategy. As Bullen describes, the exposure that the chapel installation provided Tiffany Studios, as the firm marketed itself after 1900, undoubtedly resulted in commissions.[7]

We get a sense of a selection of Tiffany Studios' art-historical models from the list of works it lent to this exhibition which included: a fourteenth-century white velvet and gold-work chasuble, (p. 32); a fourteenth-century miter, or bishop's hat, of white silk

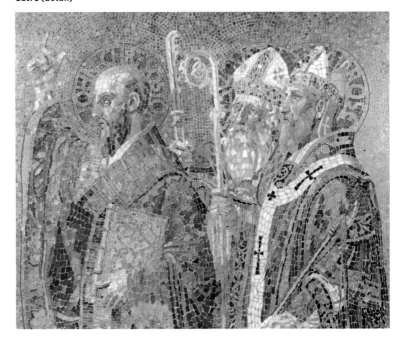

and gold-work (p. 52); a copy of an eighteenth-century French monstrance (p. 52); a reproduction thirteenth-century French gilt pastoral staff in the Gothic style (p. 54); several reproduction seventeenth-century Italian sanctuary lamps and one undated sanctuary lamp described as being made of "gilt wire work with Jewels" (p. 62); a twelfth-century silver sanctus bell and two reproduction thirteenth-century sanctus bells (p. 62); a selection of contemporary Stations of the Cross, specifically Stations I, XII, and XIII by Miss Edith Woodman and an unidentified bronze Station of the Cross made in France during the nineteenth century; and two eighteenth-century processional lanterns (p. 70).[8] Though one wishes the catalog were illustrated, this list suggests the medieval, Renaissance, baroque and nineteenth-century textiles, metalwork, and lighting fixtures that, at the very least, the firm collected and most likely consulted for its own designs.

This point is further underscored by the illustrated *Glass Mosaic* booklet produced by the firm in 1896. Featuring a large-format photograph of the chapel as its frontispiece, the booklet announces its purpose as illustrating "Tiffany Glass mosaics for walls, ceilings, inlays, and other ornamental work; unrestricted in color, impervious to moisture and absolutely permanent." The second image and first featured commission is the lectern and candlesticks made for the chapel. Immediately following the text on page 18 is a full-format image of the *Fathers of the Church* mosaic also made for the 1893 World's Columbian Exposition (Catalog 6). This volume is particularly interesting because it enumerates historic models so as to suggest

what Tiffany Studios may have consulted, or wanted the public to think it consulted, for its contemporary commissions. This promotional booklet underscores the firm's fine work while demonstrating the breadth of work possible. The text confirmed for the reader that Tiffany rooted his religious work in the past, that he was knowledgeable about and sensitive to the history of church art, architecture, and decoration intimating that he could therefore be trusted to interpret visually a congregation's present decorative liturgical needs.

The "pitch" opens with a romanticized history of the development of mosaics tracing mosaic use back to "the minute inlays which enriched the sacred emblems, mummy cases, jewelry and ivories of the Egyptians, the Assyrians, and other ancient peoples" which, according to the firm, were "the initiatory steps in development of architectural decorative mosaic."[9] The volume intersperses discussion of the major Christian-themed mosaics from the fifth through the fourteenth centuries and the history of mosaic production with images of

Tiffany Studios' current production, roughly evenly divided between religious and secular works. The effect is to present the firm as continuing in the grand tradition of European mosaicists while positioning its decorative work in the very same grand tradition, and thereby validating it in the eyes of history.

According to the narrative and visuals, Tiffany Studios counts its works among mosaic programs created in the fifth century for the mausoleum of Galla Placidia in Ravenna; the sixth-century triumphal arch of the church of Santi Cosma e Damiano in Rome; the sixth-century church of Hagia Sophia in Constantinople and all of the work in Ravenna created during that period including San Vitale and Sant'Apollinare in Classe; St. Mark's Basilica in Venice produced in the eleventh century; mosaics made during the twelfth century in Palermo and Monreale—in short, in the continuum of the major art-historical models dating from the early Christian period through the Middle Ages.[10]

The text argues that Tiffany himself was an innovator when it came to using mosaic in the decorative programs of America's buildings, noting that

> In America, artists like Louis C. Tiffany and others, knowing its value, have been trying for years to introduce it in their work, Mr. Tiffany employing it as long ago as 1879, in the decoration of the Union League Club in New York, and from that time to this using it wherever he could, endeavoring to make manifest all its color-decorative possibilities.[11]

The volume concludes with a list of references, commissions that can be viewed by the reader in person to confirm the fidelity of the firm's work and place in the history of Western art and architecture. Among the sites noted and illustrated is St. Agnes's Church, Ninety-second Street, New York (sadly, torn down in 1943), featuring a "white marble altar, reredos, pulpit, chancel rail, sedilia, and baptismal font enriched with inlays of glass mosaics." This commission is significant because it becomes a signature image for the firm, often reproduced in subsequent marketing materials,[12] and for the historic models its form suggests, which are not mentioned in *Glass Mosaics*, but certainly known and consulted by Tiffany.

Among the models Tiffany had in his personal archives was a group of souvenir photographs he either collected on his travels or had collected for him. Images of historic vestments and of medieval Italian churches featuring liturgical furniture and appointments in the Cosmatesque style. As Jennifer Perry Thalheimer illustrates in this volume, Louis C. Tiffany took an active role in cultivating the aesthetic that came to be identified with Tiffany Studios. Trained as an artist, Tiffany was an active leader of his design studio who favored an aesthetic informed by his European travels and eclectic collecting habits.[13] As a young adult, Tiffany made two "grand tours" which included stays in London, Paris, Rome, Naples, Florence, and Sorrento among other cities.[14] These centers are particularly important to this discussion because the images of medieval churches that he collected from them or cities near to them provided

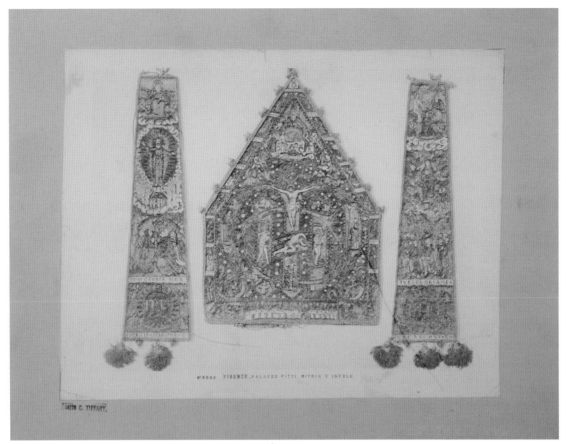

Fig. 17
Tiffany Studios study image
(unknown photographer)
Miter and lappets
Photographic print mounted on
mat board
Written at bottom of image in the
plate: "No. 9902 FIRENZE_Palazzo
Pitti Mitria e Infule"
7 ¾ × 10 inches, mat size 11 × 14 inches
The Charles Hosmer Morse Museum,
Winter Park, Florida (65-030:
0006)

direct models for much of the marble mosaic work
the firm produced. These photographs, taken together
with the list of materials displayed in the 1895 religious
art exhibition held in the firm's showrooms, further
suggest just how much Tiffany was influenced by the
canon of religious art and architecture.

Tiffany's knowledge of the history of art and
architecture may be interpreted as part of an overall
marketing strategy as well. Tiffany Studios' promotional
materials and the public persona of its director were
actively cultivated to emphasize the traditional
continuum in which both Tiffany and his firm saw
themselves as operating. The image of Tiffany as a well-
traveled and well-educated artist/designer is exemplified
by statements made by Samuel Bing published in 1898.
Discussing Tiffany's artistic formation, Bing stated that

> [w]hat impressed the young artist and
> filled his heart with a transport of emotion
> never felt before, was the sight of Byzantine
> basilicas, with their dazzling mosaics,
> wherein were synthesized all the essential
> laws and all the imaginable possibilities of
> the great art of decoration.

Bing further described how Tiffany's aesthetic was
deeply wedded to the artist/studio head's firsthand
knowledge of the history of art:

> Exploring the depths of a far-distant and glorious
> past with the aid of these venerable monuments,
> Tiffany dreamed a dream of Art of the Future: in
> the fossilized remains of our ancient patrimony
> were revealed to him the primordial principles
> that live for all time.[15]

Bing's florid comments underscore the fact that Tiffany's
aesthetic was drawn from vast visual sources, be they
monuments and objects he saw in person during his
travels or photographs of such places and things, which
he took care to amass.

An example of the variety of resources that
Tiffany had at his fingertips may be found in the
list of objects his firm lent to the 1895 exhibition of
religious art. Reading the entry in *Lexicon and Catalog*
for the fourteenth-century white velvet and gold-
work chasuble and white silk and gold-work miter
owned by Tiffany Studios brings to mind the photo
in his archives of a miter and lappets (the fillets that

Cat. 9
Louis Comfort Tiffany (1848–1933)
Design for cope for the Reverend
Edward McCurdy [McCarty]
St. Augustine's Church, Brooklyn,
New York, ca. 1890–1915

hang from the miter) from the Palazzo Pitti (Figure
17). This example makes clear how fine embroidery
and appliqué on a liturgical vestment can elegantly
convey the narrative moments from Jesus' death and
resurrection. Designers in the Tiffany Studios may
have looked to this image or others like it for inspiration
for a cope designed circa 1890–1915, but never fabricated,
for the Reverend Edward W. McCarty, St. Augustine's
Church, Brooklyn (Catalog 9). The watercolor describes
what would have been a luxurious ecclesiastical
garment. Interlocking designs of yellow bands and
jeweled crowns on a foliate ground are accented by a
richly stylized border. The letters "IHS," an acronym
for *Jesus Hominum Salvator* (Latin for Jesus Savior
of Mankind), which remind us of the Greek name of
Jesus, are inscribed in a crown of thorns set within a
shield-like form that would have rested on the wearer's
shoulders. The cope's design suggests the intricacy and
fine craftsmanship of the Florentine model observable
in the photograph reference.

Cut stone and glass tesserae laid in complex
geometric patterns, known as Cosmati work after the
family of medieval artisans known for its production,
deeply influenced Tiffany's work. In the case of the
liturgical furniture and interiors produced by Tiffany
Studios, photographs from Louis C. Tiffany's personal
archives show that he was looking to medieval and
Renaissance Italian church interiors, in particular to
the Cosmatesque decorative mosaics in the churches of
San Lorenzo (Figure 18) and of Santa Maria in Aracoeli
in Rome (Figure 19); the church of Santa Maria in
Castello in Tarquinia (Figure 23) and Terracina

Vestment for Rev. L. M.

Fig. 18
Tiffany Studios study image (unknown photographer)
Mosaic and marble, San Lorenzo, Rome, ca. 1895
Photographic print mounted on mat board
Written at bottom of image in the plate: "4322 Roma Sedia Bisantina S. Lorenzo"
7 ⅞ × 10 ⅛ inches, mat size 11 × 14 inches
The Charles Hosmer Morse Museum of American Art, Winter Park, Florida (65-030:0639)

Fig. 19
Tiffany Studios study image (unknown photographer)
Guilloche design on ambo in mosaic, ca. 1895
Photographic print mounted on mat board
Written at bottom of image in the plate: "5733 Chiesa di S. Maria in Aracoeli—Dettaglio dell'Ambone"
10 ⅛ × 7 ¾ inches, mat size 14 × 11 inches
The Charles Hosmer Morse Museum of American Art, Winter Park, Florida (65-030:0656)

Fig 20
Tiffany Studios study image (unknown photographer)
Thirteenth-century floor mosaics in guilloche
patterning, Terracina Cathedral, ca. 1895
Written on the image in the plate: "5999. Terracina
Cattedrale Dettaglio del pavimento"
10 ⅛ × 7 ¾ inches, mat size 14 × 11 inches
The Charles Hosmer Morse Museum of American Art,
Winter Park, Florida (65-030-0642)

Cathedral (Figure 20).[16] The baptismal fonts, glass and stone mosaic-decorated altars, pulpits, and sanctuary walls made for churches like All Hallows' Church, Wynecote, Pennsylvania; St. Michael's in New York City; Christ Church Cobble Hill, Brooklyn (see page 50); and Christ Church, Pomfret, Connecticut (Catalog 10), all take decorative cues from these medieval Italian churches' Cosmatesque mosaic decoration.

During the twelfth and thirteenth centuries, Cosmati work was commissioned by kings and popes, and its esteemed style was reserved for use by royals and significant ecclesiastics. Three examples were installed in London's Westminster Abbey during the second half of the thirteenth century: the pavement in front of the high altar laid ca. 1260 (Figure 21); the shrine of St. Edward the Confessor consecrated in 1269; and the tomb of King Henry III finished sometime after 1290.[17] Though images of these have not yet surfaced in Tiffany's personal archives, it is likely that he saw these monumental works on one of his stays in London. The Westminster pavement in particular features the very forms—guilloche border, roundels, rectangles, and squares of inlaid marble—repeatedly used by Tiffany Studios on all manner of liturgical furniture and even in the Tiffany Studios' showroom sign at 347–55 Madison Avenue.[18] Discussing Cosmati work in Italy that has similar features to the Westminster pavement, Steven Wander identifies what he calls the pavement's "identical twin" in Santa Francesca Romana in Rome and also notes shared features with the ambo (or pulpit) in Santa Maria in Castello in Tarquinia and the tomb of the Savelli family in Santa Maria in Aracoeli,

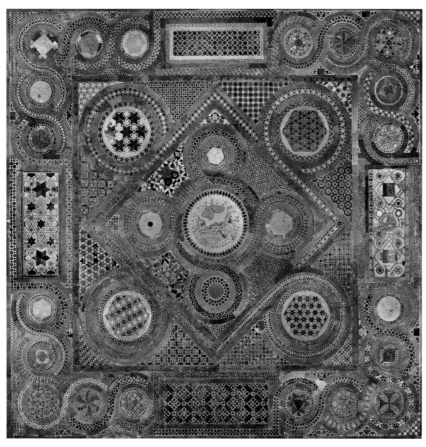

Fig. 21
Cosmati pavement, Westminster
Abbey, 2nd half of 13th century
Dean and Chapter of Westminster,
London

Cat. 10
Tiffany Studios, New York
Baptismal font, Memorial to George
Bradley and Emma Pendleton
Bradley, 1908

Rome.[19] Tiffany's archives contained images from both of these churches, including the ambo in particular, underscoring the importance of these monuments as models for Tiffany Studios' marble and glass mosaic work in liturgical furniture and objects.

It is worth noting that the firm was looking to medieval Cosmatesque models for their brilliant decorative patterns alone. The significance of the works' meanings was either not understood or not accorded much value by the firm. As Wander records, twelfth-century Cosmatesque work used porphyry and various marbles and glass, and, in the case of the Westminster pavement, Purbeck marble in a nod to vernacular materials.[20] Dorothy Glass explains the symbolism of the material choices, noting that "porphyry had had specific royal connotations" since the time of Emperor Constantine I (d. 337).[21] Discussing the revival of the form of porphyry *rotae* or roundels and their placement to mark a processional route in a church, Glass writes that "the succession of porphyry roundels served the same function as the narrow, red carpet used in churches today for many ceremonial occasions."[22] She demonstrates that, far from merely decorative embellishments, the disposition and design of Cosmatesque pavements in churches and the use of the material porphyry indicated status and reflected a specific liturgical need. In contrast, Tiffany Studios emulated the Cosmatesque style almost exclusively in colored glass set in marble, and manipulated the geometrized patterns for decorative effect alone. Although the furniture adorned with Cosmatesque work served a liturgical function—the chairs at Christ

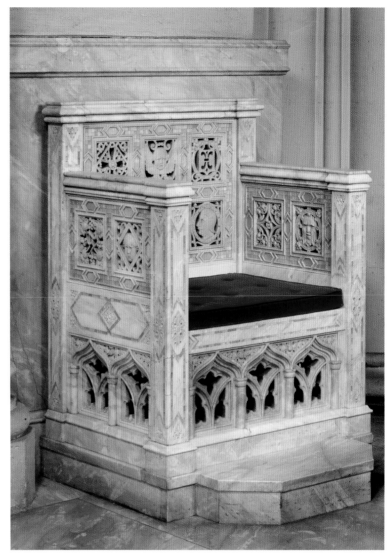

Fig. 22
Tiffany Studios, New York
Bishop's chair, ca. 1916
Marble and favrile glass mosaic
Christ Church Cobble Hill, Brooklyn, New York

Church Cobble Hill, Brooklyn, for example, were reserved for the celebrant (Figure 22), and the pulpit at St. Agnes's Church for the reading of the Gospel—the applied mosaic inlay betrayed no specific change to reflect those functions.

Tiffany Studios' Cosmati-inspired watercolor design for a free-standing marble pulpit is particularly striking (Catalog 11). It takes its cues from the ambos or pulpits in the churches of Santa Maria in Castello in Tarquinia dating to 1143 (Figure 23) and in the church of San Lorenzo fuori le Mura in Rome dating to the thirteenth century (Figure 24). As previously mentioned, Tiffany had images from both churches in his visual archives and, in the case of Santa Maria in Castello, a photograph of the ambo itself. Both Italian medieval

Cat. 11
Louis Comfort Tiffany (1848–1933)
Design for marble pulpit, ca.
1895–1900

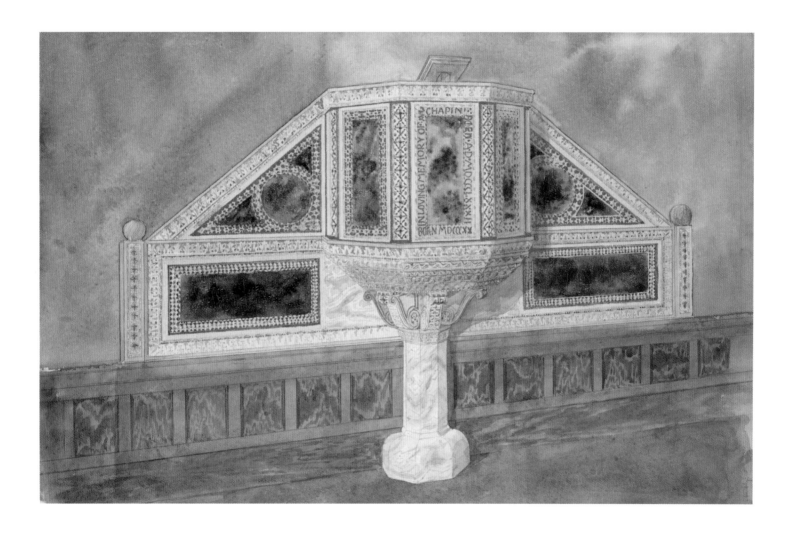

Fig. 23
Tiffany Studios study image (unknown photographer)
Mosaic ambo, Santa Maria in Castello, Tarquinia, ca. 1895
Photographic print mounted on mat board
Written at bottom of image in the plate "5844 Corneto
Tarquinia—Chiesa di S. M. in Castello, Ambone"
7 ⅞ × 10 ¼ inches, mat size 11 × 14 inches
The Charles Hosmer Morse Museum of American Art,
Winter Park, Florida (65-030-0652)

Fig. 24
Ambo, ca. 13th century
Marble inlaid with porphyry and green
marble, decorated with Cosmati mosaic
Basilica of San Lorenzo fuori le Mura
(Saint Lawrence outside the Walls), Rome

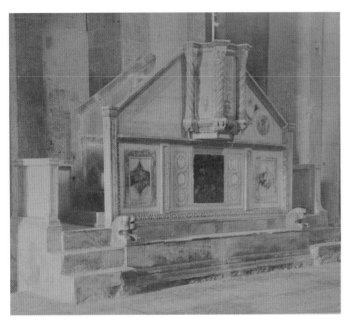

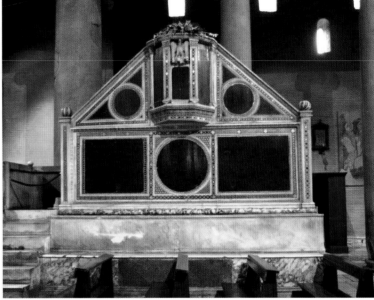

ambos consist of a raised, three-sided marble pulpit decorated with inlaid stone rectangular panels and roundels framed within fine geometric borders. Tiffany Studios' design looks to these ambos for the general form and surface decoration of its late-nineteenth-century design; however, the firm adjusted the design presumably in response to the American congregation's liturgical needs and in relation to the scale of the building. The watercolor indicates that the pulpit overhangs a wood-paneled chancel divider. The few steps up to the pulpit would have been behind this chancel rail. The pulpit itself is supported not by coursed masonry, but by a freestanding small pier with a capital composed of volutes. The potential memorial function or naming opportunity is suggested by the inscription framing the pulpit's central rectangular panel, which beginning at lower left and moving up reads: "In loving memory of A.W. Chapin. Died AD MDCCLXXII Born MDCCXX."

Tiffany Studios also expanded the use of the style into other objects not specifically known for Cosmatesque embellishment in the Middle Ages.

Though direct precedents exist for ambos, candlesticks, bishops' chairs, and pavements, there seem to be few direct precedents for the many Cosmati-inspired freestanding baptismal fonts produced by Tiffany Studios. As a selection of watercolor designs for fonts from the Metropolitan Museum of Art's collection suggests, Tiffany Studios conceived a number of baptismal fonts in marble with inlaid glass mosaic decorative embellishments, clearly taking cues from Cosmati work (Catalogs 12, 13, 14, 16). None of these four examples is marked to indicate a specific commission, suggesting that they were designs made speculatively to show potential customers what the firm could produce. Three of the four designs show variations of octagonal fonts inlaid with Tiffany favrile glass mosaic, indicated by the delicate watercolor washes. In the case of Catalog 14, the mosaic design incorporates ecclesiastic symbols: one rectangular panel features the Chi-Ro, Christ's monogram in Greek, and the second panel the Greek letter Alpha, meaning the beginning. The rectangular panels are interspersed with a mosaic

APPROVED BV

Cat. 12
Louis Comfort Tiffany (1848–1933)
Design for baptismal font, late 19th–
early 20th century

Cat. 13
Louis Comfort Tiffany (1848–1933)
Design for baptismal font, ca. 1902–20

TIFFANY·STVDIOS
ECCLESIASTICAL·DEPT
NEW·YORK

Cat. 14
Louis Comfort Tiffany (1848–1933)
Design for baptismal font, late 19th–
early 20th century

Cat. 15
Louis Comfort Tiffany (1848–1933)
Design for baptismal font, late 19th–
early 20th century

cross inset in a square. It is reasonable to assume that the rectangular panel opposite the Alpha is the Greek letter Omega, meaning the end, and that, in keeping with the pattern, the panel opposite the Chi-Ro features another Chi-Ro. For Christians the Alpha and Omega represent Jesus as the beginning and the end of all things, appropriate symbolism for a font used in the sacrament of Baptism, which initiates a member into the communion of the faithful.

Though unmarked, a watercolor from the Metropolitan Museum of Art's collection shows a baptismal font that was executed (Catalog 16). A photograph of it is featured in the Tiffany Studios' *Memorials in Glass and Stone* published in 1913 and reissued in 1922.[23] The caption in the printed booklet notes that the font was made of "Sienna [*sic*] marble and Tiffany Favrile Glass Mosaics" for the Madison Avenue Reformed Church in Albany, New York (Figure 25). The baptismal font's inclusion in this promotional booklet suggests that Tiffany Studios considered it an especially fine example.

A particularly striking example of a Tiffany Studios' monumental font is an elaborately carved spherical one (Catalog 15). The graphite drawing indicates the domed cover to have a stylized geometric pattern of three fish inscribed in a circle (the number most likely an allusion to the Christian concept of the triune God), leaves, and circles arranged as quatrefoils. The cover's handle takes the form of a cross inscribed in a circle. The five slender columns supporting the basin, with geometric designs that may suggest mosaic inlay, act as foils for

the font, emphasizing its formal monumentality and liturgical significance as the object around which new members are initiated. A sculpted band articulates the font's lip; its stylized, yet seemingly nonsensical, Gothic lettering suggests the potential for a memorial inscription as does a band articulated on the circular base. As Elizabeth De Rosa discusses later in this volume, baptismal fonts like the one at Christ Church, Pomfret, Connecticut, were often commissioned as memorial objects.

This selection of baptismal font watercolor designs also illustrates Tiffany Studios' facility in multiple media. An example of the firm's finesse is found in a watercolor of a baptismal font with cover designed for the Presbyterian Church in Kingston, Pennsylvania (Catalog 17). The design drawing indicates an octagonal font carved in a Gothic revival style featuring rosettes inscribed in quatrefoils on the basin and slender lancet designs on the pedestal. Though intended to be fabricated in wood to match existing woodwork, according to the notation on the watercolor,[24] the design would be equally elegant in marble or stone, materials the firm also expertly handled (Catalogs 18, 19). The oak and mosaic inlay pulpit made for South Presbyterian Church in Syracuse, New York, dating to 1907, is a finely executed example of Tiffany Studios' ability to translate forms into a variety of media (Catalog 20).

Tiffany Studios' innovative liturgical designs also extended to its work in metal. The impact of the candlesticks and cross made as showpieces for the Tiffany Chapel is demonstrated in two suites of

FONT· COVER· WITH· CROSS· HANDLE·

· CROSS· HANDLE· BRONZE· BOLT·

· LOOSE· COVER·

X

FONT

· OCTAGON·

SCALE 1½"= 1'·0"

· BAPTISMAL· FONT· WITH· COVER·

FOR· PRESBYTERIAN· CHURCH· KINGSTON· PENN·

NOTE· TO· BE· OF· WOOD· TO· MATCH· PRESENT· WOODWORK·

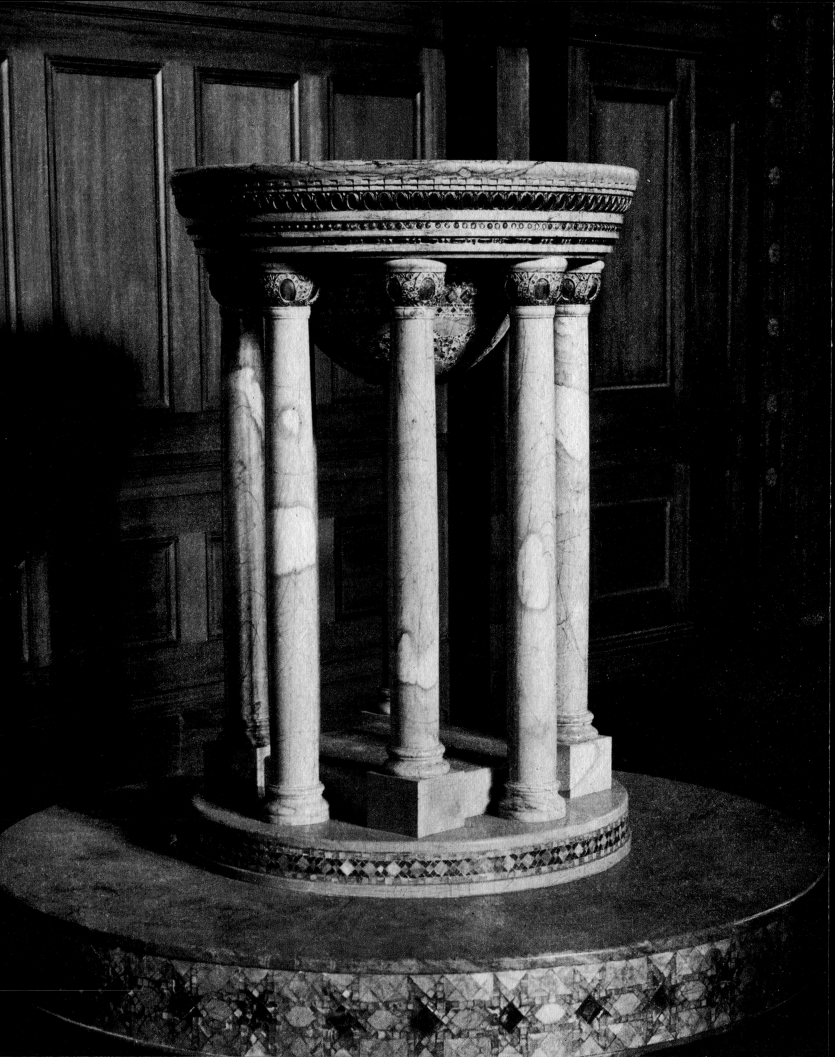

Fig. 25
Tiffany Studios
Baptismal font executed for the
Madison Avenue Reformed Church,
Albany, New York
Siena marble and Tiffany favrile
glass mosaics
Published in Tiffany Studios,
Memorials in Glass and Stone (New
York, 1913)

Cat. 16
Louis Comfort Tiffany (1848–1933)
Design for marble baptismal font,
ca. 1902–20

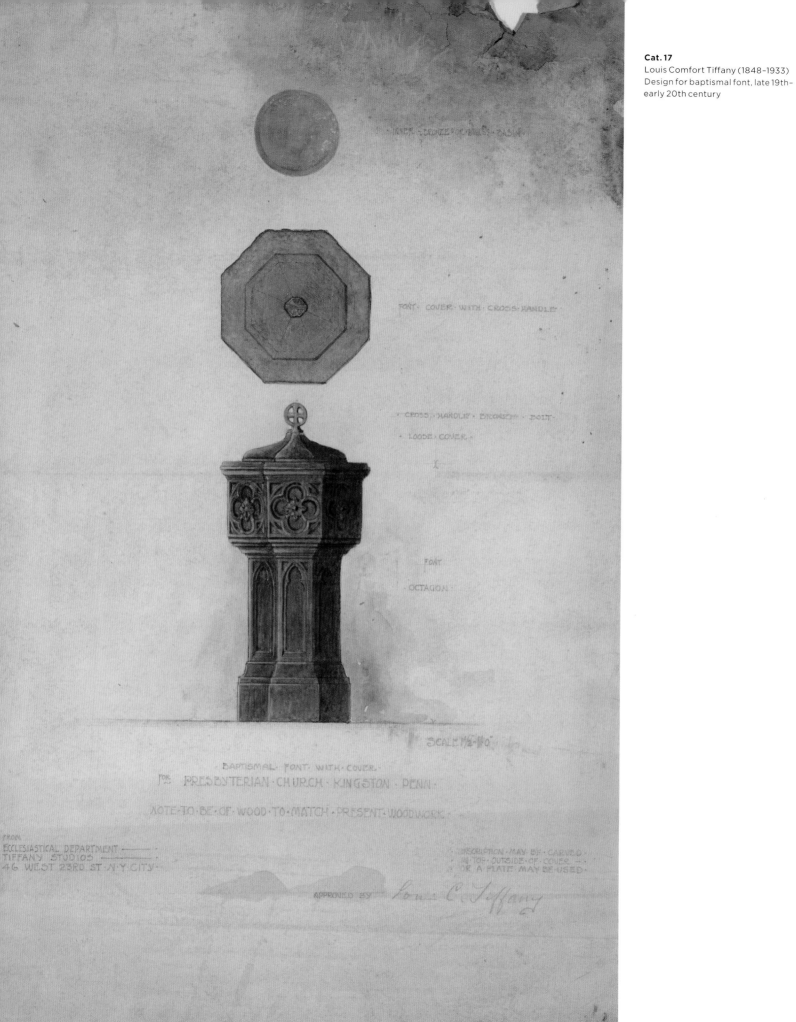

Cat. 17
Louis Comfort Tiffany (1848–1933)
Design for baptismal font, late 19th–
early 20th century

INNER · BRONZE · OR · BRASS · BASIN

FONT · COVER · WITH · CROSS · HANDLE ·

· CROSS · HANDLE · BRONZE · BOLT ·
· LOOSE · COVER ·

FONT

OCTAGON ·

SCALE 1½"=1'0"

· BAPTISMAL · FONT · WITH · COVER ·
FOR · PRESBYTERIAN · CHURCH · KINGSTON · PENN ·

NOTE · TO · BE · OF · WOOD · TO · MATCH · PRESENT · WOODWORK ·

FROM
ECCLESIASTICAL DEPARTMENT
TIFFANY STUDIOS
46 WEST 23RD ST · N·Y·CITY ·

· INSCRIPTION · MAY · BE · CARVED ·
· IN · TOP · OUTSIDE · OF · COVER ·
· OR · A · PLATE · MAY · BE · USED ·

APPROVED BY Louis C. Tiffany

Cat. 18
Louis Comfort Tiffany (1848–1933)
Design for baptismal font, late
19th–early 20th century

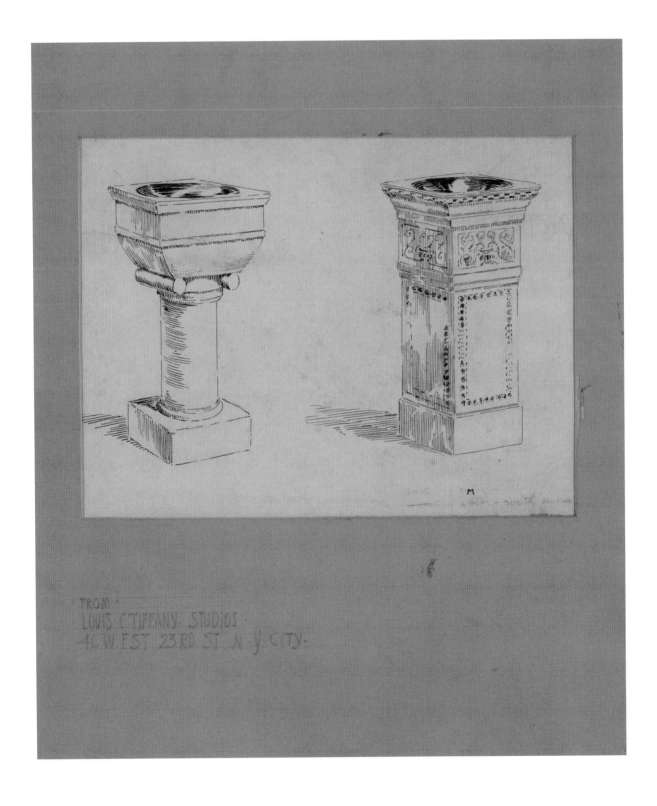

Cat. 19
Tiffany Studios, New York
Suggestion for a marble altar for
Archbishop Thomas Lynch, Church
of the Resurrection,
Greensburg (?), Pennsylvania, n.d.

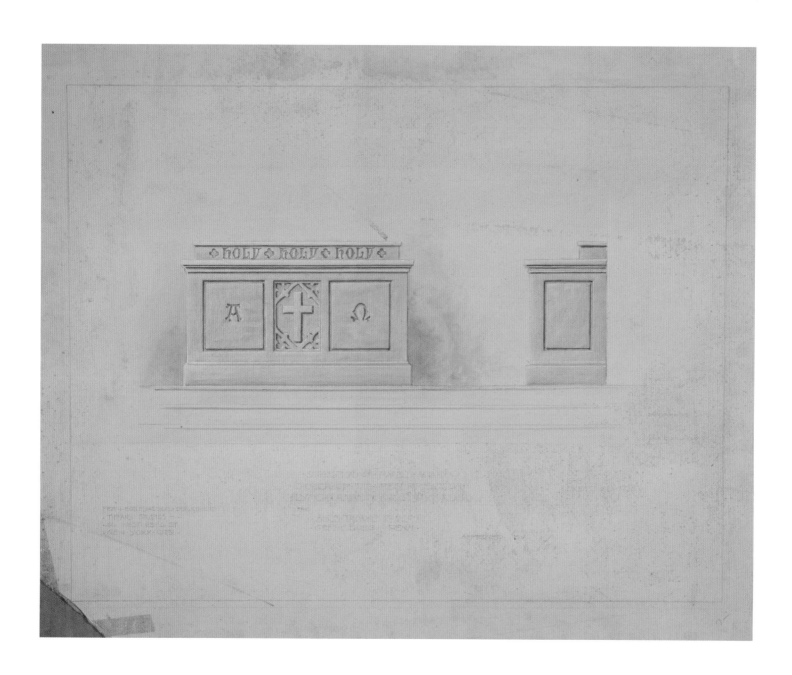

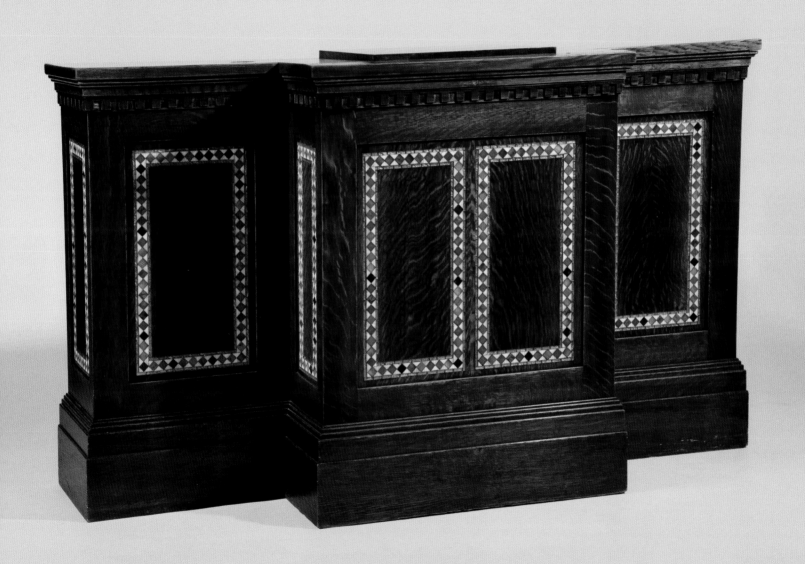

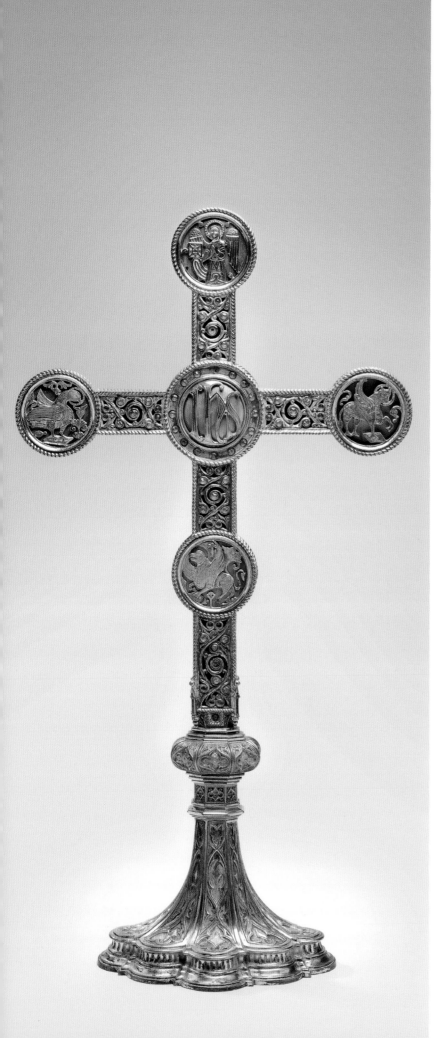

Cat. 21
Tiffany Studios, New York
Altar cross, ca. 1916

Fig. 26
Chalice, 14th century
Silver, gilded copper, "basse-taille" enamel
8 ¹³⁄₁₆ × 5 ⁵⁄₁₆ × 5 ⁵⁄₁₆ inches
The Walters Art Museum,
Baltimore, Maryland (44.223)

liturgical metalwork still in use by their respective congregations. An altar cross and pair of candelabra from Emmanuel Parish of the Episcopal Church in Cumberland, Maryland (Catalogs 23, 24, 25, 26), and an ensemble of objects including an altar cross, candlesticks, book stands, and vases from Christ Church Cobble Hill, Brooklyn (see page 50 and Catalogs 21, 22), suggest the range of stylistic influences and historic objects that informed the firm's unique designs.

The bronze altar cross set with turquoise and the pair of seven-branched candelabra were made for Emmanuel Parish in 1906. The church's east end is an integrated Tiffany interior designed beginning in 1905. Tiffany Studios conceived of the liturgical objects in concert with the marble altar, elegantly carved reredos, and several windows. Emmanuel Parish retains the original drawings for what was to have been a suite of

Fig. 27
Bust of Maximian, detail from
Justinian's Court, 547 CE
Mosaic
Church of San Vitale, Ravenna, Italy

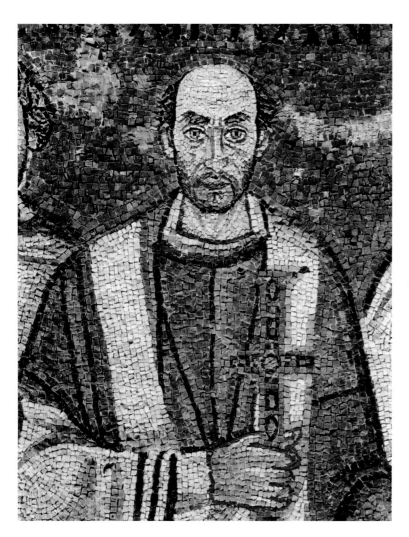

objects, including candlesticks (ultimately executed by the Gorham Manufacturing Company in faithful adherence to the Tiffany Studios' design) candelabrum, a processional cross, and a chalice-like vase (Catalogs 23a, 23b, 24, 25, 26).[25] As many scholars have noted, the firm took its design cues from Byzantine and medieval Italian metalwork. A model Tiffany may have known is the *Victory Cross* made in 908 by the Gauzón Castle Workshop, now in the treasury of the Cámara Santa in Oviedo Cathedral, Spain. Bullen cites an image of the votive crown from the treasury of Guartazar, in Toledo, Spain, made of gold, precious stones, pearl, and crystal dating to 653–72 as a specific model for an electrolier that once hung in the Kinney Chapel, Kinnelon, New Jersey.[26] The metalwork, gem encrustation, and particularly the jeweled cross hanging from the votive crown's center, are likely inspirations for the firm's filigree and gem-encrusted candlesticks made throughout this period (Catalog 3). The finely wrought chain is a recurring motif in Tiffany Studios' lighting fixtures (Catalogs 27, 28).

Emmanuel Parish's altar cross also suggests a second model. The smooth, warm gold color punctuated by the blue turquoise embellishments set at the cross's ends and center call to mind the sixth-century mosaics Tiffany admired in Ravenna, in particular the cross carried by the figure of Bishop Maximian, on the church of San Vitale's apse wall (Figure 27). Ravenna's holy sites were filled with elaborate crosses executed in mosaic. Tiffany certainly would have been familiar with San Vitale and Sant'Apollinare in Classe, both of which prominently feature gem-encrusted gold crosses executed in mosaic.

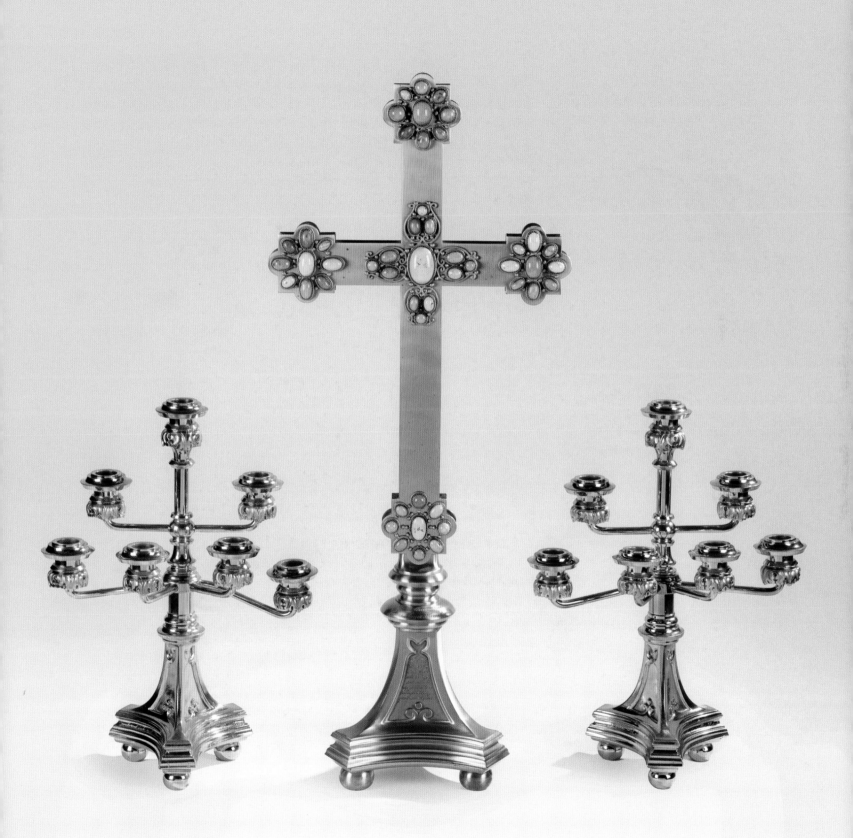

Cat. 24
Tiffany Studios, New York
Sketch for altar cross, ca. 1905

Cat. 25
Tiffany Studios, New York
Sketch for vase (not executed), ca. 1905

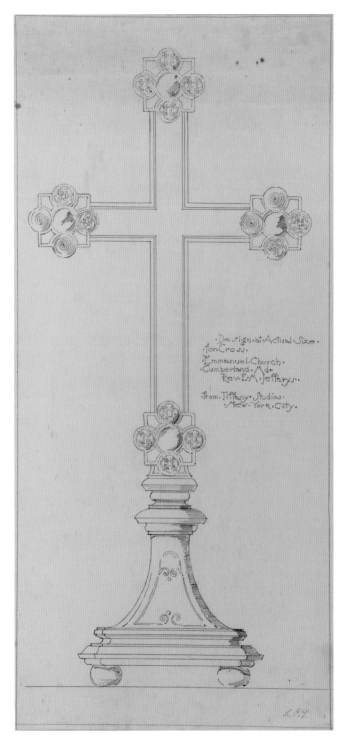

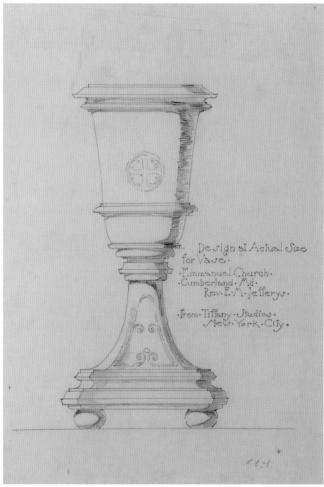

·Design·at·Actual·Size·
for·Vesper·Lights·
·Emmanuel·Church·
·Cumberland·Md·

·from·Tiffany·Studios·
·New·York·City·

Cat. 27
Tiffany Glass and Decorating
Company, New York
Electrolier, ca. 1900

Cat. 28
Tiffany Glass and Decorating
Company, New York
Electrolier, ca. 1897

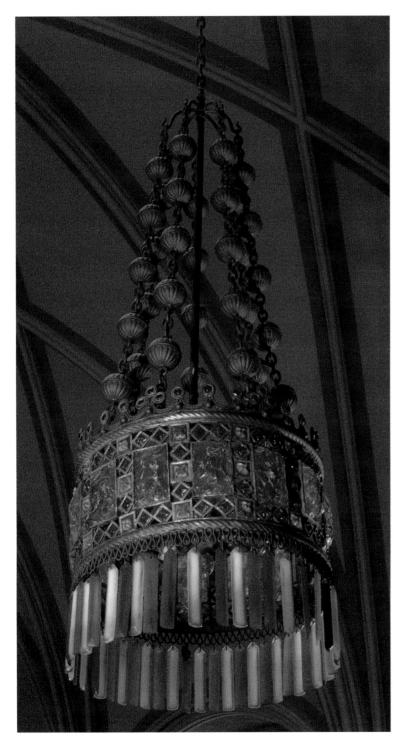

Emmanuel Parish's altar cross suggests that the firm was equally adept at looking at original models and translating them into different media as well.

The gilt silver objects with glass and enamel inlay made for Christ Church Cobble Hill, Brooklyn, in 1916 were also a custom design. The style of objects suggests that Tiffany Studios looked to medieval crosses chased in silver and gold and to chalices produced in Italy in centers such as Siena and Bologna (Figure 26). The flared ends of the altar cross are now fully rounded to include the symbols of the Evangelists on the ends (Catalog 21). At the cross's center are the letters "IHS." Each Evangelist's symbol is set against a deep blue favrile glass background, and the central monogram shimmers against a golden-yellow glass ground. The cross is studded with glass jewels in an identical golden-yellow hue. The form suggests that Tiffany had in mind both Byzantine mosaic crosses as well as examples like the *Victory Cross* and the *Cross of Desiderius*, produced from the eighth to ninth centuries with gems cut from the second through the ninth centuries, now in the Museo della Città, Brescia, Italy.

As this essay suggests, Tiffany Studios actively looked to art-historical precedents to inform its liturgical production. Though evocative of the long visual tradition of Western art, Tiffany Studios' style was not purely derivative. Rather, the firm incorporated various period styles and combined them to serve contemporary taste in a specifically American liturgical context. Tiffany Studios shrewdly located itself within this grand tradition, thus simultaneously influencing and creating an American liturgical aesthetic. The firm clearly understood the power of historical models, particularly during the Gilded Age which saw America's most wealthy citizens actively collect European treasures from all periods and build homes and houses of worship emulating historic European styles. Through its expert marketing, fine craftsmanship, innovative designs, and continuous notable commissions, Tiffany Studios became part and parcel of the American religious aesthetic.

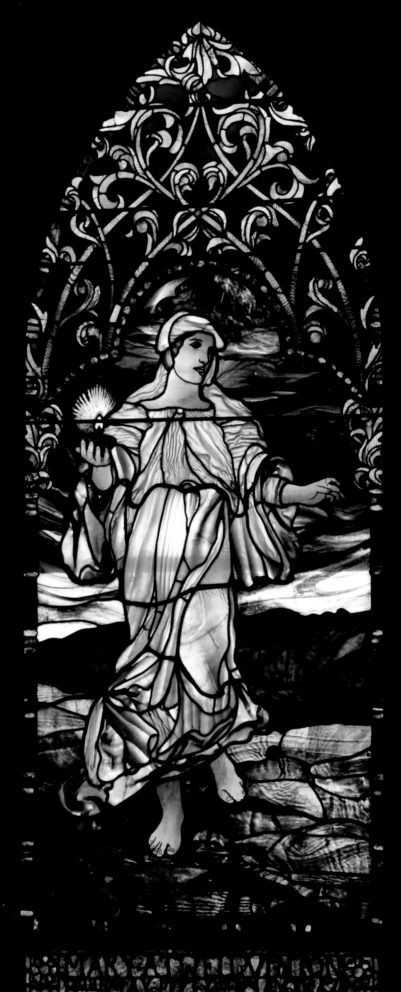

"Unimaginable Splendours of Colour": Tiffany's Opalescent Glass

LINDSY R. PARROTT

During the last quarter of the nineteenth century, the art of stained glass took a dramatic turn. Frustrated with the prevailing trend of creating windows through painting and staining the surface of the glass, which hampered the passage of sunlight, and disappointed by the limited color palette and thin, characterless glass available to the stained-glass trade, Louis C. Tiffany, working concurrently with his contemporary John La Farge (1835–1910),[1] struck out to revive what they believed to be the principles of medieval stained glass. Tiffany prized the windows of the twelfth and thirteenth centuries for their richly colored glass and what he viewed as a judicious use of painted decoration. Inspired by this artistry, Tiffany applied these same tenets and traditional fabrication techniques to new types and colors of glass in varying opacities to create "translucent pictures."[2] Within a short period of time, this imaginative combination of traditional methods and innovative materials wholly redefined the art of stained glass.

As the Gilded Age ushered in a new desire for lavish decoration and rich color, churches and synagogues commissioned decorators, Tiffany among them, to adorn their houses of worship. Tiffany not only supplied the artwork to meet this demand, but he also served as tastemaker. While colored glass had been a decorative mainstay in houses of worship for centuries, never before had it approached the range of color, opacity, and texture seen in opalescent sheet glass and "jewels." Tiffany's creative application of opalescent glass to windows, mosaics, lighting fixtures, and other decorative elements radically transformed the interiors of religious institutions in America between the late nineteenth and early twentieth centuries. These interiors were a visual feast, shimmering with "unimaginable splendours of colour."[3]

THE BIRTH OF THE "AMERICAN SCHOOL" OF STAINED GLASS

By the 1870s it was clear that a native stained-glass tradition was sorely lacking in the United States. It was noteworthy, therefore, when two of America's leading painter-decorators took up the medium and "showing true Yankee grit... struck out on a bold, independent line."[4] According to Tiffany, "Those of us in America who began to experiment in glass were untrammeled by tradition, and were moved solely by a desire to produce a thing of beauty irrespective of any rule, doctrine, or theory beyond that governing good taste and true artistic judgment."[5] This new approach to decorative windows threw caution to the wind. Virtually every type of glass available was considered for use, and the medium itself was pushed to the limits. Windows were designed with small, intricately cut pieces of glass, some of which were superimposed in layers to create richly colored and textured pictures. This exuberant use of materials led to such a radical aesthetic departure that it was christened the "American school of stained glass."

From the outset, these advances in stained glass garnered a great deal of attention from critics and the press. Newspapers, popular magazines, and specialist journals began reporting on the innovations and advances almost immediately. So novel were the

Fig. 29
Louis C. Tiffany & Co., New York
St. Mark window from St. Mark's
Episcopal Church, Islip, New York,
1878 (destroyed)
Leaded glass
Published in Charles De Kay, *The Art Work of Louis C. Tiffany* (Garden City, NY, 1914)
The Neustadt Collection of Tiffany Glass, Long Island City, New York, Gift of Dorothy Mareb

materials and concepts that many of the articles devoted space to defining and explaining them. As one author noted in the *Journal of the Franklin Institute* in 1887:

> The subject of colored glass windows is a very large one…. In its nomenclature, we have permitted ourselves to fall into rather careless habits. The terms "painted," "stained," and "mosaic" glass are used indiscriminately to designate any glass work involving color, but a moment's consideration will show them far from synonymous.[6]

The confusion with this terminology persists to this day and, therefore, some definitions are also useful here.[7]

"Stained glass" is a generic term that is often applied to any window composed of pieces of glass assembled with lead, regardless of design and surface treatments. This description, however, is misleading. A window is technically only "stained" if silver nitrate is applied to the glass surface and fired, resulting in a permanent, transparent color ranging from pale yellow to deep orange. "Mosaic" glass is a period term referring specifically to leaded-glass pictorial windows, but it is seldom used today. "Leaded glass" is perhaps the most useful term to describe the wide range of objects made with glass and lead—and it is the term that will be used in this essay to describe Tiffany's windows. "Painted" glass is also something very specific. Like stain, paint is a surface application. In "painted" glass, opaque vitreous paint or intensely colored enamels are applied to the surface of the glass and fused with heat.

For centuries these traditional techniques were the primary methods of applying color and details to glass. All surface applications, however—whether applied in broad strokes, faint washes, or uniform mattes—serve to obstruct light and mask the inherent character of the glass. For these reasons, Tiffany rejected this tradition. In an article in *Harper's Bazaar* Tiffany described how in the early days people asked him:

> "Why not be satisfied with painting on glass?" Too formal, too cold, I declared. Glass covered with brush work produces an effect both dull and artificial…. I could not make an inspiring window with paint. I had to use a medium that appealed to me.[8]

Opalescent glass proved to be the medium through which Tiffany realized his ambitions in leaded glass. This type of glass was not an entirely new discovery, but

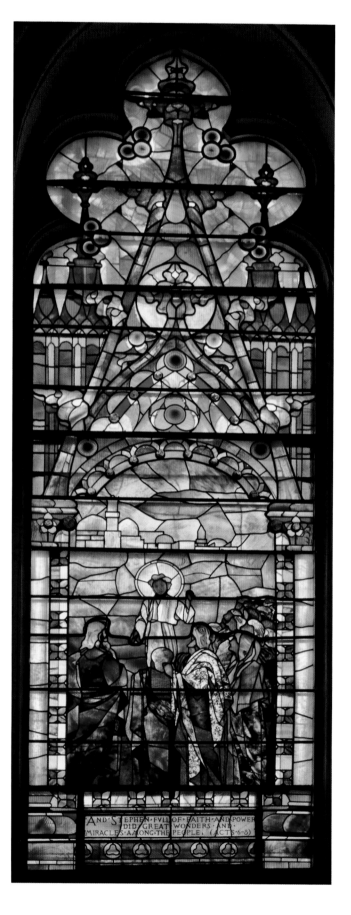

Fig. 30
Louis C. Tiffany & Co., Associated
Artists, New York
Francis D. Millet, designer
St. Stephen Preaching, ca. 1881
Leaded glass
St. Stephen's Episcopal Church, Lynn,
Massachusetts

its application to decorative windows was novel. Initially made to imitate porcelain, opalescent glass was widely used to make pressed-glass objects, such as tableware. In the 1870s flat sheets of opalescent glass were just becoming available, albeit in very limited quantities, to the stained-glass trade. Characterized by an internal glow and a milky translucency that captures light and amplifies color, Tiffany was quick to envision its creative potential. If opalescent glass could be made in a variety of colors, patterns, textures, and translucencies, it could be used to render detail and shading in leaded-glass windows and "avoid the 'dullness and opacity' which invariably accompany the use of paint."[9] Tiffany's quest was to find a medium that was intrinsically expressive— one that worked with the light instead of against it. To quote Tiffany's close friend and biographer:

> Starting from the principle that these effects ought to be expressed in the substance of the glass itself, he sought… a material in which colors and combinations of color, hues, shades, tints and tones should be there without surface treatment, so far as possible.[10]

Tiffany began to experiment—eager to see if it would be possible to "paint" pictures *with* glass, rather than *on* glass.

Initially, Tiffany took as his materials nearly any type of colored glass. Crown glass, antique glass, cathedral glass, opalescent glass, and three-dimensional glass "jewels" each had characteristics that Tiffany was able to make use of in his new windows, which were fabricated in the traditional method of joining pieces

Fig. 31
Louis C. Tiffany & Co., Associated
Artists, New York
Francis D. Millet, designer
St. Stephen Preaching, detail, ca. 1881
Leaded glass
St. Stephen's Episcopal Church, Lynn,
Massachusetts

of glass together in a grooved lead matrix.[11] Among Tiffany's earliest experiments is a window depicting St. Mark and his lion among the clouds, which he created in 1878 for St. Mark's Episcopal Church in Islip, Long Island (Figure 29). This window is particularly significant because it was Tiffany's first ecclesiastical design as well as his first figural composition. Like most of Tiffany's first designs in leaded glass, the composition of this window is rather flat. St. Mark and the lion are placed in a shallow picture plane, and the lion is difficult to make out among the billowing clouds. Tiffany seems much more concerned with the use of the different kinds of glass than the formal considerations of the picture's composition. Here, Tiffany "painted" St. Mark using several different types of glass in innovative ways. Opalescent glass of varying thicknesses was used to create a play of light and shadow across St. Mark's robe, giving his figure a sense of solidity. Heavily wrinkled glass gives the illusion of fabric gathered in his lap. And a piece of crown glass has been cut so that the concentric striations of the glass suggest the flow of fabric around the bend of St. Mark's knee. Although tentative, there is spontaneity to this window in design and glass selection that is exciting in its anticipation of the diversity of glass and its elaborate combinations and juxtapositions in Tiffany's future windows.

Within three short years, Tiffany was clearly more confident with designing and constructing windows, but continued to search for ways to expand color effects. One of Tiffany's experiments resulted in a patent for a technique of layering windows to enhance the brilliancy and color of opalescent glass.[12] Filed in October 1880, the patent describes Tiffany's invention of a leaded window of opalescent glass in one design backed with a leaded window of transparent colored glass in a different design, with an intervening airspace separating the two. The numerous windows decorating St. Stephen's Episcopal Church in Lynn, Massachusetts, are the only known examples of this patented technique.[13] The top portion of the *St. Stephen Preaching* window is particularly illustrative (Figures 30, 31). The decorative patterning of the back window creates a kaleidoscopic yet subtle patchwork of muted tones punctuated by accents of vibrant color. This technique, however, was not widely used. It was undoubtedly expensive to create two entirely different panels for a single window, and it is safe to assume that Tiffany quickly realized it would be simpler and perhaps even more effective to have glass made that would produce these same color effects.

In the early years Tiffany also grappled with the best way to render facial features and flesh areas with a minimum of paint. In *St. Stephen Preaching*, only the barest painted outlines depict eyes, nose, and mouth, and to further soften the effect, the painted glass is obscured by the overlay of two pieces of glass. Apparently compelled to take the possibilities to an extreme, in the *Ascension* window, also at St. Stephen's Episcopal Church, Tiffany eliminated paint altogether and used metal overlay to render details in the flesh areas (Figure 32). The overlay was a matrix of interconnected lines on the glass, attached at various points to the surrounding lead. The technique was daring and the results were curious. The metal overlay gives the figure a primitive, cartoonish look, and although Tiffany maintains the

Fig. 33a
Louis C. Tiffany & Co., New York
Elihu Vedder, designer
Mary Atwell Vinton Memorial
Window, detail, ca. 1883
Leaded glass
Christ Church, Pomfret,
Connecticut

Fig. 33b
Louis C. Tiffany & Co., New York
Elihu Vedder, designer
Mary Atwell Vinton Memorial
Window, detail, ca. 1883
Leaded glass
Christ Church, Pomfret,
Connecticut

Fig. 32
Louis C. Tiffany & Co., Associated
Artists, New York
Augustus Saint-Gaudens, designer
The Ascension, detail, ca. 1881
Leaded glass
St. Stephen's Episcopal Church,
Lynn, Massachusetts

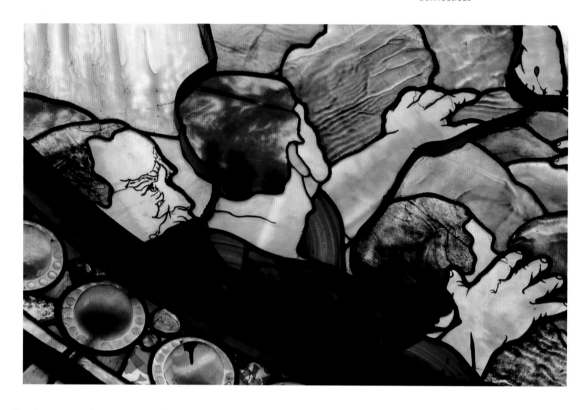

purity of the glass, he does so at the expense of any subtlety of shading or depth of expression in the figures. In an apparent attempt to improve on the overlay technique, Tiffany combined it with inlays of glass to reduce the number of lines necessary to hold the overlays in place. This technique can be seen in the Mary Atwell Vinton Memorial Window at Christ Church in Pomfret, Connecticut. In addition to wire overlays on the hands and feet, the eyes and mouth have been formed with a leaded inlay of glass (Figures 28, 33a, 33b). On the whole, these effects are astonishingly modern and their inventiveness is not without its charm.[14] Their limitations, however, are evident and were likely the reason Tiffany seems to have abandoned them almost immediately.

Tiffany was eventually forced to concede that certain areas in his windows would have to be painted. But his incredible enthusiasm for the idea of painting only with glass initially fought the necessity for compromise. His determination is evident, for example, in the continued use of opalescent glass to depict hair. As seen in a detail of the Brooke Memorial Window from St. Michael's Episcopal Church in Birdsboro, Pennsylvania, the angel's face is capped by a heavy and unmoving block of color, a somewhat awkward effect and incongruous with the refined and delicate painted features (Catalog 29). Aesthetics would eventually win out and Tiffany would make his peace with a limited and judicious use of paint in his windows—to the apparent relief of at least one of his designers, who commented that "having learned a lesson that one may be too much of a purist, our glass-makers now use vitrifiable colors when it is necessary."[15] Having resolved the conflict of incorporating painted areas into his windows, Tiffany enthusiastically continued to experiment with expanding the range of colors and types of opalescent glass.

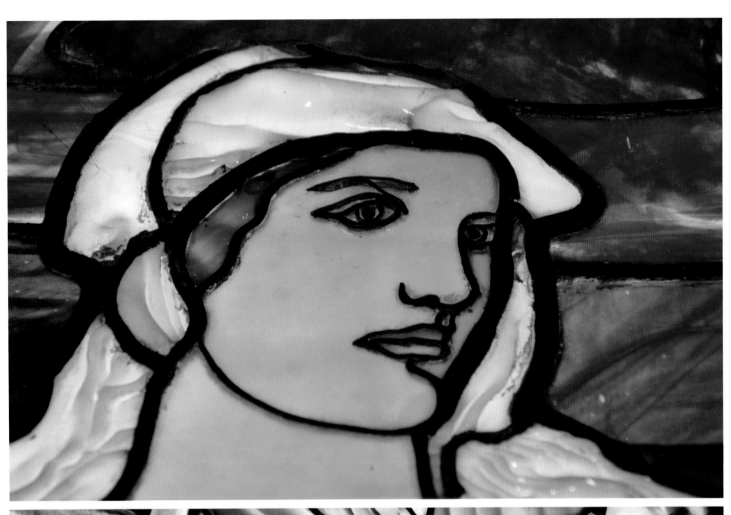
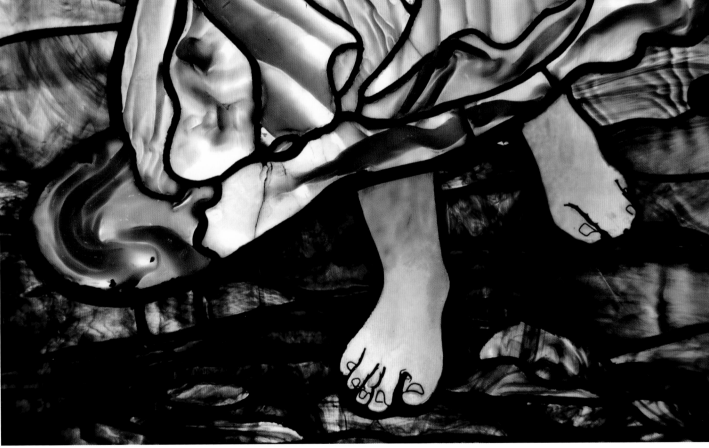

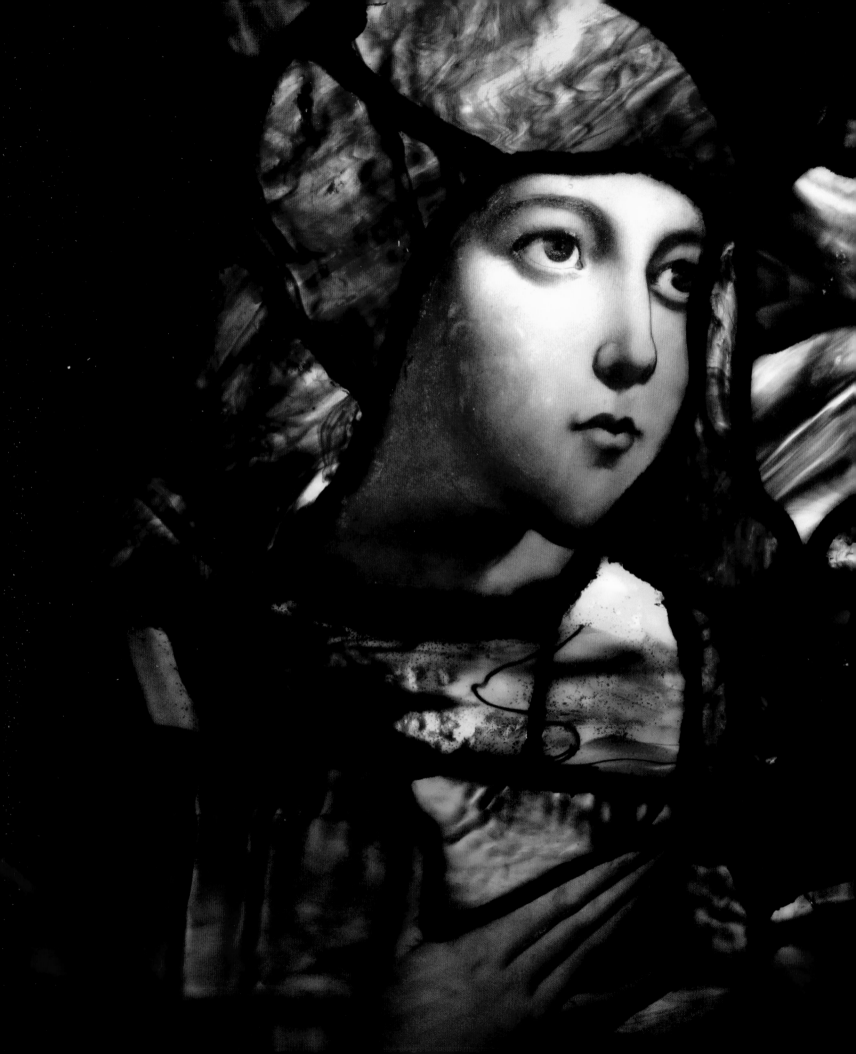

GLASSHOUSES

As described by Samuel Howe, art critic and former superintendent of the Tiffany Glass and Decorating Company, American stained-glass artists devoted "time, and much—very much—money to the development of an agent, the main object of which is to tone, soften, qualify and control the rays [of light]."[16] Tiffany was chief among them.

Public enthusiasm for Tiffany's leaded-glass windows quickly escalated, generating many requests for commissions and the need for ever greater quantities of glass. But in the early 1880s, opalescent sheet-glass production was a fledgling industry and only a handful of glasshouses were producing the material.

Production was physically demanding, requiring a coordinated effort in grueling conditions. Furnaces blazed twenty-four hours a day at more than 2,000 degrees. Workers dipped heavy iron ladles into pots of molten glass and quickly transported the fiery liquid to the rolling table where it was cast onto the smooth iron surface. Multicolored sheets required a ladle of each individual color. In rapid succession, the molten colors were thrown onto the table in a predetermined order and, using a fork-like tool, the table man mixed the red-hot mass with deft, heaving motions. Although mixed together on the rolling table, the individual colors remained separate, forming one-of-a-kind patterns of swirls, twists, and puddles of color as the glass was rolled flat, so that no two opalescent sheets were ever identical. In order to prevent breakage, the glass sheets were quickly transferred to a long multi-chambered oven, or annealing lehr, where, as the glass passed from chamber to chamber, it was gradually cooled.

Glass recipes, and even the equipment used to make the sheets, were fiercely guarded secrets. Toiling as though they were alchemists, glassmakers assiduously experimented with new glass formulas and attempted to refine old ones. Not all colors were compatible, and successful combinations were achieved by trial and error. Glassmakers investigated improved methods to control heat, one of the most critical aspects of the glassmaking process because temperature affects not only the saturation of color and the translucency of glass, but its inherent stability as well. In addition, the quality of ingredients had to be continually monitored as impurities could adversely affect the finished product. As one of the glasshouse superintendents described in humorous terms,

> One curious thing about the manufacture of... colored glass... is the uncertainty of results. As one might say in whisper, there are only two things more uncertain—the mood of a woman and the heels of a mule. We, for instance, never know exactly how the shades [of color] will be in the finished product.[17]

Although the uncertainties of glass production were frustrating to manufacturers, the "surprises" of some experiments were welcomed by glass artists. An unusual surface pattern or color and striking variations in opacity could often be used to artistic advantage.

In his early days of window production, before opening his own furnaces, Tiffany obtained his glass from

Cat. 30
Tiffany Studios, New York
Design attributed to Edward P. Sperry
*Lydia Entertaining Christ and the
Apostles*, Griffin Memorial Window for
Centennial Baptist Church, Chicago,
Illinois, before 1910

several different manufacturers. The precise timeline
of Tiffany's involvement with specific manufacturers
is difficult to pin down, as is a full account of which
glasshouses produced which types of glass. Suffice it to say
that during this time it was extraordinarily challenging to
locate sufficient quantities and varieties of sheet glass to
satisfy Tiffany's artistic demands.

The Berkshire Glass Works in Massachusetts
supplied Tiffany with various kinds of glass, and,
although their range of stock colors was somewhat
limited, he continued to purchase Berkshire glass
throughout the 1880s.[18] Examples of their streaky glass in
rich browns and greens can be seen in the foreground of
the Mary Atwell Vinton Memorial Window in Pomfret,
Connecticut (Figure 33b).[19]

Tiffany's own glass experiments got underway
closer to home, where he directed the production of
glass to his specifications at Francis Thill's Empire
State Flint Glass Works, one of the oldest glasshouses
in eastern Brooklyn.[20] The factory occupied six city
lots and contained two furnaces, with fourteen large
and nine small pots and was also equipped with four
annealing lehrs and six annealing ovens. Over 200 men
and boys were employed. Production was varied and
included "vases, urn-jars, ring-jars, fish-globes, siphons,
chimneys… various articles of glass used for chemical
purposes, with a general line of flint and colored
glass-ware…."[21] It is likely that while at Thill's, Tiffany
encountered James Baker, a stained-glass artist who had
patented a process to manufacture disks of brilliantly
colored and semi-translucent glass for decorative
windows.[22] Examples of this glass can be seen in two

of Tiffany's early religious windows: *St. Mark* from
Islip, New York, and the *Ascension* window in Lynn,
Massachusetts (Figures 29, 32); in both, the concentric
striations are used to suggest the movement of fabric,
especially around the knee and the forearm, respectively.

According to Tiffany's biography, he established
his first glasshouse in 1878 under the direction of Andrea
Boldini, purportedly a worker from the famed Salviati
glass factory in Murano, Italy.[23] The glasshouse, however,
apparently burned down twice within a short period of
time and Tiffany returned to working with glassmakers
in Brooklyn. Disgruntled with sharing an already limited
supply of glass and glassmaking expertise with other artists,
especially John La Farge, Tiffany entered into an exclusive
contract with glass manufacturer Louis Heidt in 1881.[24] This
agreement stipulated that Heidt would produce window
and other decorative glass exclusively for Tiffany, and
restricted Heidt from sharing any glassmaking processes
imparted by Tiffany or discovered during the course of
their experimenting.[25] It is unclear how long this contract
remained in place—Tiffany's biography states that the two
men worked together "from about 1880 to 1893," but this
has proven difficult to verify.[26] Regardless of the duration
of their partnership, it is safe to say that Tiffany kept Heidt
busy as his commissions increased.

Public interest in opalescent glass windows
surged in the mid-1880s. In a Milwaukee church in
1887, Tiffany installed the largest opalescent window
in the world, *Christ Leaving the Praetorium*, which
measured 20 by 30 feet and was based on Gustave
Doré's famous painting of the same title.[27] A year
later, Tiffany stated that the demand for his memorial

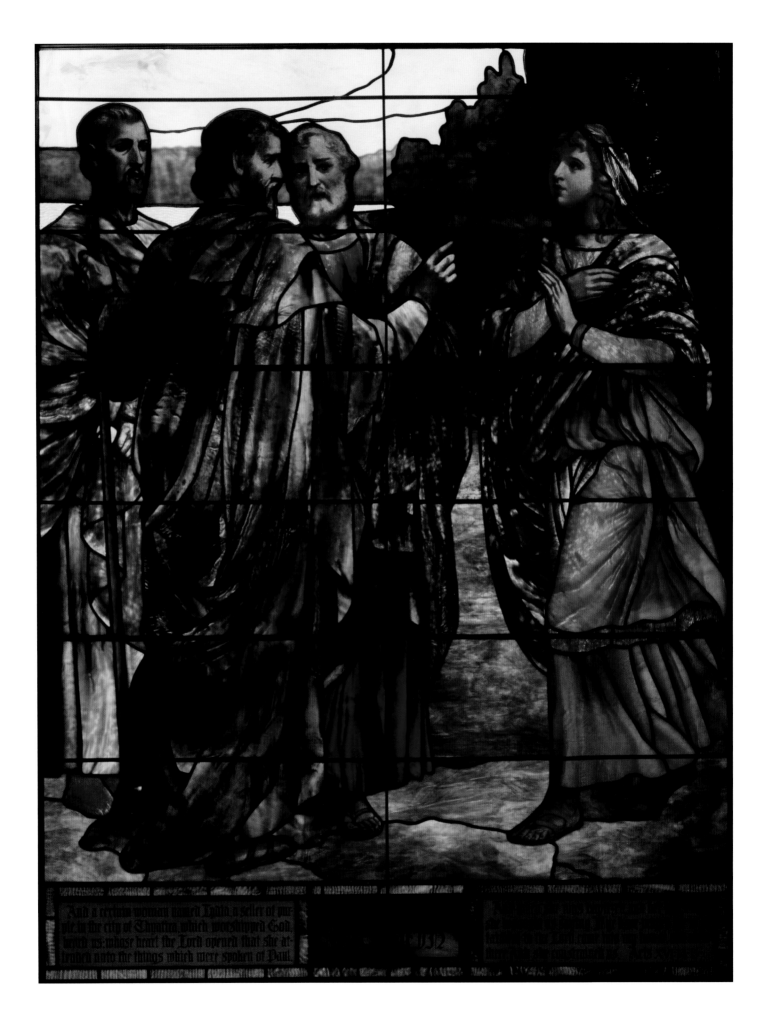

And a certain woman named Lydia, a seller of purple, in the city of Thyatira, which worshipped God, heard us: whose heart the Lord opened, that she attended unto the things which were spoken of Paul.

windows had rapidly increased and his firm had erected more windows in the previous six months than it had during the preceding two years.[28] This statement explains the tremendous quantity of glass Tiffany began purchasing from the newly opened Opalescent Glass Company in Kokomo, Indiana (1888–present). Kokomo's accounting ledger from 1888 to 1893 records that Tiffany bought between 12,800 and 15,400 pounds of glass in 1890 alone.[29]

Given the staggering upswing in Tiffany's commissions, the considerable amount of money he was paying others for glass, and his quest to create glass that satisfied his artistic sensibilities, Tiffany's thoughts naturally returned to opening his own furnaces. He hired Englishman Arthur J. Nash (1849–1934) to oversee the glassmaking activities, and the furnaces opened in 1892–93 in Corona, Queens.[30] Under Nash's experienced hand, flat glass was produced "not with a view to mathematical accuracy as in the average commercial factory. The purpose [was] rather to seek chance or accidental effects which… so enrich the field of the artist."[31] This experimentation eventually resulted in a range of colors never before seen in the stained-glass industry. Every imaginable shade, tone, and hue, in a full spectrum of colors, came out of Tiffany's furnaces.

Tiffany was justifiably proud of his glass. In March 1899, Tiffany Studios announced that the commissions placed for Easter memorial windows doubled in number those of any previous Easter in the history of the company and attributed this to "the greatly increased appreciation of the superior artistic merit" of their work, and to the "quality of the Tiffany Favrile glass."[32] It is important

to note, however, that even after he established his own furnaces, Tiffany continued to use commercially available glass if it suited his purposes.[33] It would have been impractical to make what he could buy commercially.

OPALESCENT GLASS
"One of the most important advances in art"[34]

"There are two great secrets in the make-up of opalescent windows—one is the art of making the glass itself, the other that of selecting glass to express something, to tell a story, or convey a thought."[35] At the Tiffany Studios, an artistic vision would begin to take material form when "the artist descends into the cellar, where an immense amount of glass of all hues and textures is stored in classified presses, just as books are in a library, but according to colors instead of titles, to select his glass."[36]

Drapery glass

One of the first kinds of opalescent sheet glass to be produced was called "drapery" glass because it mimicked the folds and drape of fabric. To create its three-dimensional texture, metal hooks or paddles were used to push the edges of the still molten but rapidly cooling glass until it buckled into ridges and folds. Due to the varying thickness within the sheet, however, problems were initially encountered in the annealing process, which "taxe[d] the skill and ingenuity of the glassmakers to the utmost," according to glassmaker John Dannenhoffer.[37] Tiffany concurred, commenting, "How many years have I toiled to make drapery glass? My chemist and my furnace

Cat. 31
Tiffany Glass and Decorating
Company, New York
Frederick Wilson, designer
Suggestion for a window for First
Congregational Church, Ansonia,
Connecticut, ca. 1900

men for a long time insisted that it was impossible…. New styles of firing ovens had to be built, new methods devised for annealing the glass."[38]

The sculptural quality of drapery glass caused an immediate sensation. Figures were given tangible volume and windows "moved" with the flow of the glass. A highly successful use of drapery glass can be seen in the robe of the Mary Atwell Vinton Memorial Window (Figures 28, 33b). Specific areas of each sheet have been carefully selected to depict the bottom edge of a billowing, wind-blown gown. Note the attention given to the diffusion of light as it moves through the undulating surface of the glass. Within the thick folds color is dense and nearly opaque, while the flat areas between the folds are thinner and therefore more translucent and lighter in color.

The *Lydia Entertaining Christ and the Apostles* window is a veritable celebration of drapery glass (Catalog 30). The four life-sized figures are swathed in shimmering folds of light and color. The intricate draping of fabric follows the figures' postures and gestures in a naturalistic manner. Lydia's garment is especially compelling because of its use of "fan" drapery glass. Fan glass is made by holding one end of a roller still and pushing the other end in short, regular intervals across the molten surface of the glass to create fan-shaped folds that emanate out from a single point. Note the graceful fan glass that sweeps across Lydia's thigh just under the artful blousing of material at her waist. The vibrant watercolor sketch for a figural window in the First Congregational Church in Ansonia, Connecticut, shows a detailed treatment of the color, shading, and movement of the drapery glass

to be used for the garments and would serve as a guide for selecting the glass for the window (Catalog 31).

Another specialized type of drapery was "feather" glass, characterized by short, v-shaped folds and used primarily for angels' wings (Figure 34). This was apparently a very difficult texture to master. According to a 1903 Tiffany brochure, it took fifteen years to successfully produce this effect.[39]

Cat. 32
Tiffany Studios, New York
Ornamental window with
Alpha and Omega, Curtis
Memorial Window, after 1910

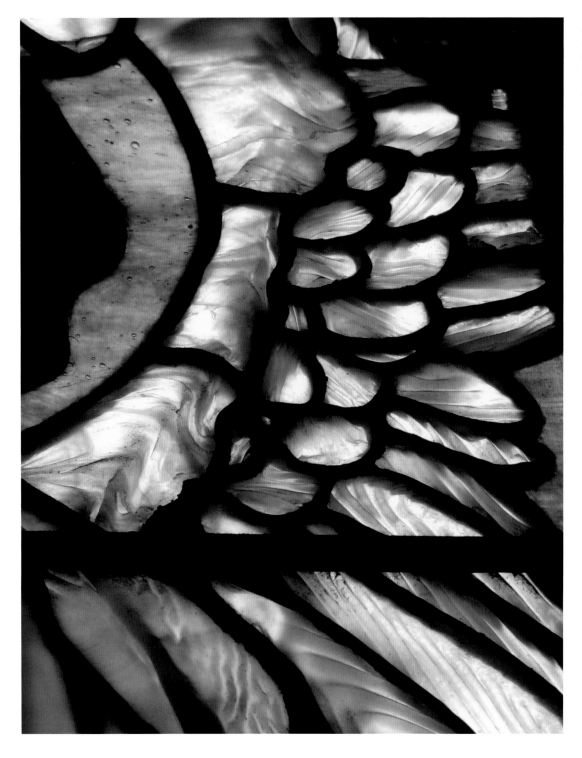

Fig. 34
Tiffany Studios, New York
Woodward Memorial Window,
detail, before 1910
Leaded glass
First Unitarian Congregational
Society, Brooklyn, New York

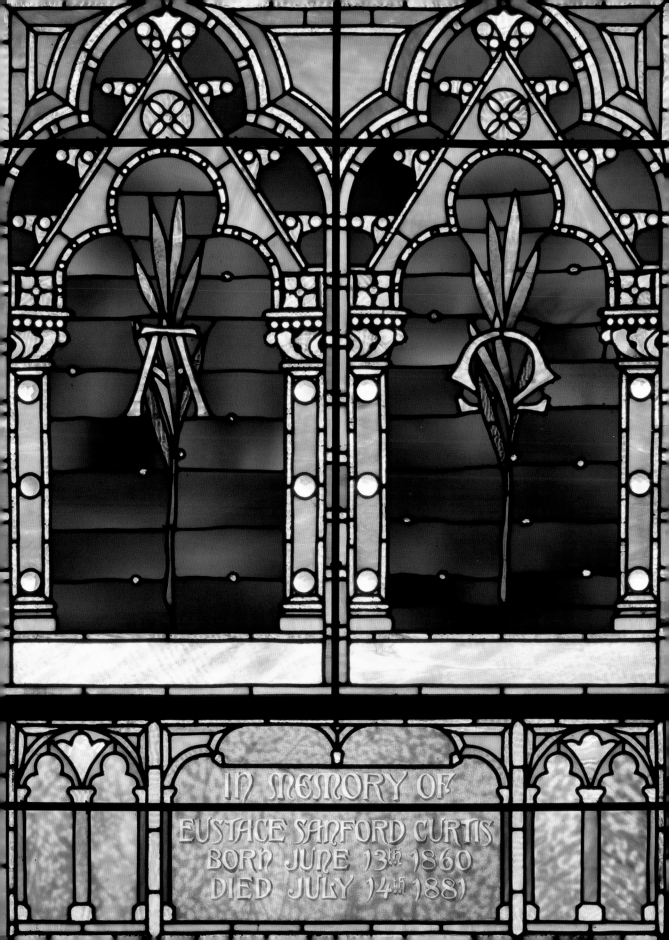

IN MEMORY OF
EUSTACE SANFORD CURTIS
BORN JUNE 13th 1860
DIED JULY 14th 1881

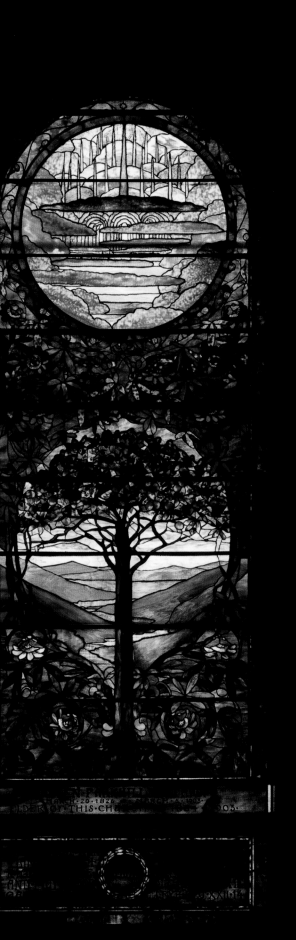

Fig. 35
Tiffany Studios, New York
Agnes Northrop, designer
Northrop Memorial Window, 1903
Leaded glass
Bowne Street Community Church,
Flushing, New York

Cat. 33
Tiffany Studios, New York
Design attributed to Agnes Northr
Vine-Covered Cross window, after

Ripple glass

"Ripple" glass is another type of textured glass made
and used extensively by Tiffany, beginning as early as
1878. According to Leslie Nash, manager of the Tiffany
Furnaces, rippled glass was made by using a moving
table and a roller geared to move at a slightly faster rate.[40]
The difference in speed caused wrinkles or ripples in
the molten glass, which were suggestive of water, leaves
ruffled by wind, or the woolly fleece of sheep. It can
often be seen in the fringes of garments (Catalog 30), in
decorative borders (Catalog 32), and in ornamental (non
pictorial) windows. Ripples could be tight or loose, high
or low, with both combinations possible in a single sheet.

Confetti, or foliage glass

The glass known today as "confetti" or "fractured" glass
may have been originally called "foliage glass" because
the paper-thin glass flakes embedded into the surface of
the sheet were often used to delineate leaves.[41] Foliage
glass is made by first blowing a very thin glass bubble
and then shattering it into small pieces called "fract."
The fract is strewn on the iron table and the base glass is
rolled over the fragments, fusing them into overlapping
and haphazard patterns on the underside of the glass. This
glass is most frequently used to portray dense foliage as in
the Northrop Memorial Window (Figure 35).

Spotted glass

Mottled, or "spotted" glass, as it was called by Tiffany,
was made in a range of colors and densities. The size
and groupings of mottles varied widely within a sheet,
with spots often densely clustered at one end and

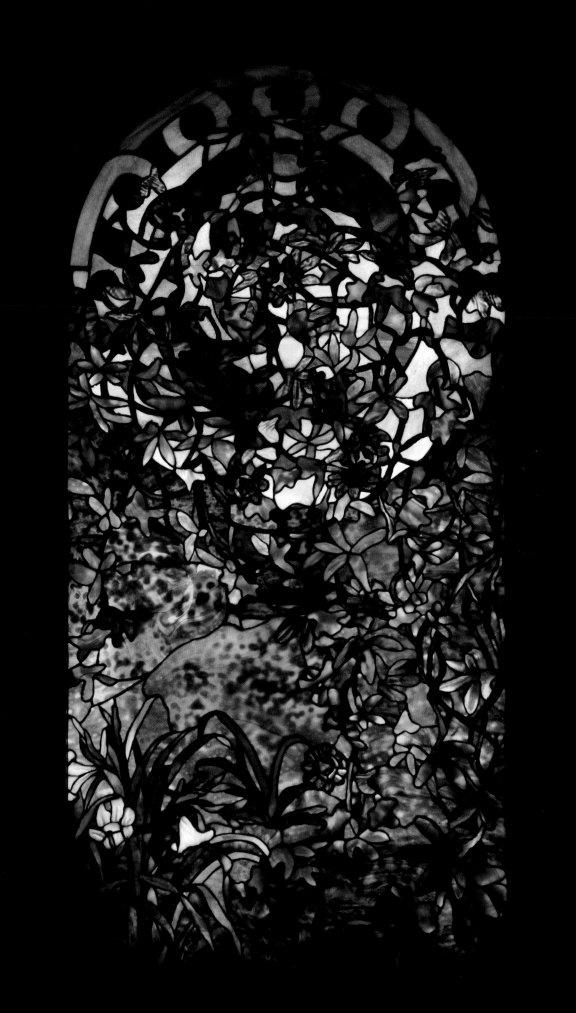

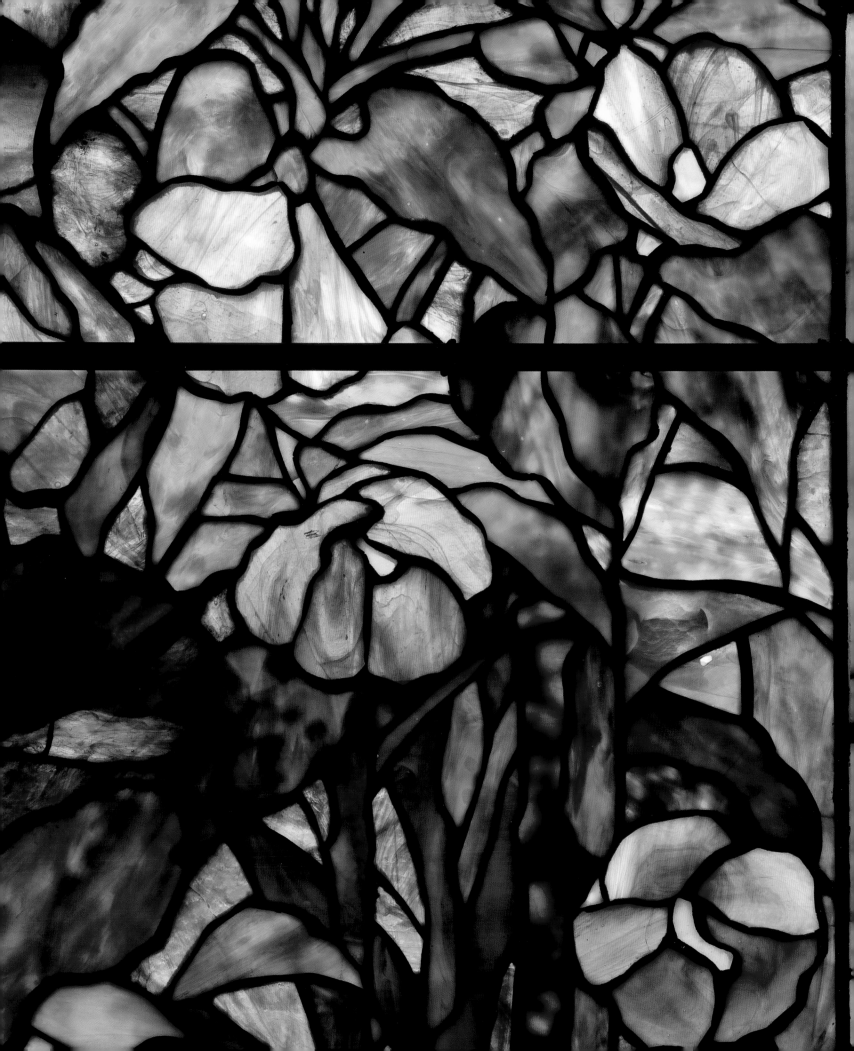

gradually thinning out down the sheet. Spotted glass was especially useful in landscape windows. A wide variety of green spotted glass was available for sunlit foliage and patches of cool shade, as seen in the *Vine-Covered Cross* window (Catalog 33).

Streaky glass
"Streaky" is the modern name given to glass composed of two or more colors. Tiffany's 1894 trademark application indicates that he referred to some of this glass according to use, for example "Sunset" and "Sunrise" glass.[42] According to company price lists, Tiffany was able to combine as many as five colors in a single sheet, no small feat since color recipes were not always compatible.[43] The applications for streaky glass were many: details found in nature such as sky, water, rocks, bark, foliage, and flower petals and in figures for hair and garments (Catalog 29, detail of catalog 37). Streaky glass was produced in virtually every texture. The value of this glass is made clear by Samuel Howe:

> The hardest problem of all is to discover a piece of glass to represent the sky. To choose from say thirty or forty tons of glass a piece sometimes only twice the size of one's hand, which should show the mysterious grandeur of a natural sky with the activities of a soft pearly cloud floating through a clear blue combined with certain wild, free breezy movements, to suggest wind,… that shall at the same time have an air quality, be thin in places,… with a glimmer of vivid light to mark the soft veinings

and delicate glitter; to give perspective play to the scheme.[44]

This effect is perfectly demonstrated in the movement of blue and yellow light through veils of white clouds in *The Soldier of the Lord* (Catalog 34). The watercolor sketches showing two proposed treatments for an ornamental memorial window clearly indicate the intended use of a variety of streaky glasses including the orientation of the streaky pattern (Catalogs 35, 36).

Hammered glass
"Hammered" glass is made by passing a roller with a hammered texture over molten glass; the result is a patterned surface made up of small convex circles. Although not made at the Tiffany furnaces, this glass was used extensively in Tiffany's windows. The hammered texture had a diffusing quality that was used to great effect in "plating," a technique in which two or more pieces of glass are layered. This could be done to mute or change color, or to create the illusion of distance. In the Betts Memorial Window, the lead lines of the hills are softened by the hammered plate and so appear to recede (Catalog 37).

Luster glass
"Luster," or iridescent, flat glass is produced by either adding metallic oxides to the molten batch or by exposing the molten glass to metallic oxide fumes. A rainbow of iridized colors and a host of complex patterns were made at the Tiffany furnaces. Lustered glass is highly reflective, and was therefore frequently used for

Cat. 34
Tiffany Glass and Decorating
Company, New York
The Soldier of the Lord, ca. 1900

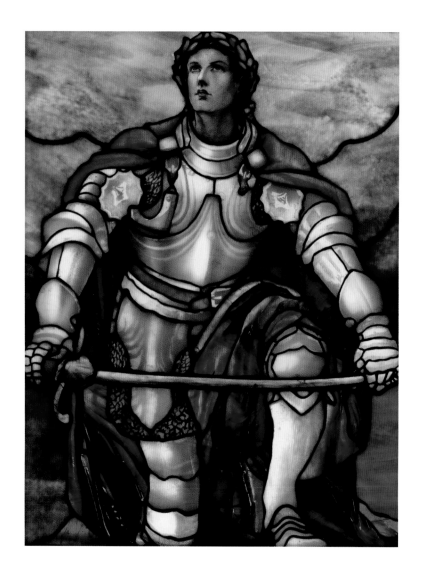

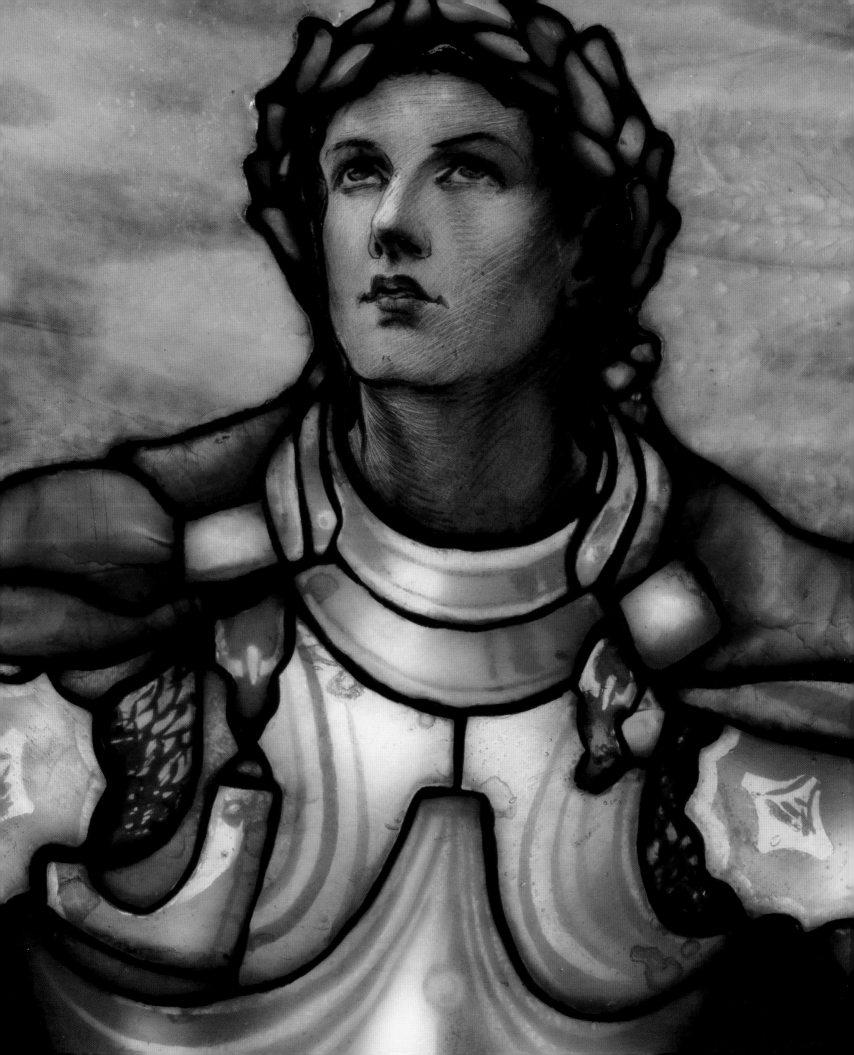

Cat. 37
Tiffany Studios, New York
Landscape window, Betts Memorial
Window, before 1910

Cat. 35
Alice Cordelia Morse (American,
1863–1961)
Design for stained-glass window for
Beecher Memorial Church, Brooklyn,
New York, 1889–90

Cat. 36
Alice Cordelia Morse (American,
1863–1961)
Alternate design for stained-glass
window for Beecher Memorial Church,
Brooklyn, New York, 1889–90

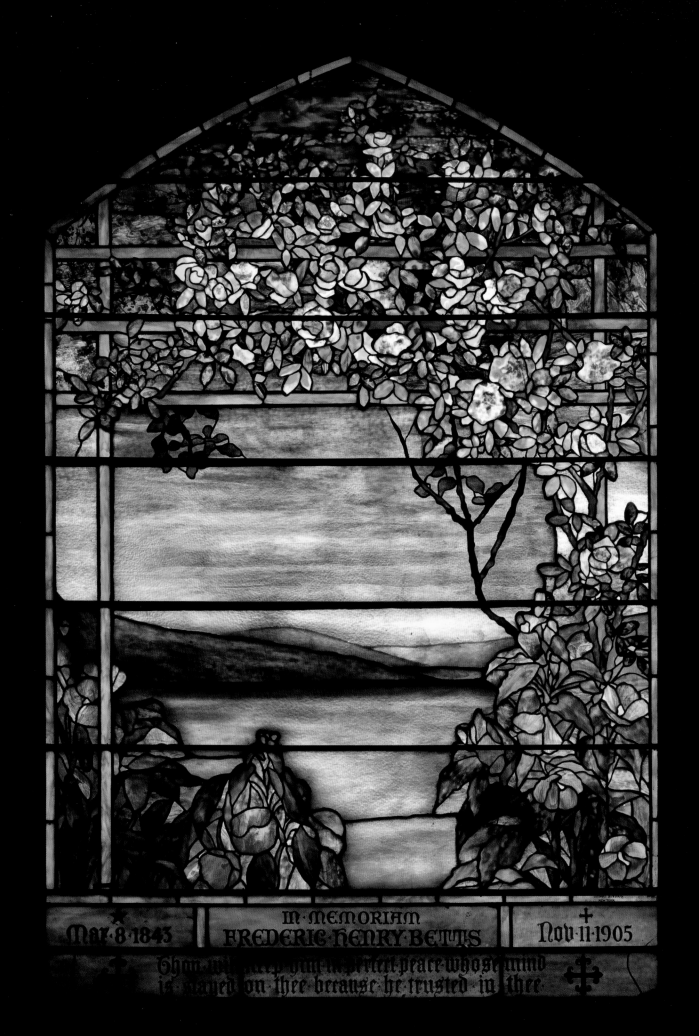

IN·MEMORIAM
FREDERIC·HENRY·BETTS
Mar·8·1843 Nov·11·1905

Thou wilt keep him in perfect peace whose mind
is stayed on thee because he trusted in thee

mosaics, such as the prototype for a column possibly at
St. Michael's Episcopal Church in Manhattan (Catalog 38).
The gold luster of the chains, crosses, and tassels
shimmer against the changing hues of satin blues.

Glass "jewels"

Mold-pressed and hand-faceted "jewels" added
sparkling accents and unexpected dimension to
Tiffany's windows. Used first in his windows, they
were later applied to objects such as mosaics, lighting
fixtures, and liturgical items. Tiffany both made
and purchased jewels, and the resulting cache was a
tantalizing assortment of shapes, sizes, textures, colors,
and opacities: teardrops, trapezoids, apostrophes, and
geometric shapes of all kinds; smooth or rough; single
or multicolored; iridized or opalescent; shiny or matte;
translucent or opaque. The jeweled electrolier at the
United Presbyterian Church in Binghamton, New York,
was designed so that the light would illuminate and play
off the jewels and dance behind the curtain of prisms
below (Catalog 27).

The revolutionary and far-reaching effects of
opalescent glass on the art of stained glass in America
were anticipated from the start; its use would not only
inspire a new artistic aesthetic in glass, but animate a
burgeoning and diverse religious sensibility. In 1888, one
of Tiffany's colleagues assessed the art of stained glass in
America, writing that the field

> has acquired new vigor and even now blossoms
> as the rose. That this art, which is so nearly
> allied to the old world of the past, should

find its renaissance in the last years of the
nineteenth century amidst the dust and clamor
of our new-world mart is curious enough. But
in a country where, in default of cathedrals
inherited from ages gone by, our interest in the
church is in part manifested by the fact that
there are more than four thousand religious
edifices of different denominations now in the
course of construction, this revival is more
than curious; it becomes a question of eminent
artistic importance. In the old world the field
of the glass-stainer is virtually limited to the
Roman Catholic Church and the Established
Church of England. Here, with the widening
of sect-distinctions, the churches of nearly all
denominations are open to him, and it needs
no gift of prophecy to foresee, in the near
future, the clear sunshine gaining admittance
to all our churches through colored glass,
and carrying with it messages of faith and
fortitude, of joyous hope and reverent memory
(Catalogs 39, 40).[45]

Tiffany's development and innovative use of glass
speaks to his indefatigable enthusiasm for new artistic
effects and his unwavering pursuit of beauty. His legacy
however transcends the personal. Using "unimaginable
splendours of colour," Tiffany was instrumental in
resurrecting the art of stained glass and creating a
distinctly American religious aesthetic.

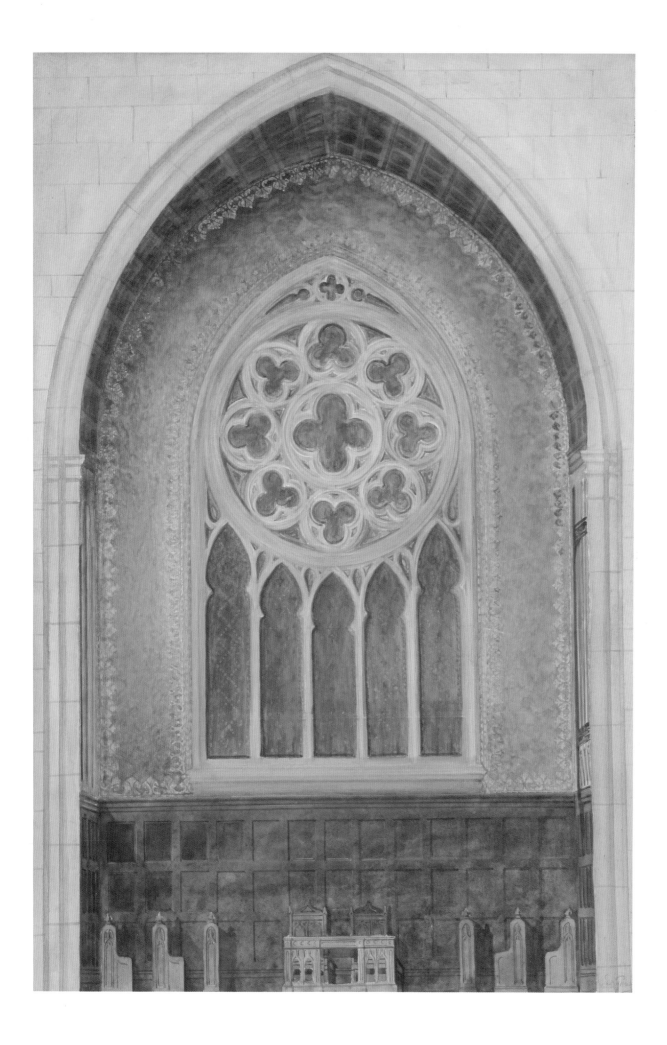

Cat. 39
Tiffany Studios, New York
Suggestion for chancel
decorations, n.d.

Cat. 40
Tiffany Studios, New York
Design for an altar and rose
window, n.d.

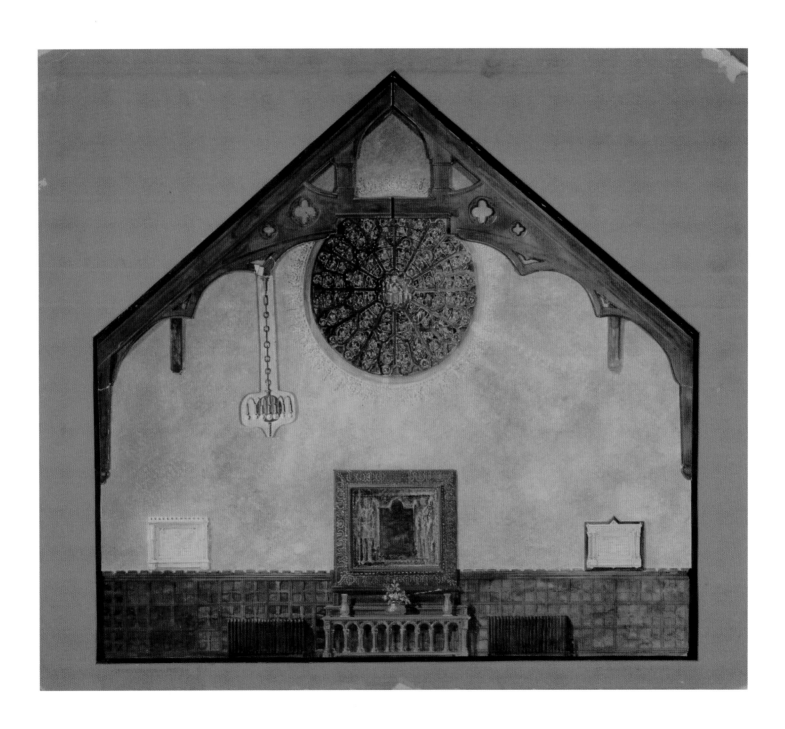

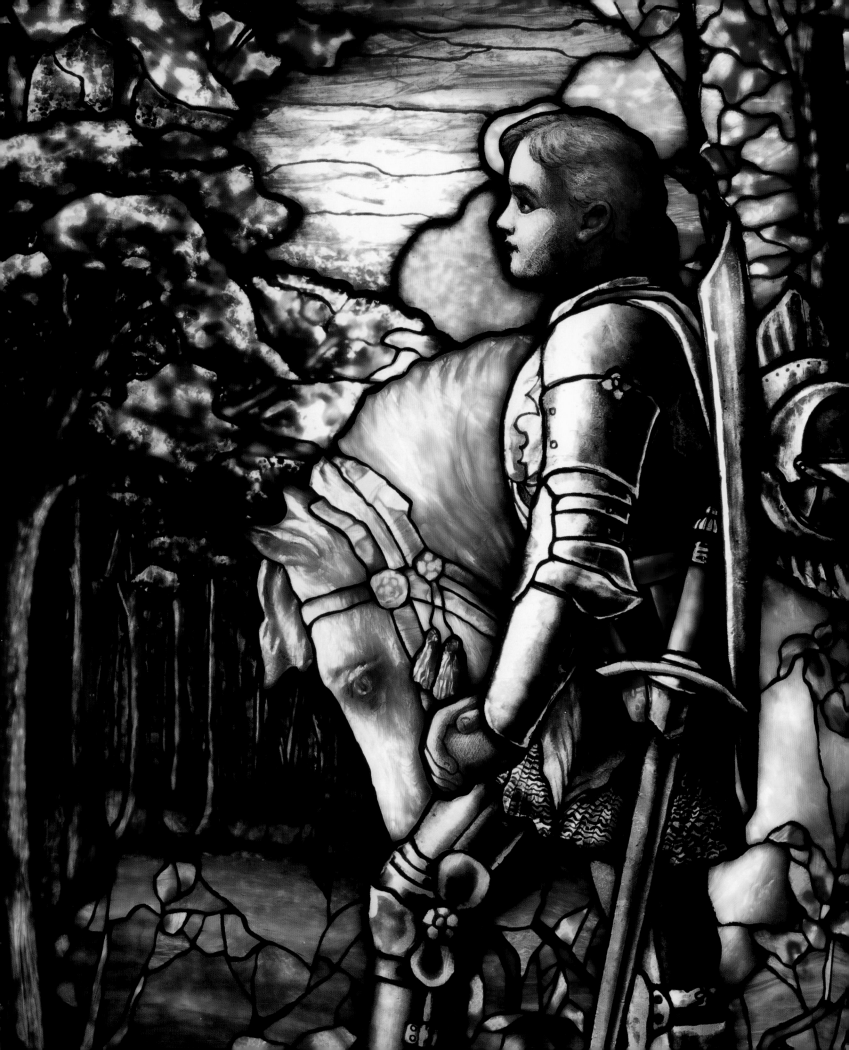

With Joyous Hope and Reverent Memory: The Patrons of Tiffany's Religious Art

ELIZABETH DE ROSA

From Egyptian tombs to papal sepulchers, from the Taj Mahal to the Royal Mausoleum at Frogmore, the history of art is filled with grand funerary memorials. Indeed, across time and cultures they have formed a significant portion of all artistic activity. Throughout most of human history, however, such memorials were commissioned primarily by and for rich and powerful people. With the great rise in living standards and the creation of a middle class in the nineteenth century in western Europe and America, a vast number of new patrons were able to commission monuments to honor family members and community leaders. Full-scale monuments remained costly, but even simple cemetery headstones or plaques in religious institutions could be and were erected by the thousands to honor private citizens.

During the nineteenth century the types as well as the numbers of memorials began to change. In Europe and the United States interested parties debated what form memorials should take. Charles Winston (1814–1864), an English lawyer, stained-glass amateur, and respected author, wrote persuasively about the practicalities of using stained-glass windows for memorials. First he observed that stained-glass windows were relatively inexpensive compared to other funerary monuments. "The sum which will procure a handsome painted window, would produce a very plain or indifferent tomb," he wrote. He also argued that glass windows were sturdy and had survived the vicissitudes of time often better than plaques or sculptures.[1] Windows had the added advantage of being present among the community of religious worshipers rather than tucked away in cemeteries that for reasons of sanitation had been moved outside of towns and cities. Windows also enhanced the interiors of new religious buildings and helped to defray the cost of construction and decoration by encouraging parishioners to fund individual windows or church furnishings.

Following the end of the American Civil War until the advent of World War I, the demand in the United States for such memorials was insatiable. The often-cited statistic that in 1880 more than 4,000 new churches were under construction in the United States gives some idea of the building boom that paralleled the population explosion and the growth of American cities (see the essay by Peter W. Williams in this volume).[2] Each new building and rural cemetery provided opportunities for memorials. An important component of Tiffany's genius was that he recognized, encouraged, and then fulfilled the popular longing to memorialize.

As individuals, Tiffany's clients represented a wide demographic that ranged from wealthy industrialists to Sunday school students donating nickels to sponsor a memorial. Collectively, Tiffany's patrons came primarily from the most populous and well-established end of the religious spectrum, namely Anglo-Saxon Protestant sects: Presbyterians, Episcopalians, and Congregationalists. In addition there was a smattering of commissions from other Protestant, Catholic, and Jewish groups that shared claims to being long-time Americans. A notable example was the Spanish-Portuguese Synagogue of Congregation Shearith Israel in New York, heirs of the first Jewish settlement that had arrived in New Amsterdam in

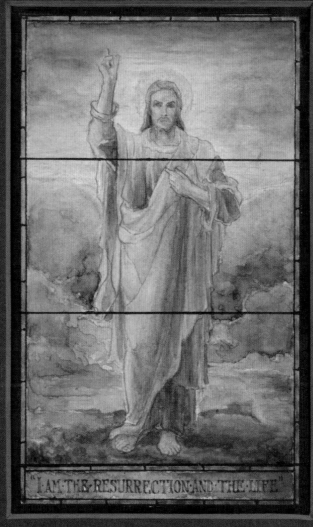

"I AM THE RESURRECTION AND THE LIFE"

~SKETCH~N° 2656~ ~SCALE~1½"=1'-0~

~SUGGESTION~FOR~
WINDOW
~MR~JOHN~W~BRENNAN~
~HUDSON~N~Y~

~IN~MAUSOLEUM~AT~
~HUDSON~N~Y~

~ECCLESIASTICAL~DEPT~
~TIFFANY~STUDIOS~
~NEW~YORK~CITY~N~Y~ ~APPROVED~BY~

1654. Spanish-Portuguese Jews who immigrated to the United States in the late nineteenth century had come by way of eastern Europe and Turkey rather than the Netherlands. The new arrivals shared neither the language nor the religious practices and traditions of the original New York congregation; integration of the new and old residents was challenging. Congregation Shearith Israel displayed its claim to Americanness by commissioning Tiffany to decorate the interior of its new synagogue, dedicated in 1897.[3] Tiffany's own press releases and advertisements never failed to point out the Americanness of his production. There is

> [g]eneral recognition of the Tiffany Studios as the greatest exponent of progressive American art... [Tiffany has created] a fusion of the best modern spirit with an assimilated spirit of the best medieval creations in colored glass,

he declared in an advertising brochure published in 1913.[4] Congregations desiring to set themselves apart from the burgeoning diversity of religious practice chose Tiffany's modern American-style windows in part to demonstrate their own modernity but also to identify themselves as Americans of long standing.

Early in his window-making career, Tiffany's advertising literature instructed potential buyers on the practical issues of choosing an appropriate memorial. In 1888 Tiffany published a copyrighted article, which we would now label an advertorial, in the *Century Advertising Supplement*.[5] The author offered helpful suggestions about issues that a patron should take into account such as lighting, the direction of the window opening, location within the building, and the size and character of the building. "An elaborate window in a simple church is not always desirable; nor is it desirable to attempt a simple or low-priced window for a large church where there is apt to be or follow work of a high grade."[6]

Tiffany's advice to customers also addressed the larger issue of themes and meaning for their memorials. At first he included a rather Victorian attitude that memorial windows should provide moral improvement to the viewers. His brochure of 1893 published in connection with his vast display of religious art at the World's Columbian Exposition maintained that it is

> useful that those who have led exemplary lives and have finished the good fight should be remembered by those still in the battle; remembered not only by their friends and immediate relatives, but by all the people of the church.

In addition, memorial windows should provide object lessons to the viewers and "consolation to bruised hearts, rebellious and weary souls" as well as records of the growth of individual churches.[7] A simple, single figure window design might focus on life after death as seen in a watercolor design drawing of Jesus labeled "I am the Resurrection and the Life (Catalog 41)."

Tiffany also recommended that windows show incidents from scripture that were "particularly

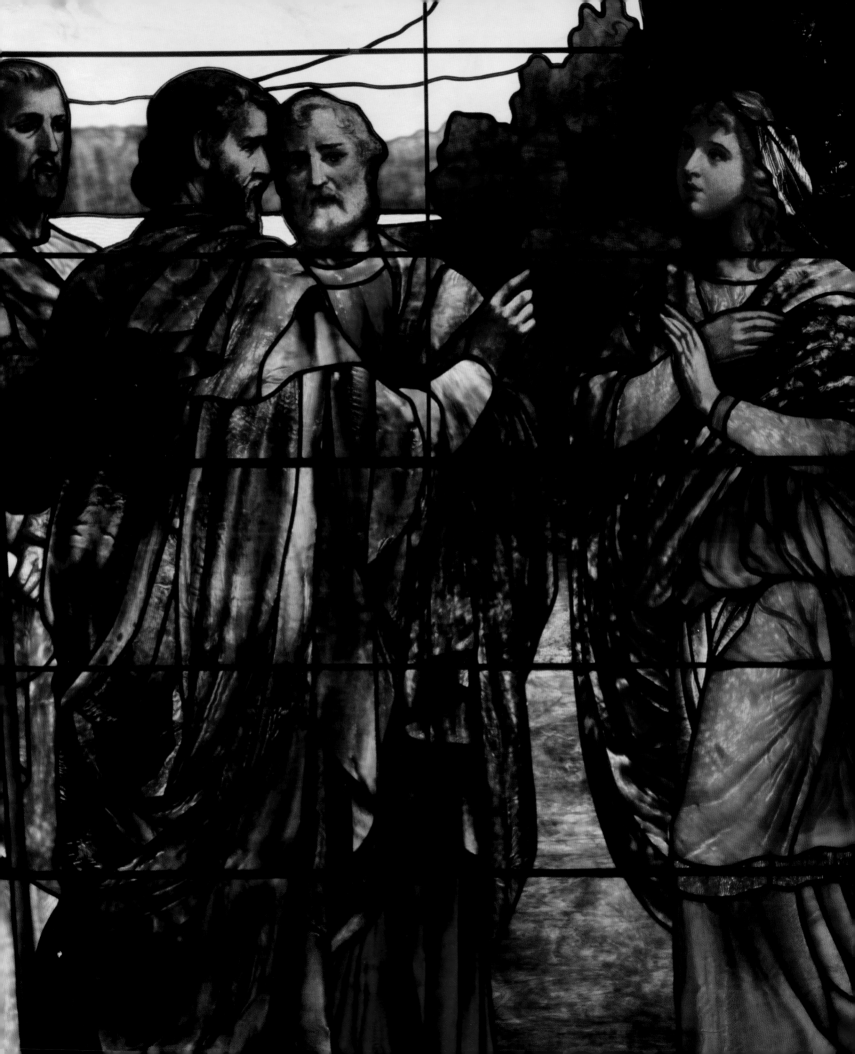

Fig. 36
George Frederic Watts (English,
1817–1904)
Sir Galahad, 1860–62
Oil on canvas
75 ½ × 42 ⅛ inches; framed:
85 ½ × 50 × 3 ¼ inches
Harvard Art Museums/Fogg
Museum, Bequest of Grenville L.
Winthrop, 1943.209

applicable to the person or persons remembered."[8] Just three years later, Tiffany's justifications for stained-glass memorials elaborated on the means by which memorial windows could be personalized:

> What could be more appropriate as a memorial to a youthful student than the scene in the Temple between the doctors and Child Jesus? as a memorial to a young mother than the representation of the Nativity? to a faithful pastor than Christ the Good Shepherd? to a mother and father than the Presentation in the Temple? to a dutiful and loving woman than Our Lord with Martha and Mary in the house of Lazarus at Bethany? to a little child than the Master surrounded by children? to a young man than the beloved apostle, St. John the Evangelist? What could be more suggestive than the emblems and symbols for the primitive Church—the hidden language of martyrs? All this is recognized nowadays.[9]

Even in a window for which no donor or dedicatee is known, the viewer can often surmise from the clear narrative what sort of person is being honored. *Lydia with the Apostles*, a window originally located in the Centennial Baptist Church, Chicago, conveys the seldom-told story from Acts 16:13–15 of an early Christian seller of purple fabric (Lydia) who offered hospitality to the apostles (Catalog 30). The donors surely had in mind a memorial for a woman known for her generosity.

This emphasis on individual experience and memory is arguably the hallmark of religious memorial art of this period, and echoes the romantic zeitgeist of the nineteenth century. Three memorial windows, one for a young child, one for a church leader, and the other for a political leader, illustrate the skill of Tiffany's designers in formulating personalized memorials.

OGDEN CRYDER

In 1902 Edith Ogden Cryder and Duncan Cryder memorialized their son with a window of Sir Galahad placed in St. Andrew's Dune Church, Southampton, New York (Catalog 42). The window copies a popular Victorian painting by George Frederic Watts (1817–1904) (Figure 36).

During the nineteenth century tales of the Knights of the Round Table rode the wave of enthusiasm for all things medieval. Sir Thomas Malory's fifteenth-century English-language compilation of *Le Morte d'Arthur* was reissued in dozens of versions including illustrated

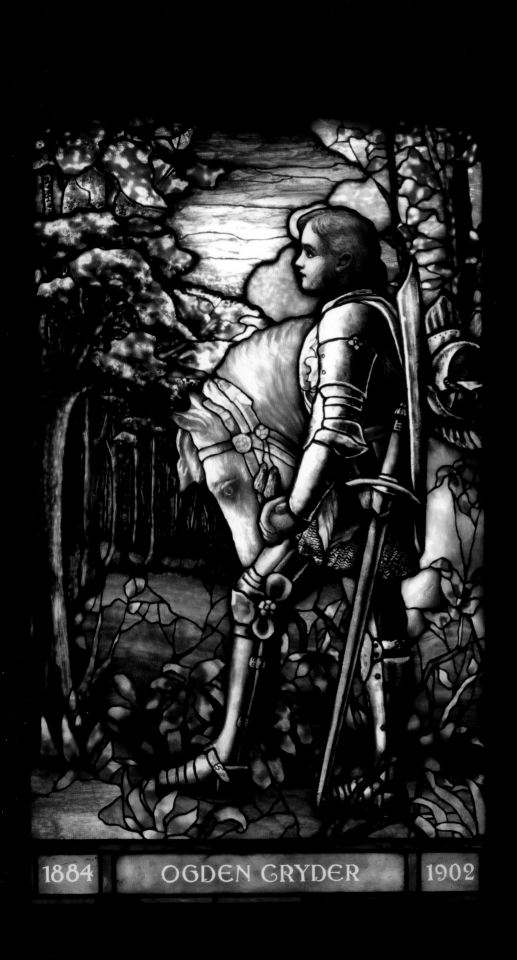

1884　OGDEN CRYDER　1902

volumes for children. Alfred, Lord Tennyson (1809–1892) and William Morris (1834–1896) wrote books devoted to Galahad, who had come to represent the purest of the knights of the Round Table and had acquired an association with Christ that was not present in the original French romance.[10] Watts had such success with his first Sir Galahad image (1860–62) that he elaborated on the theme with several versions produced over many years. In his second version of the composition he accentuated the association between Galahad and sainthood. The pure white horse and the white cloud that creates a halo around the head of the young knight merge themes of bravery, gallantry, and Christian purity in a single image. The congregants at Dune Church would have understood perfectly the religious meaning as well as the sentiment embedded in the image. The main change Tiffany's designers made to the Watts composition was to personalize it more explicitly for the donors by making the sweet-faced youth even younger than Watts's Sir Galahad. Ogden Cryder had died when he was eighteen years old.

JEFFERSON DAVIS

Although individual families usually provided the initiative and financial backing for memorials, there were many instances of organizations or religious groups sponsoring remembrances. A pair of windows in St. Paul's Episcopal Church in Richmond, Virginia, dedicated to the memory of Jefferson Davis (1808–1889), created a personalized memorial that had a political subtext. In 1889, the year of Jefferson Davis's death, members of the

vestry of St. Paul's began discussing ways to memorialize their two most famous congregants, Jefferson Davis and Robert E. Lee (1807–1870). By 1892 a pair of windows honoring Lee was placed above and below the gallery of St. Paul's. Both windows depicted scenes from the life of Moses and were designed by the important English stained-glass maker, Henry Holiday (1839–1927).[11]

By 1896 a women's committee led by Mrs. George Ross had raised enough money through a general subscription to commission Tiffany's firm to design upper- and lower-story windows to honor Jefferson Davis as well.[12] Both panels were designed by Frederick Wilson, whose figural work is discussed by Diane C. Wright in this volume. We do not know who initiated the ideas for themes, but Tiffany sent sketches for the committee's approval in 1897 and the windows were dedicated on Easter Sunday, 1898.[13]

Like Lee, Davis's pre-Civil War service to the United States was extensive and honorable, but his post-war experience was radically different. Both men were West Point graduates and had served in the Mexican War. Davis was a senator from Mississippi, and had been Secretary of War in the Pierce administration. When the southern states withdrew from the Union, Davis resigned from the Senate, expecting to serve as a general in the Confederacy. He was deeply disappointed to be asked instead to become its president. Upon setting up the capitol in Richmond, Virginia, he was baptized and worshiped throughout the war at St. Paul's.[14]

Following the war, Davis was imprisoned at Ft. Monroe where he was briefly manacled. Subsequently he was indicted for treason and remained in jail for two

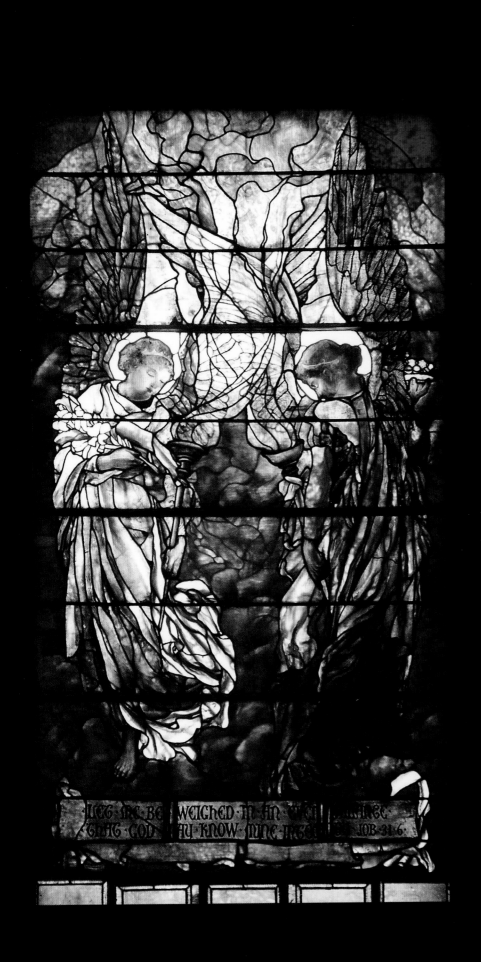

Fig. 37
Tiffany Glass and Decorating
Company, New York
The Angels of Goodness and Mercy,
Jefferson Davis Memorial Window
(upper part), installed 1898
Leaded glass
St. Paul's Episcopal Church,
Richmond, Virginia

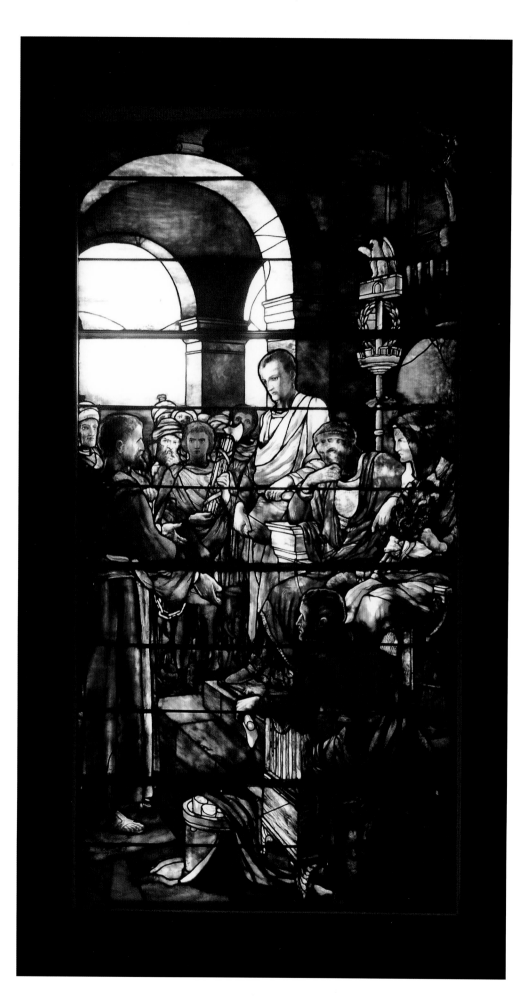

Fig. 38
Tiffany Glass and Decorating
Company, New York
Paul before Herod Agrippa,
Jefferson Davis Memorial Window
(lower part), installed 1898
Leaded glass
St. Paul's Episcopal Church,
Richmond, Virginia

years. Six months after his initial incarceration he was allowed twice-monthly visits from the rector of St. Paul's Church.[15] Released on bail in 1867, his case was never brought to trial. It was widely believed in both north and south that Davis's treatment was impeding post-war reunification of the country; Horace Greeley and a representative of J.P. Morgan were among those who contributed to Davis's bail fund.[16]

The window in the upper gallery depicts two angels in motion, one seen from the front, the other from the back as though caught in a moment of spacial turmoil. Wilson used the angel composition many times. This inscription, "Let me be weighed in an even balance that God may know my integrity" (Job 31:6), applies to the narrative scene below the balcony rather than to the angels (Figure 37).

For the lower window the theme focused on Davis's post-war suffering. As a pendant to the Old Testament narratives in the Lee window, the committee selected a New Testament scene of *St. Paul before Herod Agrippa* (Acts 25:13–26:32). The complex story of Paul's imprisonment, inability to bring his case to trial, and eventual release on bond seemed to parallel Davis's own two-year imprisonment and eventual release without a trial. The inscription, from Acts 26:31, reads "This Man Doeth Nothing Worthy of Death or Bonds" (Figure 38).[17]

The composition leans heavily on the best-known religious images of persecution in the Christian vocabulary: Jesus before Pilate. Countless artists from Giotto onward depicted a standing figure of Christ, seen in profile with his hands bound, facing Pilate who is shown seated on a raised throne. In Wilson's image Paul holds his hands out before him to show the chains, appropriate to the narrative but also a gesture that would have evoked another powerful and related image of Jesus, the *Ecce Homo* (Behold the Man). That scene, also widely represented in Christian art, showed Pilate presenting Jesus, again with bound hands, to a hostile crowd. It is associated with Pilate's words, "Take ye him and crucify him: for I find no fault in him [John 19:6]." For nineteenth-century viewers, educated and steeped in biblical texts as well as painted and print depictions of biblical scenes, the Paul/Jesus/Davis association would have been immediately evoked. Without overtly comparing the injustice and suffering experienced by Jesus to Jefferson Davis's own treatment, the design would have made its message clear. The window subject and its very personal intent are reminders of the interconnection of religion with every aspect of thought in nineteenth-century life. The donors saw no difficulty in co-opting a religious theme for what to us would seem to be a political purpose.

THEODORE CUYLER

A less frequent, but important memorial type honored a community leader on the achievement of some important milestone. In the case of another window about St. Paul titled *St. Paul Preaching at Athens* in the Lafayette Avenue Presbyterian Church in Brooklyn, the window was one of several donated by the congregation to honor Rev. Dr. Theodore Cuyler (1822–1909) for his thirty-year pastorate (1860–90) at the church. The

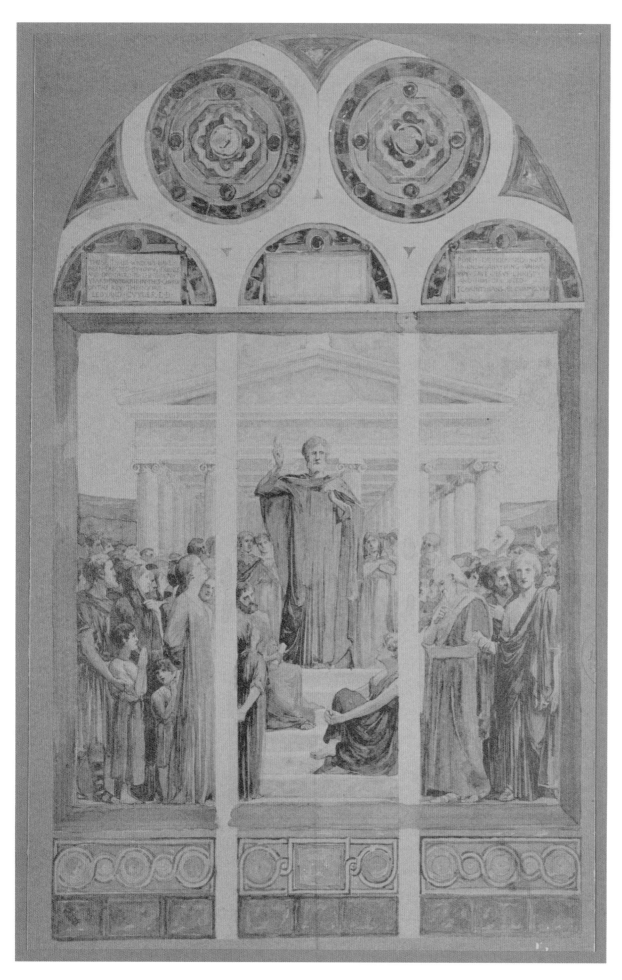

Cat. 43
Tiffany Glass and Decorating
Company, New York
Edward P. Sperry, designer
Copyright design for *St. Paul
Preaching at Athens*, 1894

window, located above a balcony along the back wall of the nave, is difficult to photograph and the subject can be best understood through a photographic copyright image dated 1894, the year after the window was installed (Catalog 43). The design, by Edward P. Sperry, an active designer for Tiffany in the early 1890s, shows a three-light window with St. Paul preaching in the center. The rigidly symmetrical composition with St. Paul elevated in the middle was typical of Sperry's work, and in the case of the St. Paul window was derived from a reworking of Jean-Auguste-Dominique Ingres' (1780–1867) famous painting of the *Apotheosis of Homer* in the Louvre, Paris. Sperry used Ingres's composition for the classical temple front framing St. Paul, the rigidly centralized figure of the saint, and for the massing of figures left and right of the podium. Sperry changed St. Paul to a standing figure from Ingres's seated Homer. The window as installed in Brooklyn has two small additional lights flanking the main composition; these contain figures representing the old and new law in the form of Moses on the left and St. John on the right.

St. Paul Preaching at Athens takes its theme from Acts 17 that describes Paul preaching to Jews and Gentiles in Athens and making many converts. It was a topic particularly appropriate to Theodore Cuyler who, over the course of his thirty-year pastorate, grew his congregation from 200 to 2,300 members, built a new church to house the crowds, and helped to establish several auxiliary churches in Brooklyn.[18] Cuyler was a great admirer of St. Paul and referred to him in his farewell sermon in 1890, quoted in full in the *Brooklyn Daily Eagle*. In the same sermon Cuyler discussed the importance of conversions and proclaimed that "[c]onverted souls are the jewels of the caskets of faithful parents, teachers and pastors. They shall flash in the diadem which the Righteous Judge shall give them in that great day."[19]

But it was more than flashing jewels that made Cuyler's conversions a central focus of his memorial. By the late nineteenth century a sense of crisis prevailed among many Protestants. The influential Congregational minister, Josiah Strong (1847–1916), wrote in his much-publicized book, *Our Country: Its Possible Future and its Present Crisis*, that the values he described as central to Anglo-Saxon Protestantism, namely spiritual Christianity and civil liberties, could and would conquer the world. "I believe that it is fully in the hands of the Christians of the United States, during the next ten or fifteen years, to hasten or retard the coming of Christ's Kingdom in the world…"[20] But action had to be quick, he believed, because the United States was beset by threats and consequently "Christian work is unspeakably more important in the United States than anywhere else in the world."[21] Strong outlined the crisis points that made American conversions so critical. Among them were Catholicism (termed Romanism), immigration, Mormonism, and intemperance. The ever-broadening variety of religious expression that characterized nineteenth-century America threatened perceived American values. To a Presbyterian congregation imbued with ideas that so much was at stake, it would have seemed particularly appropriate to equate Cuyler's talents in enlarging his church to St. Paul's conversions in the ancient world.[22]

The three-light narrative installed at Lafayette Presbyterian and flanked by the two smaller lights of Moses and St. John measures approximately 45 feet wide by 24 feet high and occupies the back wall of the nave opposite the pulpit and above the entrance to the church. It was the largest window of a redecorating program initiated by Dr. David Gregg, the minister who succeeded Dr. Cuyler, as a thirtieth anniversary celebration of the church's construction.[23]

Despite the evidence of Sperry's copyright image in the Library of Congress, publicity at the time the window was installed credited Louis C. Tiffany as its designer. Information in articles in the *Brooklyn Daily Eagle* and *Architecture and Building*, both published in May 1893, stated that it "was designed by Louis C. Tiffany and executed by the Tiffany Glass and Decorating Company under Mr. Tiffany's personal supervision."[24] The article in the *Eagle* discussed at some length the importance of the two figures of Moses and St. John. The commentary may well have been quoting Tiffany's own press release when it pointed out that "[I]n these two side lights are found the most marked suggestions of symbolism which appear in the entire work."[25] Perhaps Tiffany designed Moses and John or thought of adding them, and believed that he thereby deserved to credit himself with the window. One wonders whether the post-installation copyright was an attempt to correct the record for any future uses of the composition. The five-light window as installed has some of the hallmarks of Tiffany's own design aesthetic, notably the urge to label constituent parts of the design. According to the publicity, the two side lights represent the old and new law. Moses on the left holds the tablets

of the Ten Commandments and St. John on the right holds a book inscribed with the first lines of his gospel, "In the beginning was the Word, and the Word was With God, and the Word was God." Inscriptions with the dates of Cuyler's service to Lafayette Avenue Presbyterian Church, "April 8, 1860" and "April 6, 1890," appear above the two figures. The articles provided text contained in the upper sections, reading left and right respectively: "This window has been erected by loving friends and dedicated to the thirty years' pastorate in this church of the Rev. Theodore Ledyard Cuyler, D.D." and "For I determined not to know anything among you save Jesus Christ and Him crucified." The second quote was from Cuyler's own farewell sermon in 1890.[26] The inscriptions are now nearly illegible.

Another striking quality of late nineteenth-century memorials is that most of them placed a firm emphasis on conveying a mood of joyous hope (see Peter W. Williams's essay in this volume).[27] In the post–Civil War era, weeping angels or crucifixions largely disappeared. Instead memorials focused on scenes of triumph, good cheer, and optimism.[28] *The Righteous Shall Receive a Crown of Glory* is a glowing example of a memorial that joyfully celebrates victory over death (Catalog 44).

A popular composition of more modest ambitions was a three-figure window design of a standing woman with two small children who are kissing one another. Variously called *Charity with Jesus and John* or *The Kiss of Charity*, it lent itself to suggestions of sweet domesticity in which it could represent the biblical text from 1 Peter 5:14, "Greet ye one another with a kiss of charity. Peace be with you all that are in Christ Jesus" (Catalog 46).[29]

The charming scene evolved from images of Mary with Jesus and John. In its early form the composition was part of the long tradition of devotional images of Jesus and John as young children, usually shown with Jesus' mother, Mary, standing or seated behind them. Renaissance images such as Raphael's *Madonna del Prato* (Kunsthistorisches Museum, Vienna) often showed John and Jesus playing with some emblem, such as a miniature cross, that prefigured Jesus' death. Leonardo seems to have been responsible for the earliest image, now lost, of the two small children kissing. Frederick Wilson's design replaced Mary with a more generic figure titled Charity, and made the children older than the Jesus and John of Renaissance art. These modifications sweetened the theme and suggested a generalized domestic situation with loving children and a mother figure placed in a garden setting. The composition was thus appropriate for memorializing mothers as well as children.

BRADLEY MEMORIAL

Windows were by far the largest part of Tiffany's memorial work, but church furniture was popular as well. Of all the types of church furniture that could suggest joyous hope, the baptismal font was the most obvious choice, even when given in memory of children. The baptismal font commissioned by Helen Bradley for Christ Church, Pomfret, Connecticut, honored both her husband and child. Her husband George Bradley (1846–1906), and her daughter, Emma Pendleton Bradley

(1879–1907), had died within eighteen months of one another (Catalog 10).

George Bradley had trained as a mining engineer and built a large fortune as one of the early officers of American Telephone and Telegraph. He and his wife had experienced a major and protracted family tragedy. In 1886 when their only child, Emma, was seven she was stricken with encephalitis that caused behavioral difficulties, palsy, and mental retardation. The desperate parents sought help from dozens of doctors but finally recognized that Emma's condition was incurable. They set up what amounted to a private hospital at their country house in the lovely rural hills of Pomfret, where they were active communicants at Christ Church. The Bradleys' wills specified that following both of their deaths their home in Providence, Rhode Island, should be converted to a hospital to serve poor children who suffered from mental and neurological diseases. It was the first such undertaking in the United States that focused on children.[30]

Mrs. Bradley had given one baptismal font to Christ Church in memory of her mother when the church was first dedicated in 1882. Following her husband's and daughter's deaths she commissioned Tiffany to create a new baptismal font to be placed at the rear of the nave of Christ Church. The inscription reads simply: "George L. Bradley • October 4, 1846 • March 26, 1906" and "Emma Pendleton Bradley • July 31, 1879 • November 26, 1907." Because the larger memorial to their daughter—the creation of a children's hospital in her memory—would not be accomplished until Helen Bradley's death, the font

131

Fig. 39
Photographer unknown
Photograph of *The
Adoration of the Magi*,
Christ Church Cobble Hill,
Brooklyn, New York, 1917
From *Commemorative
Presentation Booklet:
In Memory of Alexander
Ector Orr, 1831–1914, and
Margaret Shippen Orr,
1835–1913*
Christ Church Cobble Hill,
Brooklyn, New York

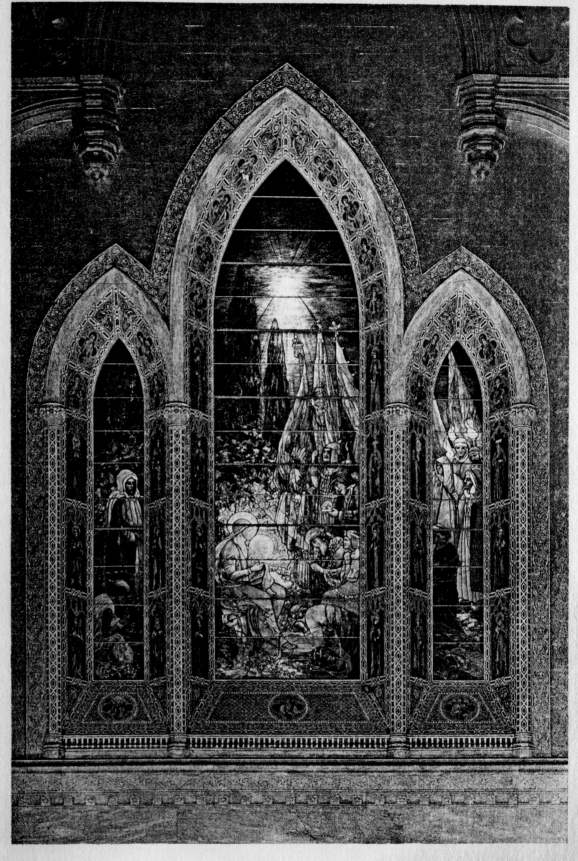

*"Adoration of the Magi"
New Chancel Window*

served as a more immediate memorial. It provided both a reverent memory in the place where Emma had spent most of her life and the joyous hope represented by baptism.

ORR MEMORIAL

The three daughters of Alexander Ector Orr (1831–1914) honored their father and their stepmother, Margaret Shippen Orr (1835–1913), with what seemed at first to be a simple project. In 1915, to coincide with the eightieth anniversary of the organization of their church, they ordered a memorial baptismal font from Tiffany Studios to be placed in Christ Church Cobble Hill, Brooklyn, where their parents had worshiped for more than four decades.[31] For the three sisters, nées Jane Dows, Mary Moore, and Juliet Ector, this turned out to be only a modest beginning of their memorializing project. The memorial to their parents soon blossomed to an entire church renovation and redecoration program.

It is not clear who initiated planning for a far more elaborate memorial than the baptismal font. Christ Church, founded in 1835, had occupied a building constructed in 1842, designed by the important architect Richard M. Upjohn (1802–1878). The eightieth anniversary of the founding of the congregation gave the redecorating program an appropriate focus. By 1916, when the Orr sisters commissioned Tiffany to redesign the entire church interior, the building seemed dated. Tiffany set out to replace the rich dark Victorian interior with his cheerful light-colored palette. The donors' stated goals

were to serve the church and to enhance the memory of Mr. and Mrs. Orr, but more specifically, "[T]he interior of the church should be so transformed that it would be a temple of quiet, sacred beauty, whose atmosphere would be a source of inspiration and spiritual uplift..." Further, they added, "It is hoped that the gift may prove a lasting tribute, worthy to remind others of the good works of those two devout followers of Christ whose memory we so reverently cherish, and that to Christ Church it may be a fruitful service of indeterminate duration."[32] The indeterminate duration was brief. In 1939 Christ Church suffered a serious fire that destroyed much of the redecorated chancel and several of the nave windows. Fortunately the overall design program was discussed and illustrated in a memorial book that was published in 500 copies for the dedication of the renovated church in 1917.[33]

The remodeling project was both extensive and elaborate. The donors apparently turned over the design decisions to Tiffany, who must have had a large budget with which to work. The centerpiece of the project focused on the altar and the space around it. A new triple-light window was placed above the altar. Tiffany claimed personal credit for the composition of *The Adoration of the Magi* that spread across three lancets. The original window was lost in the fire but was illustrated in the memorial book (Figure 39).[34] By focusing on the visit of the Magi, Tiffany combined a popular narrative about Christ, for whom the church was named, with an oblique reference to the munificence of the three Orr sisters whose gift of the decorative program served the church itself. The window frame had an unusual and expensive elaboration composed of splayed borders lined with glass

Fig. 40
Tiffany Studios, New York
Bishop's chair, detail, ca. 1916
Marble and favrile glass mosaic
Christ Church Cobble Hill, Brooklyn,
New York

mosaics that depicted thirty-nine saints in large and small formats and six cherubs.[35]

The overall decorative program for the church featured Siena marble inlaid with Tiffany's favrile glass mosaics in tones of pink, blue, and silver. Behind the altar, gold and silver inlays predominated. A mother-of-pearl panel above the altar and beneath the window represented *Ezekiel's Vision of the Holy Spirit*. It survived the fire as did the altar furniture, altar rail, pulpit, lectern, and clergy chairs (Figure 17, 40). Tiffany enhanced the original Orr gift of the baptismal font by adding an elaborately carved baptistry to the right of the altar and creating a Gothic-style gilt-wood cover for the font. The redecoration program introduced lightness and delicacy to the church interior by the addition of white marble, light-colored granite, and the flickering inlays of mother-of-pearl and favrile glass. It favored serenity over drama.

The memorial book was a significant component of the effort to memorialize Margaret and Alexander Orr. In addition to an elaborate account and photographs of the redecorated interior, the book contained portraits of the dedicatees and biographical accounts of their lives. Alexander Ector Orr was the quintessential self-made man. Born in Ireland to Scotch-Irish parents, he emigrated to the United States when he was twenty after having visited the east coast on a voyage to recover from a crippling accident. By twenty-five he had married Juliet Buckingham Dows, the daughter of a New York grain merchant; two years later he joined his father-in-law's firm. The couple had three daughters. By age thirty-two Orr held a seat on the New York Produce Exchange. His biography maintained that he had an extraordinary capacity for hard work, and sat on the boards of two dozen companies as well as church-related committees and civic groups. Still going strong at age seventy-five, Orr agreed to become interim president of the New York Life Insurance Company after the organization suffered reverses in a scandal involving its prior president.

Margaret Shippen Orr was Alexander Orr's second wife, and, prior to her marriage at age thirty-eight her life revolved around the work of women's committees at Christ Church. Her biography in the dedication book described her devotion to her husband but did not mention the three stepdaughters who commissioned her memorial. The donors were insistent that, in keeping with their father's own modesty, their names should not appear on the dedicatory plaque in the church. Apparently they did not want their names mentioned anywhere in the project, including the book they sponsored about the gift. That remarkable gift gave Tiffany a last chance to supervise the kind of grand decorative project that had made him famous at the beginning of his career.

Over the course of several decades Tiffany's memorial commissions ranged from simple single-figure windows to decorative programs for entire churches. Even though we have little direct evidence from the donors themselves about what they were looking for in their memorials, the objects they chose speak clearly of optimism, and reverent memory, just as Tiffany prescribed in his advertising literature. By the time the mood of the country changed after World War I, Tiffany had already turned his attention to his own personal memorial of a vastly different kind: creating a foundation to encourage young painters.[36]

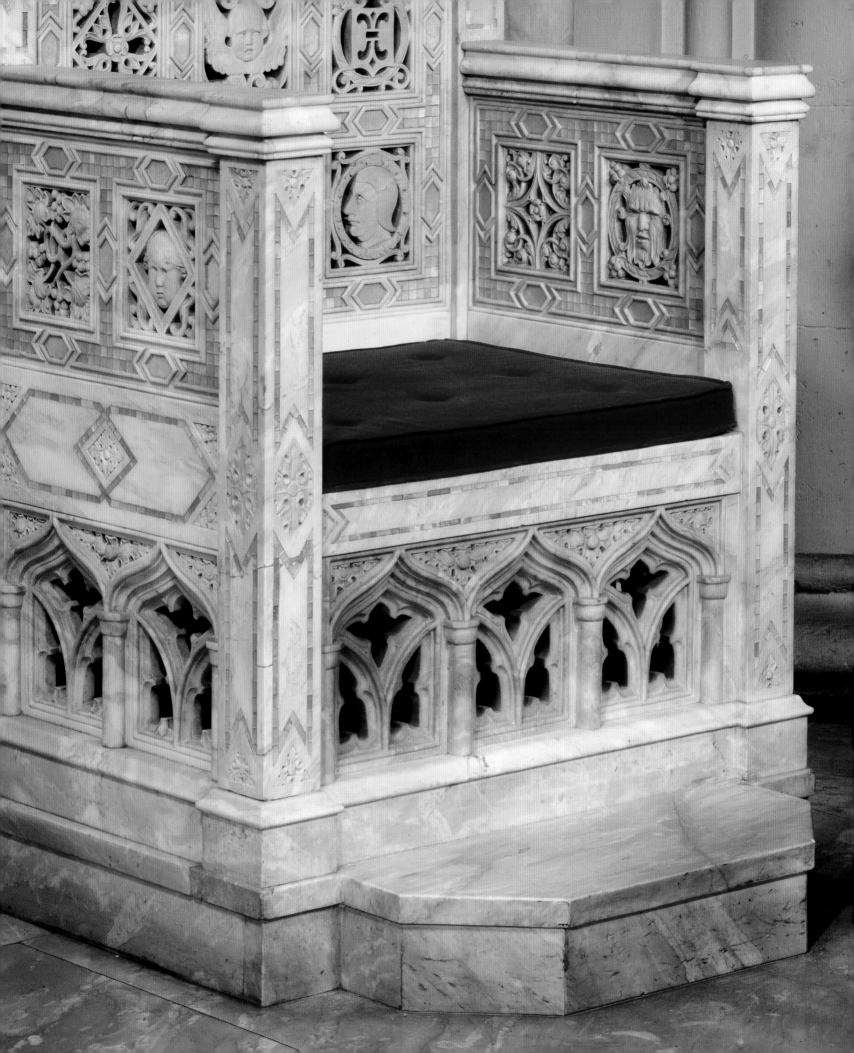

"I have heard thy prayers and I have seen thy tears" IV Kings. XX. 5.

Innovation by Design: Frederick Wilson and Tiffany Studios' Stained-Glass Design

DIANE C. WRIGHT

Tiffany Studios produced a diverse array of religious stained-glass windows in the late nineteenth and early twentieth centuries. Windows were designed by many different artists who were both employed by Tiffany on a regular basis and who worked as independent muralists, painters, and stained-glass designers. The mixture of individual styles seen throughout executed windows points to the numerous artists who had a hand in the design process and demonstrates the varied skill level among the designers. As little is known about many of the designers, it has proven challenging to attribute many windows to a particular individual. Signed drawings and watercolors that can be associated with executed windows identify the work of a number of designers. But often there are no signed preparatory works to help link windows with individual artists. Finished windows were rarely signed by the designer and frequently not signed by the studio either. Further complicating matters was the practice of utilizing popular imagery from paintings and print sources, thereby obscuring the designer's hand that translated the subject into a stained-glass composition. The hiring of a primary full-time ecclesiastic designer, Frederick Wilson (1858–1932), in the early 1890s resulted in a more cohesive look to Tiffany Studios' religious windows. Analysis of the company's early stained-glass windows and the transition that occurred when Wilson arrived permits a greater understanding of how the design process evolved at Tiffany Studios.

Tiffany's initial foray into stained glass began in the late 1870s. The earliest known figural ecclesiastic window commission was for St. Mark's Episcopal Church in Islip, New York, in 1878 and possibly the earliest religious landscape window was designed for a church in Newark, New Jersey, in 1880.[1] As Lindsy R. Parrott discusses in this volume, this first decade of fabrication is characterized by an approach that underscores the experimental state of window making at the company, in terms of design, materials, and construction. Rather than having one primary designer or even a group of in-house designers, Tiffany sought contemporary muralists and painters to produce window designs. Tiffany Studios probably also acted as a fabricator for some of these designers. Well-known artists such as the sculptor Augustus Saint-Gaudens (1848–1907) and the painter and sculptor Francis D. Millet (1846–1912) designed windows for St. Stephen's Episcopal Church, Lynn, Massachusetts, that were installed in 1881. Elihu Vedder (1836–1923), the American symbolist painter and illustrator, also designed early windows that were executed for Christ Church in Pomfret, Connecticut, the Randolph Marshall Clark Memorial Window, dating to 1882–83, probably based on his Christmas card design, and the Mary Atwell Vinton Memorial Window, dating to 1883.[2] Edwin Blashfield (1848–1936), a leading muralist of the late nineteenth century who served as president of the Society of Mural Painters and the Society of American Artists, collaborated on a mausoleum mosaic for Tiffany with Joseph Lauber (1855–1948).[3] Lauber, an artist who worked on a number of designs for both windows and mosaics at Tiffany Studios, wrote that "nearly all the artists who have essayed mural painting have worked in this [stained-glass] medium some time or other…."[4]

It was difficult to make a living as a designer of stained glass, Lauber explained, and many of these designers did it as a labor of love because the field paid so little. Over the course of its fifty-year-history Tiffany Studios produced an estimated five thousand windows, many of them religious.[5] It is in part due to the demand for window designs at Tiffany Studios and the relationships that Louis C. Tiffany himself had with many of the prominent artists of the day that the company executed works by so many different artists and designers.

In 1886, less than ten years after his foray into stained glass, Tiffany reorganized his company, announcing administrative changes and listing a number of the artists engaged by the Studios for window design. The brief article that ran in *The Critic* stated that:

> Louis C. Tiffany & Co. have just reorganized their business and will be known hereafter as the Tiffany Glass Co. Mr. Tiffany will be the President and Art Director, Pringle Mitchell the Vice-President and Manager, John Cheney Platt the Treasurer, and John du Fais the Secretary of the new company. Amongst the artists whose designs will be utilized for memorial windows and other special work are Maitland Armstrong, Robert Blum, F. S. Church, Samuel Colman, Ernest W. Longfellow, Will H. Low, F. D. Millet, Louis C. Tiffany, Elihu Vedder and Miss Dora Wheeler...[6]

Tiffany continued to make use of a long list of freelance artists but eventually shifted towards executing most of his windows from the work of a small handful of

Cat. 47
Tiffany Glass and Decorating
Company, New York
J. A. Holzer, designer
Copyright design for *Angel
of Knowledge*, 1897

Fig. 41
Tiffany Studios, New York
Rizpah window, after 1910
Leaded glass
Emmanuel Parish of the Episcopal
Church, Cumberland, Maryland

designers that had a closer and longer-term relationship to the Studios. These designers made significant contributions to the creation of windows, executing many original designs for the firm. The most prolific of these designers included Jacob Adolphus Holzer (1858–1938), Lauber, Agnes Northrop (1857–1953), Edward Peck Sperry (1850/51–1925), and Wilson (Catalogs 46, 47).[7]

As Jennifer Perry Thalheimer also notes in this volume, artistic credit was regularly given to these designers, their names appearing in both Tiffany Studios advertisements, company brochures, and newspaper accounts that announced newly installed windows. Tiffany's involvement and presence in the process was emphasized in company publications, which stated that work was done "under the personal direction of Louis C. Tiffany" (Catalog 41).[8] These artists often moved in the same social circles, belonged to the same professional art organizations, and exhibited together at places such as the Architectural League of New York. While they worked frequently for Tiffany, many of the artists also worked on an itinerant basis, a common practice in the field of stained-glass design, completing designs for competing firms such as the Gorham Manufacturing Company, Lamb Studios, and the Church Glass and Decorating Company.

Tiffany Studios' process for designing windows throughout the 1880s and into the 1890s also depended on the use of imagery and composition from popular paintings and print sources. Tiffany Studios executed windows after works by Italian Renaissance masters such as Sandro Botticelli (ca. 1445–1510), Jean Clouet (1480–1541), Leonardo da Vinci (1452–1519), and Raphael

(1483–1520). Window designs after nineteenth-century painters were especially popular, and the company looked to the work of William-Adolphe Bouguereau (1825–1905), Pascal-Adolphe-Jean Dagnan-Bouveret (1852–1929), Paul Gustave Doré (1832–1883), Heinrich Hoffman (1885–1957), William Holman Hunt (1827–1910), Jean-François Millet (1814–1875), Bernard Plockhorst (1825–1907), Frederick J. Shields (1833–1911), and George Frederic Watts (1817–1904). For example, a window on the theme of Rizpah from 2 Samuel 21 in the transept of Emmanuel Parish of the Episcopal Church in Cumberland, Maryland (Figure 41), finds its source in a print on the same theme by Doré. Similarly, a mosaic on the theme of the Last Supper commissioned by First Unitarian Church in Baltimore, Maryland, and the sample head of St. Andrew made to market it, drew from Leonardo da Vinci's famed masterpiece (Figure 42, Catalog 48).

As Elizabeth De Rosa discusses in this volume, the subject matter and images found in many of these paintings pervaded late nineteenth- and early twentieth-century consciousness and resonated with patrons who contributed money to their congregations for the execution of the windows. Great importance was placed at the time on the use of reproductions of masterpieces, which were being actively collected by museums, universities, and artists, including by Louis C. Tiffany as outlined by Thalheimer in this volume.[9] The increased use of photography made images of European paintings readily available to both designers and the general public. Illustrated books like Henry Turner Bailey's *The Great Painters' Gospel: Pictures Representing Scenes and Incidents in the Life of Christ*

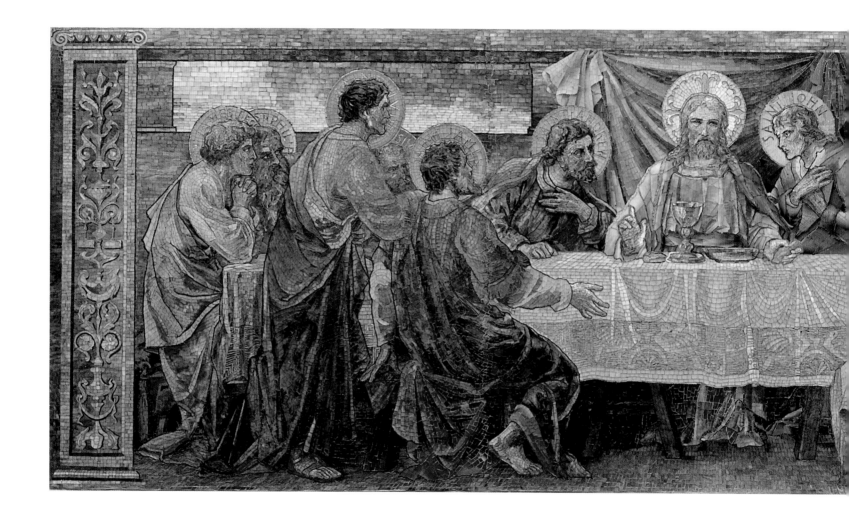

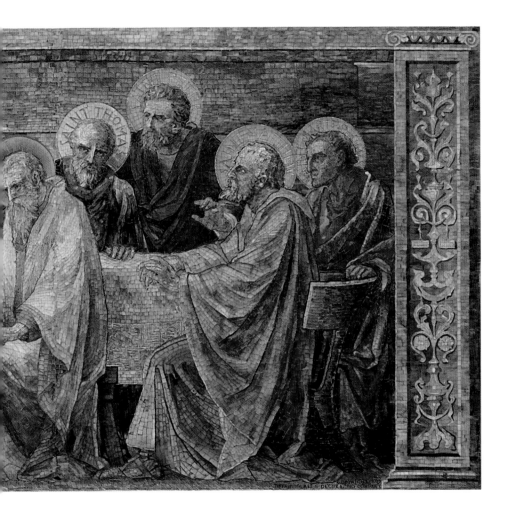

Fig. 42
Tiffany Glass and Decorating Company,
New York
Frederick Wilson, designer
The Last Supper, installed 1897
Favrile, opalescent glass mosaic
9 × 18 feet
The First Unitarian Church of Baltimore,
Maryland, Gift of the Eaton Family

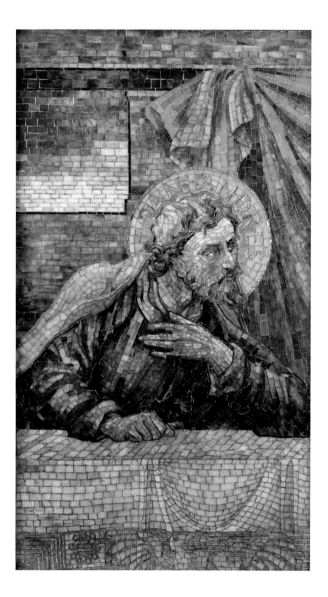

Cat. 48
Tiffany Glass and Decorating
Company, New York
Head of St. Andrew, detail for a *Last
Supper* composition, ca. 1897

company for close to thirty years. While other designers made significant contributions to the firm's ecclesiastic window designs, Wilson's work comprised a substantial proportion of the designs executed in both opalescent glass and mosaic. His considerable talent and stylistic approach as a designer, draftsman, and painter resulted in the more consistent look and feel of Tiffany Studios' windows. Wilson's compositions were still being produced long after his departure from the studio.

Wilson was one of many immigrant stained-glass designers and makers who came to the United States to work for Tiffany.[11] He was born in Dublin to artistic parents of English origin and raised in Liverpool and London. His father, Charles Wilson, worked as a decorative artist, painter, sculptor, and teacher and his mother, Elizabeth, is recorded in census records as a stained-glass designer.[12] While his earliest art training was probably introduced at home, he received a formal education at the South Kensington School.[13] He worked as a stained-glass designer and muralist in and around London from the mid-to-late 1870s through the early 1890s, producing designs for the renowned English firm Heaton Butler and Bayne in addition to having a small venture of his own, Wilson and Whitehouse.[14] Wilson married in December 1891 and by early 1892 had relocated to the United States where he worked briefly for Godwin Studios of Philadelphia.[15] His success in the field of stained glass in America was immediate. In 1893 his work was exhibited by Tiffany, then the most prestigious stained-glass maker in the country, at the World's Columbian Exposition in Chicago. In addition, a dozen of his designs were loaned by Tiffany in 1893

published in 1900 and F. W. Farrar's *The Life of Christ as Represented in Art* published in 1894 brought religious imagery into many American homes.[10] But while the use of these design sources made for compelling results and visual familiarity for the viewers, it left Tiffany Studios without an overall cohesive aesthetic for its ecclesiastic windows. Initially, emphasis was not placed on original design for the windows; rather, as Lindsy R. Parrott discusses in this volume, it was on how to translate painterly images into glass.

Tiffany Studios' hiring of British designer Frederick Wilson marked a major turning point in the design and production of the firm's religious windows. An experienced stained-glass designer and cartoonist by the time he arrived in the United States in 1892, Wilson was working for Tiffany by 1893 and remained with the

to the Ninth Annual Exhibition of the Architectural League of New York.[16]

Early sketches and copy-work show Wilson's keen interest in mastering medieval and Gothic-style ornament found in churches throughout England and Europe. He was also strongly influenced by the Pre-Raphaelite and Old Master painters, and his style not only reflects his interest in the detail and depiction of facial characteristics embodied by the Pre-Raphaelites but also illustrates his knowledge of Renaissance decorative arts and costume. He collected, among other print sources, reproductions of works by fifteenth- and sixteenth-century Venetian, Italian, Flemish, and German artists.[17] He drew on a variety of ornament and architecture books by nineteenth-century figures who championed church decoration such as James Kellaway Colling (1816–1905), Eugène Viollet-le-Duc (1814–1879), Augustus Welby Northmore Pugin (1812–1852), and John Burley Waring (1820–1877). By the late 1890s he was poised to step into a senior role at Tiffany Studios, becoming the head of the Ecclesiastical Department by 1899. When his promotion was announced in the *Christian Intelligencer* and *New York Observer and Chronicle*, the reports (probably quoting from a Tiffany Studios' press release) declared that:

> We require some sign of a fresh and vital inspiration in the worker [head of the department], such as none who depends on encyclopedias and dictionaries for his knowledge of the ecclesiastical art. Now, as in the past, there must be at the head of all such undertakings, a man capable of initiating work freely within the bounds set by Christian feeling and tradition, and, too, an army of accomplished artists and workmen, accustomed to follow his guidance. It was under such conditions that the great cathedrals of the old world were built and decorated, and it is under these same conditions that we can hope to equal or surpass them. Mr. Frederick Wilson, the artist who has just been placed at the head of the firm's Church Department, is long practiced in ecclesiastical art. His learning and his preferences are not confined to a single period in the evolution of Christian art, which did not begin and end in the middle ages.[18]

Wilson possessed a deep knowledge and understanding of religious figures, stories, and iconography, illustrated by historical references seen in his designs and found in notes made on preparatory drawings for windows (Catalog 49). His religious designs often required the depiction of large figural groups, and his ability to handle dozens of figures across both the wide flat plane and the vertical height that tall church ceilings required served him well in his ecclesiastic work. Wilson's ability to work with multi-figure windows was noted by patrons who marveled at the scale of his compositions, "When it is considered that cherubim, seraphim, angels, apostles, martyrs, prophets, saints and warriors, to the number of over one hundred, appear in it, a suggestive idea of its scope may be gained."[19] Wilson's figural work for

Tiffany in the early 1890s exhibits the traits of his early English influence and experience, and his drawings show expressiveness and a dynamic sense of movement within his complex compositions. A scrapbook Wilson kept with clippings from magazines and newspapers contains many examples of works he studied to understand the human body and motion. His figures were drawn with great consideration given to obtaining correct perspective and scale, which translated well into cartoons and, eventually, glass (Catalog 50).[20]

Opalescent-style windows made by Tiffany Studios relied primarily on the color and texture in glass and the use of plating (layering) of glass to depict images and scenery rather than the painting techniques used by medieval and English nineteenth-century makers. Tiffany did, however, employ vitreous enamels for the faces, hands, and feet of figures. As with other designers, Wilson's designs are identified in part by these painted faces, illustrating his facility in figural work (Catalogs 51, 55). Faces from his sketches, watercolors, and finished windows have strong features with full, bow-shaped lips, brilliant blue eyes, and pronounced chins and noses. Hair is often blond or red with bountiful curls. These faces are particularly well executed on many of his angels, which are often depicted as androgynous creatures that are full-bodied, vigorous, and muscular with feminine-looking clothing and shoulder-length hair. In a letter to his daughter, Wilson once noted with regard to his angelic figures, "[Y]ou are quite right as to the 'ruggedness & strength.' In my limited way those qualities are what I have, mostly, been gunning for…"[21] (Catalogs 52, 53, 54).

Identifying windows designed by Wilson simply by the painted faces is problematic, however. The sheer volume of windows being made by Tiffany Studios required the use of assistants who painted faces on windows designed by Wilson. He also worked with assistants to complete other sections of the window such as borders and background. *The Art Interchange* describes how, in 1894, Agnes Northrop assisted with the floral background of Wilson's windows.[22] In 1899 Wilson worked with at least four other known assistants: William Sterzbach, William Balfour, Max Wieczorek, and Robert L. Dodge.[23] Collaboration on the design of windows seems to have been somewhat common, although it is difficult to ascertain the exact nature of these relationships. One presumes a window's attribution was largely based on seniority, as often the best-known and most senior artist generally affixed a signature to the work. Examples do exist, however, of works signed by two contributors, using the Latin *del et inv* (*delineavit et invenit*, "drew and designed it"), including one known work signed by both Wilson and Lauber.[24]

As the artistic director, Tiffany oversaw the design process and supported the process of copyrighting work done by both the firm and by individual designers. Company brochures often declared, "[O]ur designs are protected by copyright… you are respectfully cautioned against imitations of our work."[25] Wilson, as the primary ecclesiastical designer for nearly three decades, copyrighted many of his designs, both in conjunction with Tiffany Studios and individually. The United States Copyright Office holds over 500 copyrights registered to

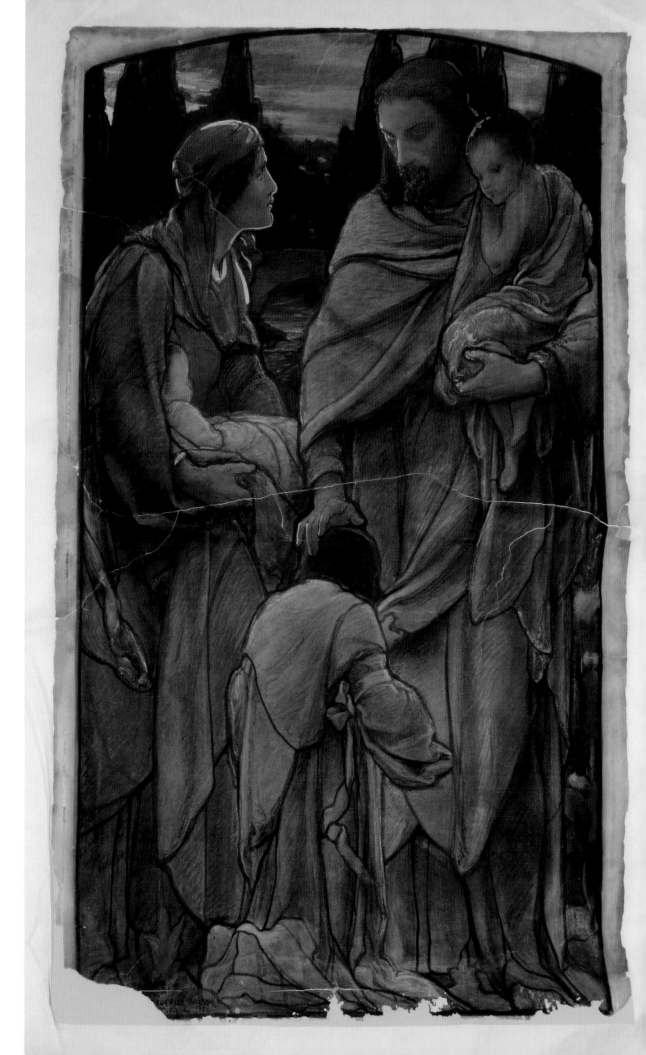

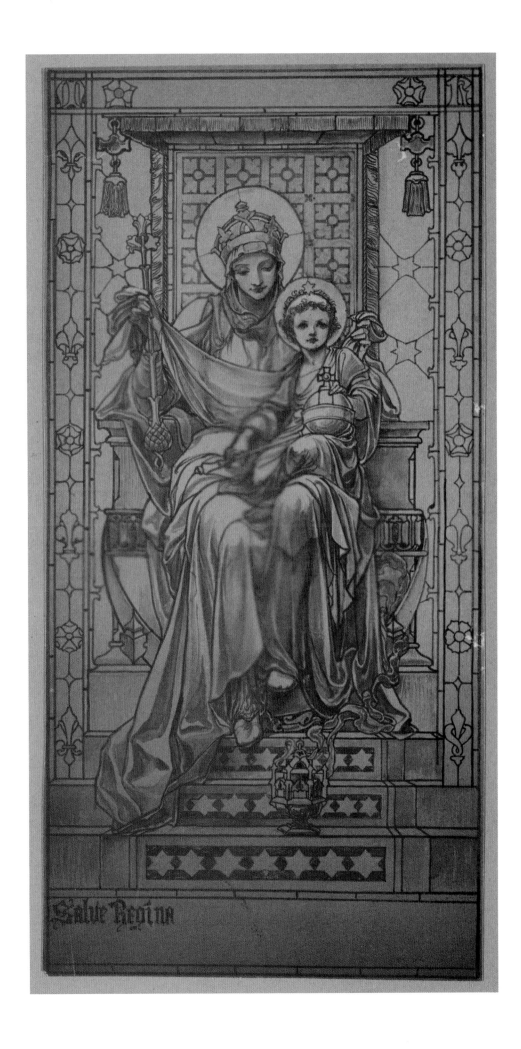

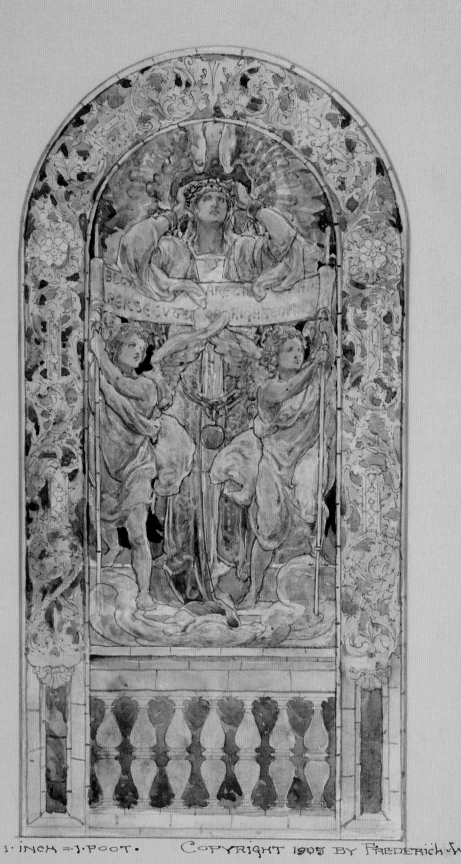

· SCALE · 1 · INCH = · 1 · FOOT · COPYRIGHT 1905 BY FREDERICK · WILSON

· ARLINGTON ST · CHURCH ·

SOUTH SIDE ·

Cat. 52
Tiffany Studios, New York
Frederick Wilson, designer
Suggested design for *Blessed are the Persecuted* window (not executed), copyrighted 1905

Cat. 53
Tiffany Studios, New York
Frederick Wilson, designer
Design for *Beatitude* window for Arlington Street Church, Boston, Massachusetts, 1905

Cat. 54
Tiffany Studios, New York
Frederick Wilson, designer
Suggested design for *Blessed are the Merciful* window, copyrighted 1905

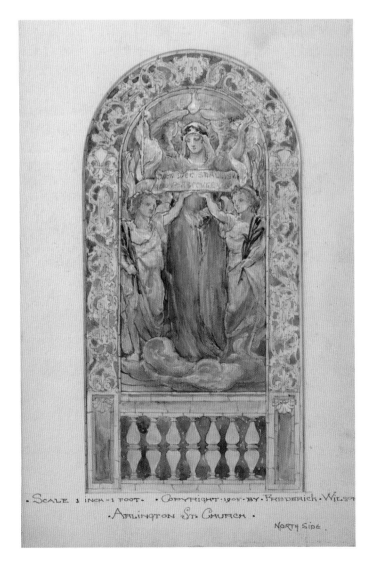

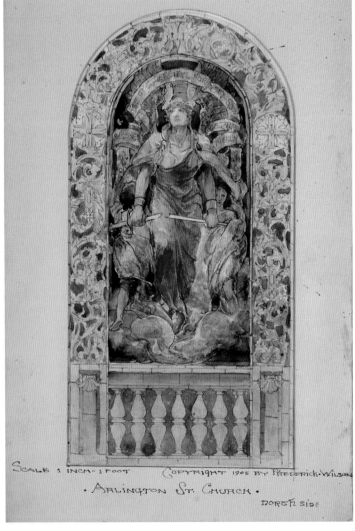

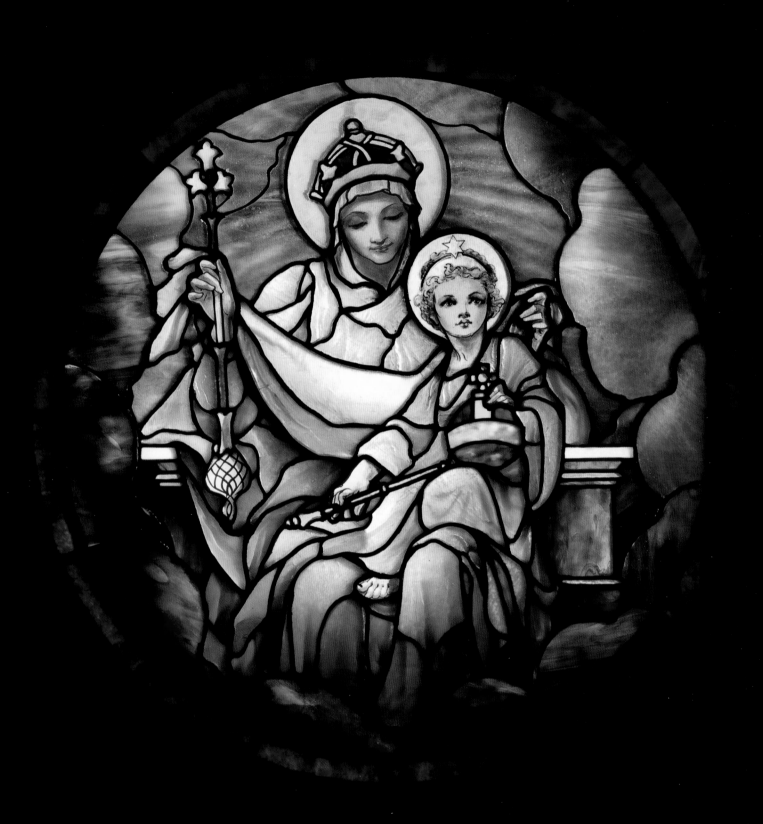

Cat. 55
Tiffany Studios, New York
Frederick Wilson, designer
Salve Regina window for chapel
at Stony Wold Sanatorium, Lake
Kushaqua, New York, after 1910

Cat. 56
Tiffany Glass and Decorating
Company, New York
Mary E. McDowell, designer
Copyright design for *The
Valiant Woman*, 1898

Cat. 57
Tiffany Glass and Decorating
Company, New York
Mary E. McDowell, designer
Copyright design for *The Valiant
Woman*, 1898

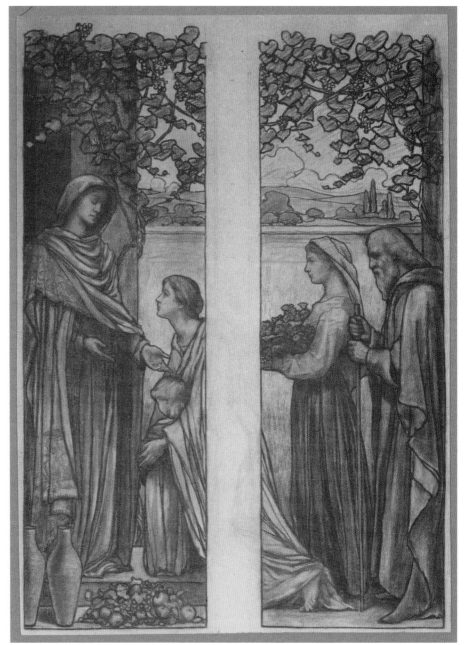

Fig. 43
Tiffany Studios, New York
Fredrick Wilson, designer
Te Deum Laudamus window,
installed 1906
Leaded glass
First Presbyterian Church,
Syracuse, New York

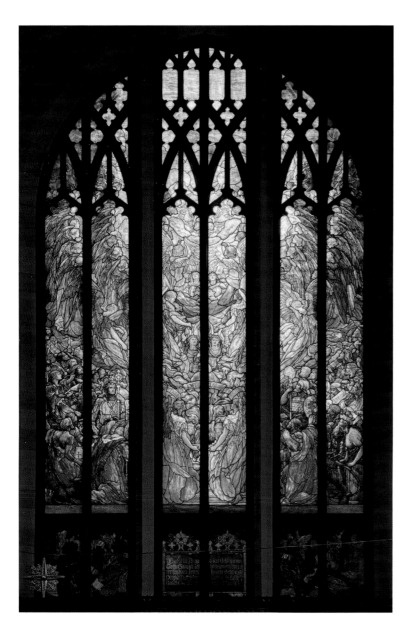

Tiffany Studios (and variations on the company name) and Wilson. While over thirty percent of these copyrights list Wilson's name, either alone or under the firm name, designers including Sperry, Lauber, Holzer, Northrop, and Mary McDowell (b. 1865) are also listed on copyright records filed under the company name (Catalogs 56, 57).[26]

Wilson's work was regularly mentioned and given critical acclaim in the press during his lifetime. Personal letters of appreciation and praise were written by ecclesiastical leaders and other patrons after the installation of windows, expressing admiration for the skill and sensitivity with which Wilson interpreted the sacred material. The *New York Observer and Chronicle* commented that "the artist has shown a deep and thoughtful conception of the theme," and that his work showed "the most exacting canons of ecclesiastical art."[27] The Reverend George B. Spalding from the First Presbyterian Church, Syracuse, New York, gave a sermon in 1906 to celebrate the arrival of the *Te Deum Laudamus* window (Figure 43), which gives insight into Wilson's personal dedication and desire to bring more than just artistic ability to the windows he was designing. Spalding proclaimed to his congregation,

> Many times did the great artist to whom was committed the task stay with his work, and writing me, or riding with me told me of the large difficulties that met him in the executing [of] its conception, and implored me to pray for him for a fresh inspiration. Letters which I hold as most precious reveal the inner history of this great window. It was begun in prayer. It

went on in prayer. It was finished in prayer. Its success is answered in prayer.

This church publication describing the window and containing the sermon concludes by stating, "Words fail to adequately describe the artist's conception and the wonderful rendering of one of the most impressive of all scriptural themes, with the sentiment and atmosphere of worship which has been injected into it."[28]

Tiffany's own acknowledgment of Wilson's capability as a designer is apparent in the public display of his work. In 1907 Tiffany organized a solo exhibition of Wilson's designs. His cartoons and paintings were recognized as having been made into many "famous memorial windows" and the show proved so popular that it was extended for an additional week.[29] In 1922 Tiffany held another public exhibition, this time presenting the work of the Advisory Art Committee for the Louis Comfort Tiffany Foundation to be shown at the Tiffany Foundation Gallery in New York. Wilson's work was highlighted alongside that of Daniel Chester French (1850–1931), Cass Gilbert (1859–1934), Blashfield, Paul Manship (1885–1966), Gifford Beal (1879–1956), and Childe Hassam (1859–1935) among others.[30] When the exhibition was reviewed by *Arts and Decoration* three works were illustrated: a statue by French, a mural by Blashfield, and a study for a secular window by Wilson.[31] His participation in this exhibition was among his last major efforts for Tiffany. Sometime around 1923 Wilson moved his family to California, where he worked for the Los Angeles-based firm, Judson Studios, as a stained-glass designer.[32]

Wilson's work and that of other designers included a wide range of Old and New Testament themes. Many of these were used repeatedly, although even if the design of the compositions was repeated faithfully, there could be variations in the glass selection, resulting in a very different window. The company suggested to its clients that a church with a limited budget could order from a list of stock windows while a congregation with more funds could request a more original composition.[33] Frequently used themes for windows included Christ Blessing the Children, the Good Shepherd, singular Old and New Testament prophets and saints, the Ascension, the Annunciation, the angel of Resurrection, the boy Christ in the Temple, and many variations on angels either attending people on Earth or seen in heavenly surroundings.[34] Some compositions such as the Sower, Christ Blessing the Children, and the Te Deum were rendered in both opalescent glass and mosaic (Catalog 58). Wilson's design for Christ Blessing the Children was rendered in so many variations it becomes difficult to say at what point the design moved away from his original intent.

Tiffany Studios' repeated use of designs was a means to cut costs, and some single-figure compositions were changed with only a slight variation and repurposed as a new prophet or saint (Catalogs 5, 59). A more complicated design could also have elements added or deleted but keep the same basic framework, as is the case of Wilson's design for the window *The Righteous Shall Receive a Crown of Glory*, the Brainard Memorial Window (Catalog 44). A design drawing published in the firm's brochure *Memorial Windows* illustrates the dual use of

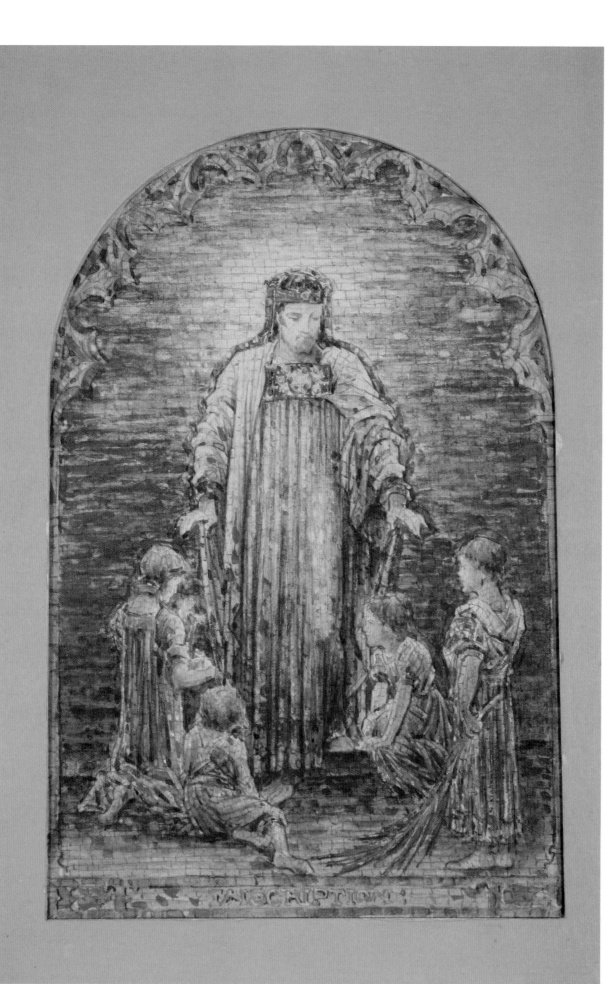

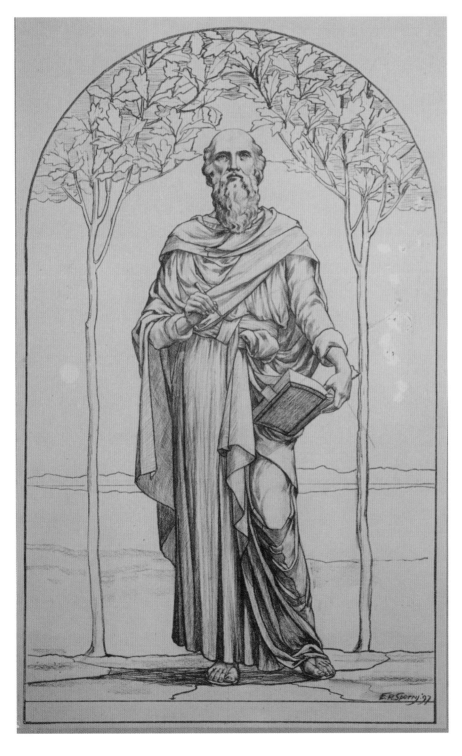

Fig. 44
Tiffany Glass and Decorating
Company, New York
Design for *They Shall Be Mine*, 1896
Courtesy of Lillian Nassau LLC,
New York

this window. Two scriptural references are cited on the
design, one from Malachi 3:17, "They shall be mine, saith
the Lord of Hosts, in that day when I make up my jewels"
and the other from Peter 5:4, "Ye shall receive a crown
of glory that fadeth not away" (Figure 44). A window
referencing the Malachi verse was executed for the
First Church in Cambridge, Massachusetts, depicting a
group of angels around a central banner containing the
Old Testament scripture. The window executed for the
Methodist Church in Waterville, New York, is essentially
the same design, but in the case of the Waterville window,
a large central cross replaces the scriptural banner and the
memorial plaque references the New Testament scripture
in Peter with the text, "The Righteous Shall Receive a
Crown of Glory."[35]

Wilson's design, the *Te Deum Laudamus*, or
Hymn of Praise, is the basis for a number of multi-figure
designs executed both in opalescent glass and mosaic,
including the previously mentioned 1906 window for
the First Presbyterian Church, Syracuse, New York. In
each *Te Deum*, Wilson depicts a multitude of figures
surrounding or making their way towards Christ. The
variations on this theme show the adeptness with which
Wilson adjusted a design for different denominations and
architectural settings. In 1896 a *Te Deum* that also includes
church leaders from across the centuries and has five
primary lights was executed for Christ Church, Rochester,
New York, and was placed in the transept. The Syracuse
window, installed in the chancel (which is nearly identical
to a watercolor created for a church in Germantown,
Pennsylvania, that was never executed) is comprised of
six primary lights (Catalog 60). In the case of the Syracuse

Cat. 60
Tiffany Studios, New York
Frederick Wilson, designer
Te Deum, suggestion for Harrison
Memorial Window, Germantown,
Pennsylvania (not executed)

Fig. 45
Tiffany Studios, New York
Frederick Wilson, designer
Te Deum Laudamus mosaic, 1923
17 × 8 feet
Lake Merritt United Methodist
Church, Oakland, California

window the Christ figure is envisioned but not depicted. In 1923 a *Te Deum* was produced for the First United Methodist Church, Los Angeles, in three panels of mosaic (Figure 45).[36] In the mosaic version the choir is depicted against an architectural and landscape background. While each version of the *Te Deum* has a distinct identity, the overall compositions bear resemblance to each other and the hand of Wilson is evident.

Tiffany's production of religious stained glass began with design input by a large number of artists who brought tremendous variety to the finished windows. Greater consistency was achieved through the use of a core group of designers and by Wilson's presence as the main ecclesiastic designer. Wilson's style has become apparent through the study of his many executed designs, and defining his work is vital to understanding the bulk of Tiffany Studios' output after 1893. Many designers' works remain unattributed, however. The attribution of work to designers whose contributions help define the Tiffany Studios' religious window aesthetic could yield further insights into Tiffany Studios' design methods.

Agnes Northrop: Tiffany Studios' Designer of Floral and Landscape Windows

ALICE COONEY FRELINGHUYSEN

Fig. 35 (detail)

Fig. 46
Unknown photographer
Agnes Northrop (1857–1953)
The Metropolitan Museum
of Art, New York,
Gift of Paul Nassau

Illusionistic autumn landscapes, light filtered through spring flowering branches, babbling brooks, verdant garden views, and lush cypress trees translated into glass are among the most glorious Tiffany windows known. Many, if not most of these may be attributed to Agnes Northrop, the foremost female artist at Tiffany Studios. Northrop worked as a designer of windows on a par with her male counterparts, and attained a preeminence—and international recognition—in the field that few women of her era achieved. Moreover, her facility with flowers and landscape scenes resonated with Tiffany's own passion for nature, and, as a result, she played an integral part in the groundbreaking development of this subject for use in memorial windows. Despite the primacy of her role, however, Northrop's life and work have remained in relative obscurity.[1]

Northrop fit the profile of women employed by Tiffany. She was artistically talented, Protestant, middle class, and unmarried. Due to her unique talents, Northrop enjoyed a higher status than the other women employed by Tiffany at the Studios and an unprecedentedly long career, beginning as a young woman in 1884 until Tiffany's death in 1933 and beyond. Although her designs were seldom authored or attributed during her lifetime, new research and a previously unknown and unpublished memoir, "My Story," written late in her life, shed fresh light on her considerable career at the Tiffany Studios.[2] Northrop's memoirs also significantly amplify our knowledge of women's roles in Tiffany's studios during the crucial early years of the 1880s and 1890s. Her role is further distinguished in that she was involved primarily in

the design of windows, rather than any aspect of their fabrication, even though, from time to time, she was asked to assist others in the design of lampshades and other objects.[3] During her career Northrop became an indispensable part of Tiffany Studios' ecclesiastic output.

Agnes Fairchild Northrop (1857–1953; Figure 46) was born to Emily Fairchild and Allen P. Northrop in Flushing, New York, where she lived nearly her entire, very long, life. Her maternal grandfather, Ezra Fairchild, was a well-known educator and established the Fairchild Institute (also known as the Flushing Institute) in Flushing in 1841.[4] Her father taught there, and it was there that he met Agnes's mother and married her. It is interesting to speculate that Louis Tiffany may have attended the Institute as a young adolescent; he acknowledged that his early schooling had been in Flushing, although he did not identify the school.[5] Although the Institute was a noted private boarding school for boys, it also gave Agnes her formal education (daughters of faculty members were allowed to matriculate), and she continued to reside at the Institute in her adult life, even after the deaths of her parents.[6] While the Fairchild Institute accounts for Northrop's academic schooling, the source of her artistic training remains unknown. Nonetheless, the arts seem to have been a part of her life. Both her older brothers were musicians, and she clearly considered herself to be an artist, with a special aptitude for "painting flowers," a skill that presaged her later career.[7]

Northrop's early aptitude for art may have led her, like other women who were eventually employed by Tiffany Studios, to study at one of a number of art training schools operating in the New York City vicinity during the late nineteenth century. Prior to her work with Tiffany Studios, she briefly held a job that she described as "painting the outside covers of books," for the publisher Randolph & Company, located on Twenty-third Street.[8] The field of artist-designed book covers was an emerging trade for women as publishers began to commission designers for their decorative dye-stamped cloth covers, rather than assigning that task to die-makers and engravers. There was an affinity between this field that emerged in the early 1880s and stained-glass design, and both were practiced by several women, notably Alice C. Morse, who worked briefly for Tiffany in the mid-1880s before embarking on an extensive career designing trade bindings for a number of different publishers.[9]

As confirmed in her memoirs, Northrop began her career with Tiffany by 1884 at the age of twenty-seven. She recalled that a friend who had been staying at the Flushing Institute asked her if she would like to go to Mr. Tiffany's stained-glass business "to do designs for Windows."[10] Her friend Mrs. Noyes introduced her to Miss Anne Van Derlip, who, according to Northrop, was the only woman designer at Tiffany's at that time. Northrop's memoirs give personal insight into these early years:

> Quietly, I think that she [Van Derlip] hated to take me, (she was doing a large window at the time) but she was very "gracious", and when Mrs. Noyes left me, Miss Vanderlip [sic] set me at work looking over some Renaissance Plates. Needless to say I was somewhat "scared" but I

kept my feelings to myself. After a while she gave
me some paper & paints and told me to copy a
small window, I accomplished it after a fashion.
Then followed other designs, original, not copies.
Mr. Pringle Mitchell was Manager, when he
approved of my staying and trying it out—I
went from there [to] designing and coloring.
That was in 1884. In the mean time Miss
Vanderlip [sic] and I became fast friends, and
with her help and Mr. Tiffany's daily criticisms
I managed to make a place for myself in flowers
and landscape (I did not do Figure).[11]

With the go-ahead from Mitchell, manager of the firm
at that time, Northrop embarked on her promising career.
The Studios themselves may have provided some of her
artistic training, and Northrop recalled that Anne Van
Derlip took her under her wing in the very beginning.
Van Derlip was one of a small number of women who
worked on windows during the 1880s and 1890s.[12] As
noted by Northrop, other women entered the firm, namely
Rebecca Mitchell (Pringle Mitchell's sister) and Grace
de Luze, said to be one of the first women to work in the
glass-cutting department.[13] They were joined by Lydia
Emmet, Elizabeth Comyns, Louise Howland Cox, Grace
Green, Louisa Sturtevant, and Dora Wheeler but, with the
exception of Northrop, the tenure of most was relatively
short-lived, and did not date much past the mid-1890s.
By the time several others joined the firm, Northrop
described her work environment as becoming "more
like an Art Studio, than a business… "[14] In the true
sense of a studio, there was a constant flow of work

from the designers to those who executed the designs,
all under the supervision of Louis Tiffany. Most of the
designers were men, and unlike the women, they had
comparatively long careers at the Studios. In addition
to Tiffany himself, they included, over a period of time,
Frederick Wilson, Joseph Lauber, Jacob Holzer, and
Edward P. Sperry.[15] Sperry, like Northrop, was from
Flushing, and exhibited alongside Northrop at the
Flushing Art Club in 1897.[16] Northrop outlasted them all,
remaining at Tiffany Studios until it closed.

Northrop took a brief leadership role in the Studios
when, in 1888, Van Derlip married John Weston, left the
firm and moved to Michigan (Tiffany did not employ
married women).[17] Tiffany then installed Northrop as
head of the Women's Department, supervising nine
women, who would become known as the "Tiffany girls."
Northrop, however, was unhappy in that management
role, and, after a few years, expressed relief when Clara
Wolcott (later Driscoll) from Cleveland joined the firm.
As Northrop recalled, "[I] gladly resigned my position in
her favor."[18] This period had proved especially trying for
Northrop due not only to her discomfort in managing
others, but also because she missed Tiffany's daily
critique of her work, on which she relied heavily. (In
early 1888 Tiffany had gone on an extended wedding trip
to the West Coast following his marriage to his second
wife, Ruth Wakeman Knox.) In Tiffany's absence, the
design aspects of the firm were put temporarily under
the direction of John Du Fais.[19] Whether Northrop was
suffering some sort of depression or not is unknown, but
the situation was such that she was given a sabbatical
over the summer months, "to make studies of plants

166

Fig. 47
Agnes Northrop, designer
Sketch for a rose window
Published in Maud Howe Elliot, *Art and Handicraft in the Woman's Building of the World's Columbian Exposition* (Chicago, 1893), p. 56

and flowers in Father's garden at the Institute." As she gratefully recalled, "[T]he garden was full of beautiful color, and I could be among the flowers."[20]

The summer of 1888 proved to be a turning point in Northrop's career. When she returned to the Studios the following winter, it was "as a more Independent artist," with her own room, as opposed to being in the large room with the other "Tiffany girls" who worked in the cutting department under Driscoll's eye. Northrop's job was to design "whatever was given to me, according to the wishes of the clients."[21] These designs varied from generic floral subjects and landscapes, themes honed through her many flower studies, to highly specific designs for some of Tiffany Studios' most exacting clients.

During those early years Northrop probably designed a wide variety of different windows. The first published record of her exhibiting any of her sketches, however, did not occur until 1893, when she is credited with exhibiting "a cartoon for a window of an art museum, designed by L. C. Tiffany, drawn by A. F. Northrop," at the Architectural League in New York.[22] That reference also sets the stage for a design collaboration with Tiffany that would last nearly five decades. The year 1893 was an important one for Tiffany (and for Northrop), marking as it did the World's Columbian Exposition in Chicago. The fair was significant as well for its inclusion of the Woman's Building, akin to a museum within the fair that was intended to draw attention to the artistic achievements of women, to promote their art, and to address the issue of lack of credit for their work. The building included a substantial presentation of applied arts by American

SKETCH FOR WINDOW. A. F. NORTHROP. UNITED STATES.

women—including decorative painting, wood carving, pottery, jewelry, book design, stained glass, and several categories of textiles. Women artists working at the Tiffany Glass and Decorating Company may have had a bit of an edge, for Candace Wheeler, who had been a partner with Tiffany briefly in the early 1880s, was the talent behind the Woman's Building, and undoubtedly asked certain of them for submissions.[23] Among the stained-glass entries was a design for a decorative rose window by Northrop (Figure 47).

Northrop's affinity for floral subjects commenced with her earliest work as an artist in the 1880s, and by

AGNES NORTHROP: TIFFANY STUDIOS' DESIGNER
OF FLORAL AND LANDSCAPE WINDOWS

Cat. 61
Tiffany Studios, New York
*I am the Resurrection and the
Life*, 1902

Fig. 48
Tiffany Glass and Decorating
Company, New York
Agnes Northrop, designer
Design for a window
Published in Polly King, "Women
Workers in Glass at the Tiffany
Studios" (*The Art Interchange*,
October 1894), p. 87

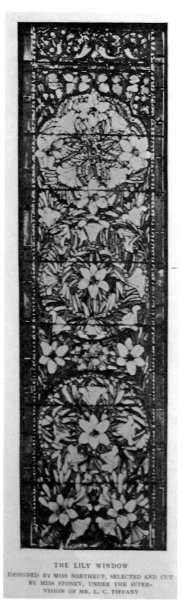

THE LILY WINDOW
DESIGNED BY MISS NORTHRUP, SELECTED AND CUT
BY MISS STONEY, UNDER THE SUPER-
VISION OF MR. L. C. TIFFANY

1894, Polly King, a writer for *The Art Interchange* in the
1890s, observed Agnes's "natural talent for flowers and
all conventional designs," and commented that "she
has wisely made these her specialties."[24] Her design
of a variation on the lily, here of conventionalized
Annunciation lilies superimposed upon a composition
loosely derived from thirteenth-century medallion
windows (Figure 48), was highlighted in the 1894 article.

Northrop's predilection for flowers and plants
was nurtured by her Flushing roots. Not only did the
Flushing Institute boast sizeable gardens, well tended
by her father, but Flushing was also the nursery capital
of the New York City area. Northrop lived near several
large nurseries, giving her ample opportunity to carefully
observe lilies and other flowers and flowering trees and
shrubs. Northrop designed purely floral windows, while
also providing the designs for foliate ornament intended
to surround figural compositions designed by others.

King, in her 1894 article, acknowledged that
Northrop was called upon to add "details and flowers
to many important decorations [or windows]."[25] One
highlighted example was the Jay Gould Memorial
Window at Roxbury, New York, dating to about
1893, where Northrop made the designs for the "floral
background for Frederick Wilson's figural design."[26] This
collaboration epitomized much of the Tiffany Studios'
output: as Diane Wright discusses in this volume, Wilson
was Tiffany's principal designer for figural windows;
Northrop, for flowers, foliage, and later, landscape.
(Northrop was, in fact, adamant that she did not draw
figures, emphatically stressing that more than once in
her memoirs.)[27] The Gould window featured palmetto

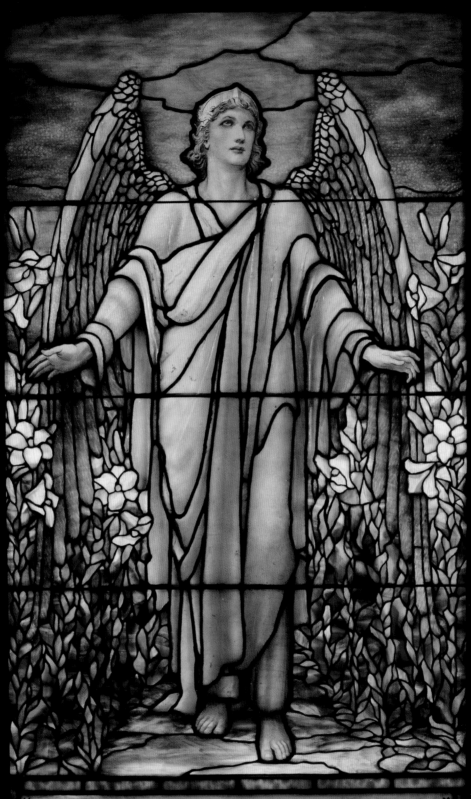

"I AM THE RESURRECTION AND THE LIFE."

Fig. 49
Tiffany Glass and Decorating
Company, New York
Louis C. Tiffany, figural design;
Agnes Northrop, border design
Four Seasons, ca. 1897
Watercolor, gouache, graphite,
and red earth chalk pencil on
white wove paper
29 5/16 × 18 9/16 inches
Purchase, Walter Hoving and Julia T.
Weld Gifts and Dodge Fund, 1967
The Metropolitan Museum of Art,
New York (67.654.317)

leaves and white lilies, the distinctive style of the latter suggesting that Northrop may have designed the lilies surrounding the central figure in a *Resurrection* window dating to 1902 (Catalog 61).

The only design drawing known to date that is signed by two artists—Louis C. Tiffany and Agnes Northrop—is for an allegorical Four Seasons window.[28] As can be seen in the drawing in the Metropolitan Museum's collection (Figure 49), the figural panels were originally surrounded by an elaborate floral border, composed of twelve individual panels (their number perhaps a reference to the months of the year), each one depicting a different flower. The figural portion of the original watercolor was signed by Louis C. Tiffany, while the floral border bears Northrop's signature. The floral border reveals a new dimension to Northrop's style, away from the decorative, hard-edged, conventionalized flowers in favor of a delicate, more naturalistic rendering, and provides a virtual vocabulary of some of Northrop's (and Tiffany's) favored motifs, with depictions of the flowering vines of climbing white clematis, purple wisteria, orange trumpet vine, and purple clematis, as well as dogwood, cherry blossoms, peonies, poppies, water lilies, lotus, and Japanese iris.

Northrop's most exceptional purely floral design, however, was a *Magnolia* window, for which she earned international acclaim for the first time (Figure 50). She submitted it as part of Tiffany Studios' exhibit at the Paris Exposition Universelle of 1900, and it was described as being "superb… nothing approaching it shown by glassworkers anywhere."[29] It depicts a lush rendering of magnolia blossoms in full flower, and reveals a rare understanding of the nature of the flower itself, evidence of Northrop's careful observation of nature. Indeed, magnolias were the subject of a photograph of hers (Figure 51), as well as a particularly beautiful watercolor study.[30] The framed Diploma of Merit she received at the Paris fair, "for her excellence of design of windows designed by her and exhibited by Tiffany Studios,"[31] became a treasured talisman of her career, and she hung it in her apartment for the rest of her life.[32]

In addition to her watercolor nature studies, the number of Northrop's surviving photographs is testament not only to her interest in nature, but also to her early interest in photography. As Jennifer Perry Thalheimer discusses in this volume, photography played a greater role as source material for Tiffany windows than has been previously recognized. On June 15, 1898, for example, Clara Driscoll wrote that "Miss Northrop has a sixty dollar camera and has taken some beautiful photographs of dogwood, ferns, and other plants that are so fine. They are of great value to her."[33]

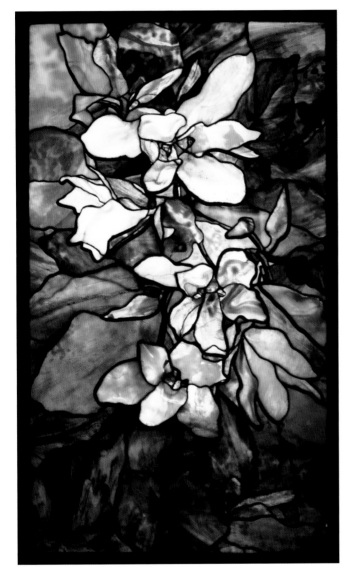

Such was Northrop's love of the camera that Tiffany was unable to curb her enthusiasm for using film when he took her on a trip to Europe in 1907. In the journal that Tiffany kept of that trip, he wrote in July that he insisted that "Dr. Mc [McIlhiney] and Mrs. D. [Driscoll] save the film and photograph only what I selected, but could do nothing with Miss N. [Northrop] who took a picture regardless of anything I said."[34]

The trip was testimony to Tiffany's regard for Northrop. Out of concern for her well-being, Tiffany had decided in January of 1907 to take a sketching tour the upcoming summer, writing that "It worries me to see Miss Northrop so miserable. What she needs is a real holiday."[35] (Northrop may have been still suffering from an illness and operation she had at the end of 1904, or perhaps she was prone to depression as her earlier sabbatical suggests).[36] "I should have to take some woman who would be a pleasant companion for Miss Northrop." After consideration of other possibilities, he invited Driscoll on the trip as a female companion for Northrop,

Fig. 52

Tiffany Studios, New York

Agnes Northrop, designer

Design for landscape window for Sarah Cochran, Linden
Hall, Dawson, Pennsylvania, 1913

Watercolor, gouache, and graphite on wove paper
mounted on original gray mat board

13 ¼ × 7 ⅞ inches

Purchase, Walter Hoving and Julia T. Weld Gifts and Dodge
Fund, 1967

The Metropolitan Museum of Art, New York (67.654.229)

paint these. Thought she would enjoy doing them and
would rest besides."[39] A few days later Tiffany "bought
a lot of flowers. Some fine dahlias, almost like chrysan-
themums—very large white daisies, phlox, baby's breath,
rose—gladiolus. Two pots of hydrangeas—A fine
show of red hot poke—and a plant that I did not know
pink flowers. Sent them all home and found Miss N.
[Northrop] arranging them when I got back."[40]

Such sketches may have served as inspiration for
the designs Northrop would make back in her own studio,
where she followed standard practices for the process
of producing a stained-glass window. As she described
it, she "always first made a small sketch on 1 inch scale—
and colored it according to the desires of those who
were giving the order—whether for a Church, house, or
Mausoleum [Figure 52, Catalogs 62, 65]."[41] (Northrop's
small renderings were executed in watercolor, a medium
well suited to conveying the subtleties of the translucency
of colored glass.) As she later wrote, she accommodated "the
size and shape of the opening, &c I worked at this with Mr.
Tiffany's daily criticism."[42] The sketch was then "cast in
the designing room into a cartoon the exact size of which
the window will be."[43] Northrop was often responsible for
these full-size cartoons that were an essential part of the
process, commenting that she always finished her full-size
drawings in color.[44]

From this point, the cartoon went to Driscoll
and her girls, who were responsible for selecting the
appropriate coloration and texture of glass, and then
cutting it into individual pieces following the template
provided by the cartoon. The drawings were essential in
furnishing for the selectors a guide to choosing colors on

deeming her to be sensible, "and Miss Northrop seems
to like her. I have always got along well with her and then
she has been at the studios a long time."[37] On July 18 of
that year, Tiffany, Northrop, Driscoll, and McIlhiney set
sail for France on the S.S. *America*, for a three-month tour
of Brittany, with the days spent touring the countryside
in a flashy French automobile, photographing, and
sketching. Tiffany described one day of sketching on
the beach: "Miss N. [Northrop] tore hers up. Mrs. D's
[Driscoll's] in pencil, no good."[38]

The trip (and Tiffany's journal of it) provides
further evidence of Northrop's particular affinity for
flowers. On July 1, for example, Tiffany bought for Agnes
"some very fine Gladiolas. Dark purple—very rich—a
peculiar salmon pink and cooler pinks—The Salmon
pink ones unusually large. Asked her to stay at home and

Cat. 63
Tiffany Glass and Decorating Company, New York
Agnes Northrop, designer
Copyright design for ornamental chancel window,
Schieren Memorial Window, 1896

the basis of the original sketch. Northrop's studio, while set apart from that of Driscoll and her designers, could be reached by walking through "labyrinthine halls to a small room with a few flower studies in color, and great sheets of manila paper tacked to the walls."[45]

Northrop was one of the few women to secure patents for some of her designs. Why Northrop, or for that manner other Tiffany designers, chose to take out a patent for some but not all of their designs is not known. The earliest of her patented designs, dating to 1896 (Catalog 63), was for an ornamental chancel memorial window, dedicated to Mary Louise Schieren, to be installed at St. Matthew's Evangelical Lutheran Church in Brooklyn, and donated by Schieren's parents.[46] As seen in the final realization of her design, dedicated at the time the church was completed in November of that year and still surviving today (Figure 53), the central panel features a jeweled cross surrounded by cherub faces, but the lower half and the side lancets illustrate one of her signature designs, the stylized vines, leaves, and blossoms of the passion flower. Consistent with the

Studios' practice as seen in the Gould Memorial Window, it is very likely that Wilson provided the designs for the cherub heads while Northrop was responsible for the floral and foliate designs. The style of the window is consistent with Northrop's known documented windows and dates to the first decade of her work in stained glass. It bears a striking affinity to an unidentified, undated window in the Neustadt Collection of Tiffany Glass (Catalog 33). Although the church from which this window came is not known, it features a cross in creamy opalescent glass virtually completely obscured by the foliage and blossoms of passion flowers, with a clump of white lilies in the left foreground.

The development of Northrop's decorative floral style is seen in windows she designed for the Reformed Church in Flushing (now the Bowne Street Community Church), her family church, where her uncle Rev. Elijah S. Fairchild became pastor in 1865.[47] In 1892 a new building was erected at the corner of Bowne Avenue and Amity Street, and it became one of the largest in Flushing. Family members, including

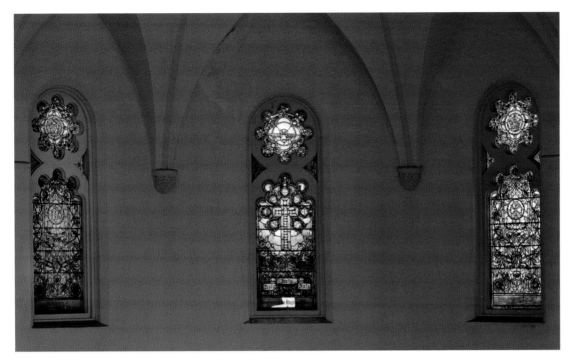

Fig. 53
Tiffany Glass and Decorating
Company, New York
Agnes Northrop, designer
Ornamental chancel window,
Memorial to Mary Louise Schieren,
1896
Leaded glass
New York City Church of Christ,
Brooklyn, New York (formerly St.
Matthew's Evangelical Lutheran
Church, Brooklyn, New York)

Northrop, worshiped there, were baptized and buried there. In fact, her family's connections to the church may have played a role in the vestry's selection of the Tiffany Glass and Decorating Company to provide the windows. The firm signed an agreement with the Reformed Church on March 22, 1892, to "make WINDOWS in colored, leaded glass, agreeably to the designs made and submitted by the parties of the second part [Tiffany] and accepted by the parties of the first part [the church]." The price of the work was agreed on at the "uniform price of seventy five cents per square foot" not including transportation. The witnesses included Northrop's father, Allen P. Northrop, and her uncle, Elias Fairchild.[48] The contract further noted that memorial windows were not a part of the contract, so it must be assumed that the contract was for decorative generic windows.

The first memorial window Northrop designed for the church was the Robert Baker Memorial Window, unveiled in early April 1899.[49] Here, the conventionalized medallion format has been replaced in the central panel with an abundance of carefully realized floral motifs: poppies and their foliage in the foreground, luscious double red peonies, and soaring Annunciation white lilies, amidst other blossoms. The motifs would undoubtedly have had special resonance for the deceased and his family, for Baker was involved

with two of the largest nurseries in Flushing.[50] Four years later Northrop designed what must have been a poignant commission, a window in memory of her father (Figure 35). Two large medallions provide a geometric structure, the top with a stylized vision of the heavenly city, and the bottom with a rigidly symmetrical central Tree of Life laden with fruit in the foreground in front of a zigzagging stream between distant purple mountains, emblematic of the voyage of life. A profusion of lush conventionalized purple passion flower blossoms and green foliage, reminiscent of the Schieren window, frame both vignettes. Floral motifs were considered especially appropriate for the window, the local paper noting when it was unveiled that "one of Mr. Northrop's chief pleasures was working in his flower garden," which would have played to Northrop's strength.[51] The newspaper reporter continued that "The window is a product of the Tiffany Studios, from a design from his [Northrop's] daughter... an artist of unusual ability, who has had the advantage of working under the personal direction of Louis C. Tiffany."[52] As such, the window was a synthesis of Northrop's favored subjects—flowers and landscape.

By the mid-1890s, Northrop increasingly focused her work on landscapes: gardens, woodland vistas, and even seascape views as subjects for both ecclesiastic

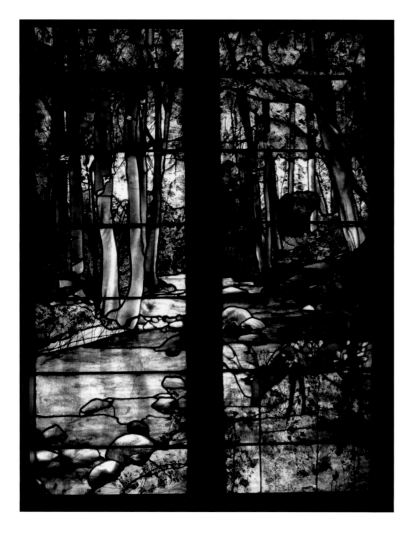

Fig. 54
Tiffany Glass and Decorating
Company, New York
Agnes Northrop, designer
The Hart and the Brook, Isaac Harding
Frothingham Memorial Window, 1897
First Unitarian Congregational Society,
Brooklyn, New York

single window was actually made up of two designs,
the landscape scene occupying the lower half below
the gallery (seen here), with the upper half above
the balcony filled in with angels designed by Wilson.
Despite the dramatic innovation in subject matter that
the landscape presented, and perhaps emblematic of
the struggles women still had in receiving recognition
for their work, the newspaper article identified only
Wilson as the designer, failing to credit Northrop for
her contribution.[55]

The landscape was not the sublime that attracted
landscape painters of earlier decades. Rather, it was a
familiar, intimate view, and it is tempting to speculate
that Northrop's neighboring surroundings served
as inspiration. That it may have been inspired by the
environment near her home in Flushing is suggested
by a luminous photograph she took of the local Kissena
Brook, part of Kissena Park (Figure 55), which captures
the scene of a meandering rock-strewn brook surrounded
by trees. This generic view would also be adapted from
an ecclesiastic setting to, as Northrop wrote, "apartments
where a window was wanted for color [and] to blot out a
view not interesting."[56]

Nearly a full decade later, an almost identical
design of the woodland landscape of 1904, with brook,
referencing the same Old Testament inscription of
the Hart and the Brook, is found in the Ezekiel Hayes
Trowbridge Memorial Window, originally in the First
Church of Christ (now the Center Church), in New
Haven, Connecticut.[57] The scene would be adapted
once again, this time in a domestic setting, for the
New York dining room commissioned by Helen Gould

and domestic windows, often incorporating some of
the same signature flowers, such as iris, hollyhocks,
lilies, passion flowers, clematis, and rhododendrons.
Some of Northrop's most important windows
are full-blown landscapes. She worked in several
different landscape styles, and adapted them to suit a
singular architectural setting or the specifications of a
particular client. The earliest woodland landscape by
Tiffany Studios dates to 1895, *The Hart and the Brook*,
the Isaac Harding Frothingham Memorial Window
for the Church of the Savior (now the First Unitarian
Church), Brooklyn (Figure 54).[53] The write-up in the
Brooklyn Daily Eagle at the time of installation, based
no doubt on a description furnished in a press release
written by Tiffany Studios' press department, was
especially glowing: "So close to nature is the scene
depicted that for a moment it seems as if it were
nature itself seen through an open window."[54] The

Fig. 55
Agnes F. Northrop
Kissena Brook
Photograph, undated
Collection of Doug Major

Fig. 56
Agnes Northrop, designer
Behold the Western Evening Light, plate 13
from Tiffany Glass and Decorating Company,
Memorial Windows (New York, 1896)
The Metropolitan Museum of Art, New York,
The Jefferson R. Burdick Collection, Gift of
Jefferson R. Burdick (1991.1007.1)

in 1910. Northrop's memoirs provide documentation concerning the Gould window, suggesting the attributions for related landscapes.[58]

It is worth examining the chronology of Tiffany's—and Northrop's—introduction of landscape windows into their repertoire. Following the 1895 Frothingham window, a landscape design identified as Northrop's appeared in *Memorial Windows*, the first of Tiffany's promotional publications that featured windows, dating to 1896 (Figure 56). If one considers this and a subsequent pamphlet as an indicator of the Studios' output, there is a significant progression. The 1896 pamphlet featured sixteen windows, all but one (Northrop's) being figural designs. That was followed by *Memorials in Glass and Stone*, first published in 1913, and reprinted in 1922. In the latter publication, a total of twelve memorial windows were illustrated, fully one-third of them landscapes. Although none of the designers are credited, the landscapes were designed by Northrop, except perhaps the Russell Sage Memorial Window in Far Rockaway, New York, which was probably designed by Tiffany himself.

Northrop designed numerous variants of the woodland theme; some heralded the glories of spring,

rather than autumn depictions. One of the most complex is the Sarah Fay Sumner Memorial Window for the First Reformed Church of Albany, where birch trees and pink flowering trees line the riverbank and masses of pale iris and water lilies dominate the foreground (Figure 57). Temporal changes, either seasons of the year, notably spring and autumn, and times of day, particularly dawn and dusk, were especially appropriate for memorial themes of birth and death, and, consequently, they feature prominently in Northrop's landscape work. In 1898 Northrop received a patent for a submission of three panels (Catalog 64) which, curiously, do not read as a single window although they all depict landscapes. The two outside panels depict the seasons, with summer on the left and winter on the right. The central panel, a memorial with its winding stream and cypress trees, and the inscription—lines from a Schiller poem—seems somewhat incongruent with the two flanking panels.

A more structured landscape composition, which features rigid vertical trees as a framing device with a canopy of greenery at the top and one or more different kinds of flowers in the foreground, provides an alternate version of the river and mountain theme. One such design dating to 1913, confirmed as

177

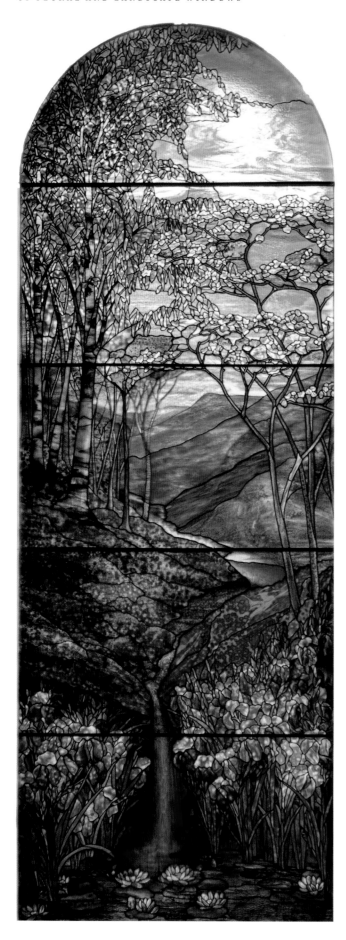

Fig. 57
Tiffany Studios, New York
Agnes Northrop, designer
Sarah Fay Sumner Memorial
Window, 1912
Leaded glass
First Reformed Church, Albany,
New York

Northrop's by her memoirs, is the landscape window commissioned by Andrew Carnegie and his wife in memory of his parents and siblings for Dunfermline Abbey (Figure 58). As arresting as the design was, this pure landscape subject offended the local clergy, and it was rejected for the abbey by the authorities because it was deemed "unecclesiastical and too modern." A journalist highlighted the inherent conflict in a newspaper account written shortly after it was completed:

> It is a sunset view filling the entire space; they wanted conventional designs drawn from geometry or hagiography and made up of little pieces of glass, set in lead, as was done in the days when the art of making large panes of glass was unknown. Mr. Carnegie selected the design at the Tiffany Studios because it expressed to him religious emotion... It did not express religious emotion to the vestrymen of Dunfermline. Here were green pastures and still waters, great rocks, birds of the air, sunshine and shadow, flowers surpassing the glory of Solomon, pine trees as beautiful as the cedars of Lebanon...[59]

Carnegie made several visits to the Studios, contributing various suggestions (some not chosen—like replacing the rhododendrons with thistles). The close similarity of the Carnegie window to a watercolor drawing suggests that it, too, was also executed by Northrop (Catalog 65). The generic design was used not only for churches and mausoleums, but was also popular for domestic settings.

Another landscape format was an asymmetrical view towards receding generic mountains with flowering branches dominating one side and other floral motifs in the foreground such as the Frederic Henry Betts Memorial Window of 1905 for St. Andrew's Dune Church in Southampton, Long Island (Catalog 37). The mountains and placid pool are surrounded by pink flowering hollyhocks and a rose bush adorned with a profusion of cream-colored blossoms. The choice of flowers may refer to the lush seaside gardens that flourished on the east end of Long Island during the spring and summer months. The overall composition, however, brings to mind, for example, the window made for William F. Skinner's New York house in 1908, where a similar trellis provides structure, and wisteria replaces the Betts flowering roses and hollyhocks, with similar

mountains in the distance.[60] In the Skinner window, the flowering wisteria suggests the vines that dominated the Skinner family estate in Holyoke, Massachusetts, called Wisteriahurst, while the distant hills suggest those seen from Laurelton Hall, Tiffany's summer estate on Long Island.

As suggestive as those landscapes were of a particular locale, Northrop, as she indicated in her memoirs, was often called upon to design one-of-a-kind windows "according to the wish of clients."[61] Such windows reflect site-specific landscape features of the church's locale. About the same time that Northrop was working on the design for the Gould landscape window, Tiffany Studios received a commission for a window for a small church in Proctor, Vermont. The town is best known for its marble quarries and stone cutting.

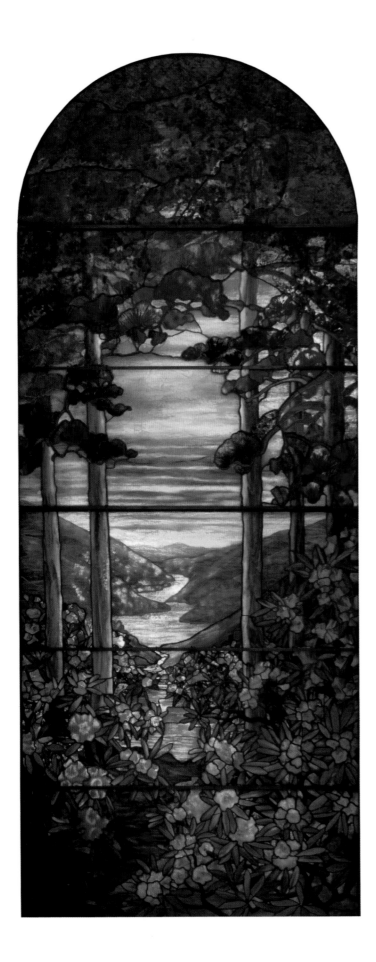

Fletcher D. Proctor contacted Tiffany Studios in 1909, requesting a window for the church to memorialize his father, Redfield Proctor, founder of the company and the town. The Tiffany Studios wrote in reply: "We will be glad to prepare special designs for your consideration, or possibly you may have some particular subject in mind."[62] Proctor evidently did have a particular subject in mind, the view of the Vermont mountains that are visible from the church. A photograph of Mt. Pico (Figure 59), a mountain which the Proctors partially owned, was sent to Northrop, and she made several sketches which were sent back and forth for final approval, after which the cartoon was made.[63] Proctor paid several visits to the Studios (and drove a hard bargain, negotiating the original estimate of nearly $5,000 to a final price of $2,000). The resulting window, completed in 1911, is a luminescent depiction of that spectacular site-specific mountain view in summer (Figure 60). Northrop's style is particularly evident in the rendering of the trees, which bring to mind those in the Carnegie window of just a few years later.

So successful was that window that when Fletcher Proctor himself died in the following year, his widow went to Tiffany Studios to commission a companion window—Autumn—in her husband's memory. There is no record of photographs for this window, yet it, too, features the Vermont countryside with its fiery autumn foliage. It is likely that Northrop was also responsible for the design of Proctor's third window dating to nearly two decades later, this time a memorial to Fletcher Proctor's widow depicting Spring, complete with a foreground field of daffodils.

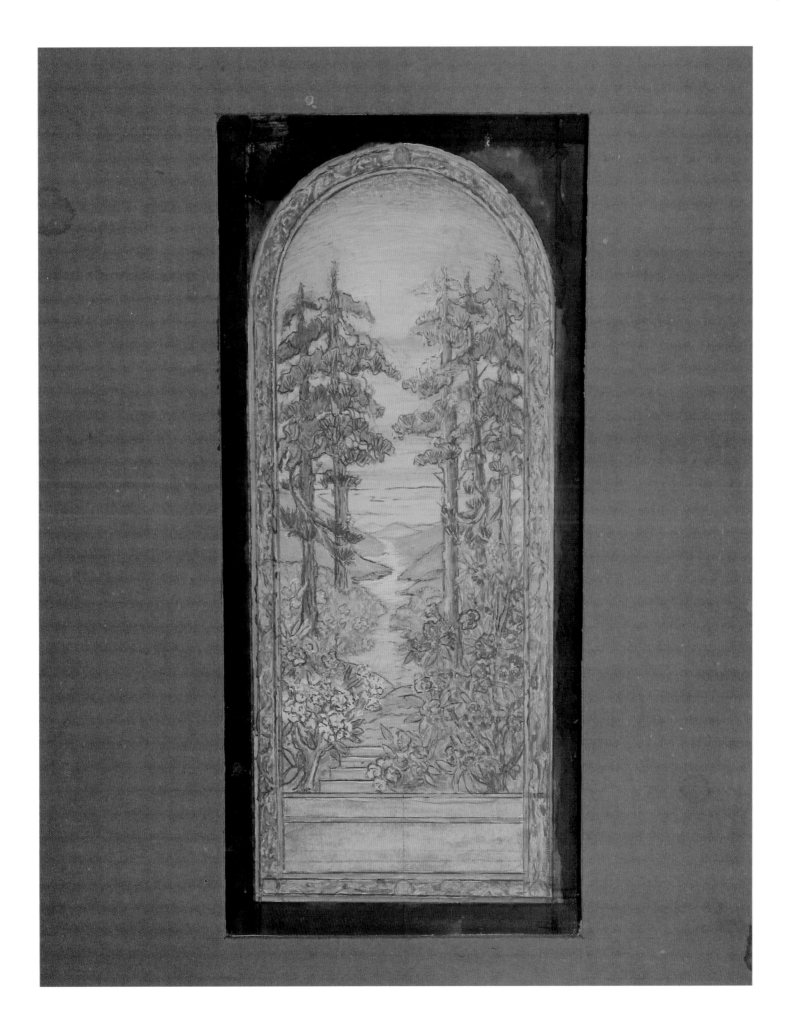

Fig. 59
Mount Pico, Vermont
Photograph sent by
Fletcher D. Proctor to
Tiffany Studios, 1910
The Metropolitan Museum
of Art, New York, Gift of Paul
Nassau (from the collection
of Agnes Northrop)

Fig. 60
Tiffany Studios, New York
Agnes F. Northrop, designer
Redfield Proctor Memorial
Window, ca. 1909
Leaded glass
Union Church, Proctor, Vermont
Courtesy of Union Church;
photograph by Erik Borg, 1979

Another landscape-specific window designed by Northrop was the Alice McElroy Kinsbury Memorial Window of 1914 for First Presbyterian Church in Albany, New York. Regrettably, there is no original correspondence between the donor and Tiffany Studios, yet the existence of the original drawing confirms Agnes's role in the design. The lunette window, remarkably faithful to the drawing executed for it, was probably also based on a photograph. It features a cluster of white birches in the left foreground and majestic pines on the right framing the scene, with various flowers, including buttercups, daisies, and wild roses. The window was said to be an interpretation of a scene on Lake Luzerne, a place where the deceased spent her summers.[64] The "water on the lake, dancing in the early morning light," reflects "perfectly the golden opalescent tones of the sky. Potash Mountain, bold of outline, but softened by the morning mists, can be seen in the distance."[65]

One window that Northrop extolled, mentioning it in both versions of her memoirs, was a landscape for a small summer chapel on Mt. Desert Island, Maine, St. Jude's Church in Seal Harbor, dating to 1912. Northrop depicted a seacoast view, capturing the light on the Maine coast with reflections on the water. The rigid erect pine trees that frame the composition are consistent with her distinctive style. She would make

a companion to the window nearly three decades later, when, in 1940, she designed another Maine view, this time the dramatic sunset view of Bear Island Lighthouse from Northeast Harbor.[66] Northrop completed this commission while working for the Westminster Studios, the firm that succeeded the Tiffany Studios after Louis Tiffany's death in 1933.

At the time of Tiffany's death, workers from the original firm incorporated and continued to fill Tiffany Studios' outstanding commissions, and to carry on in the business of leaded-glass windows until 1944. Northrop, though now seventy-six, was committed to pursuing her career as a window designer, and felt grateful for the opportunity to join the "3 or 4 others who had been with Mr. Tiffany's team in the newly formed company."[67] In correspondence she had with the Reformed Church in Flushing, Northrop mentioned exhibiting the St. Jude's window at Westminster Studios for ten days before sending it to Maine for installation, and she described the new firm as an "offshoot of Mr. Louis C. Tiffany's Studios."[68] Northrop promoted their work, saying, "This is a little advertisement thrown in! I love the work—the more the merrier."[69]

Her promotional efforts must have worked, for two years later Northrop designed her final window for the Reformed Church (now the Bowne Street Church) in Flushing, in about 1942, over forty years after she designed the Robert Baker Memorial Window. The new window was a memorial to Thomas Hanna MacKenzie and his wife, Frances, and was signed Westminster Studios. A far cry from the one that she had designed for her father, it depicts, like the previous window at St.

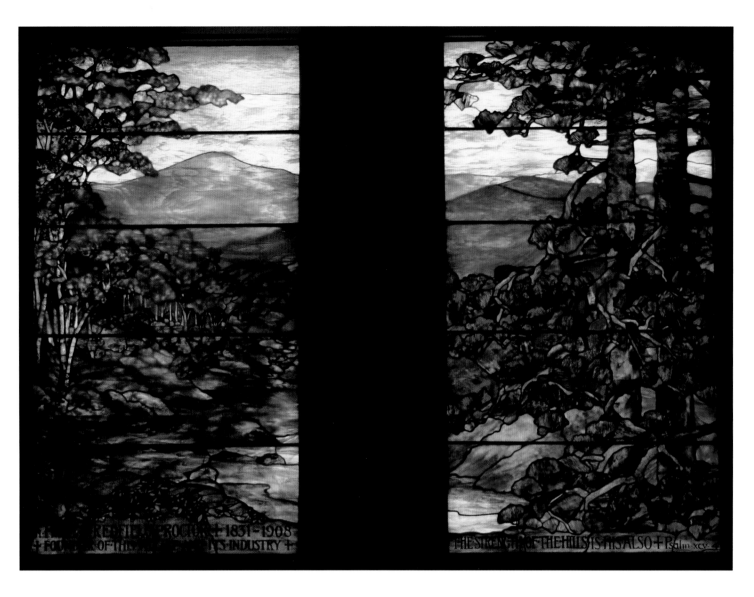

Jude's, a simplified landscape, a hill with sheep, cypress trees, and a vivid red sky.

Northrop never wavered in her admiration for Tiffany and remained loyal to him throughout her long life. After his death, at a time when Tiffany's work was well out of favor and suffered public barbs in the press, she wrote a response to criticism of his work, included in a review of the Museum of Modern Art's exhibition on "Machine Art" in 1934, where the author characterized Tiffany lamps as "silly and fussy," or the "gimcracks of yesterday."[70] Northrop, now living in Noroton, Connecticut, felt compelled to write a rebuttal: "As one who worked for years with Mr. Tiffany I must assure her that he always advocated simplicity, which combined with dignity and beauty, was the keynote of his creative genius."[71]

In her extraordinary five-decade-long career at Tiffany Studios, Agnes Northrop broke new barriers in a field dominated by men and established herself as one of the leading designers of windows. Her talents were perfectly matched to Tiffany's, and once landscapes were introduced as subjects, with the exception of Tiffany himself, Northrop was the sole designer of landscape windows. From the beginning of her time at the Tiffany Glass and Decorating Company copying Renaissance designs, her style evolved from a highly decorative conventionalized floral one to a more delicate naturalistic one in fully realized landscapes. Northrop was an attentive student of nature, her observations enhanced by her sketches and early and avid use of photography. Her gift for translating nature into designs for windows was significant in the dramatic new landscape subjects in service for ecclesiastic settings. While many more of her windows still need to be identified, from what we now know of her documented work, Northrop left behind an extraordinary legacy.

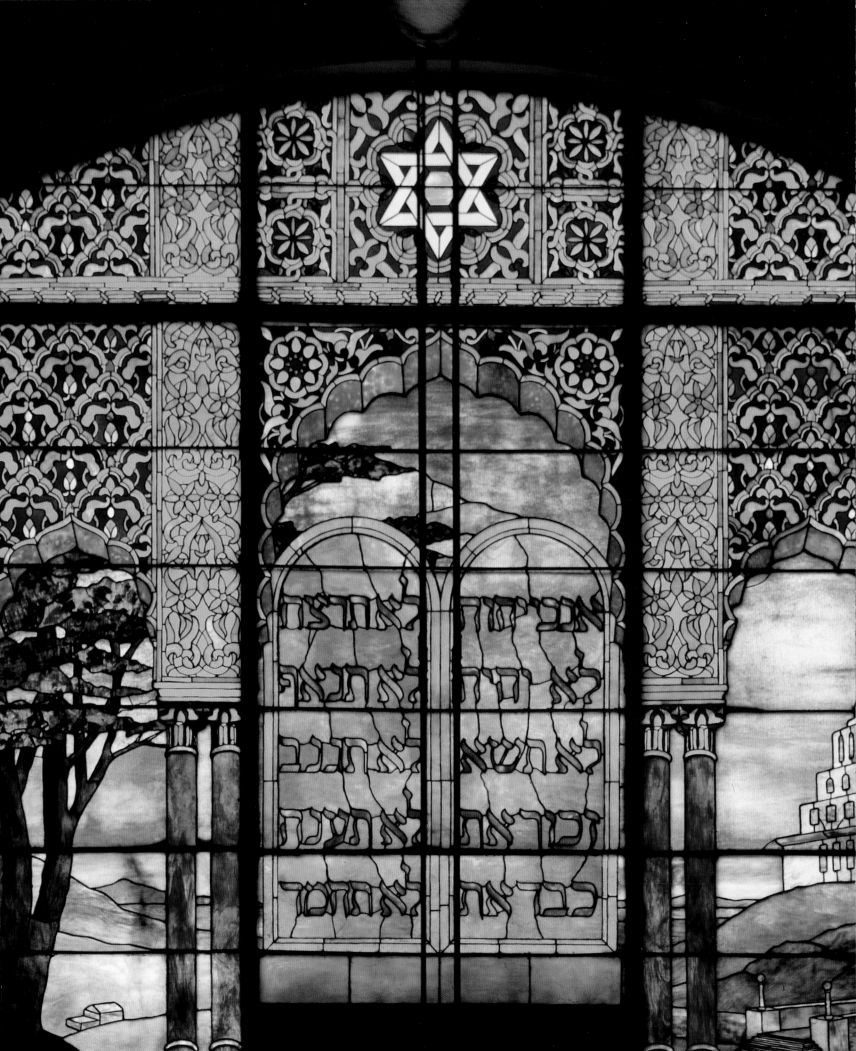

Translations in Light: The May Memorial Window at Temple Emanu-El, New York

ELKA DEITSCH

Fig. 61 (detail)

As early as the thirteenth century, synagogues have used stained- or painted-glass windows to dual effect. They serve not only to provide a degree of privacy from people and events outside the house of prayer, but also to inspire through beauty and religiosity as the shifting colored light dynamically plays across the open interior space of the synagogue.[1] A visitor entering the Beth-El Chapel, in New York City's Temple Emanu-El on Fifth Avenue and Sixty-fifth Street, is rewarded with a view of a glorious stained-glass window, commissioned by the temple in 1899 from the Tiffany Glass and Decorating Company. The scene depicted in the Lewis May Memorial Window (Figure 61) has as its center a large image of the Ten Commandments, with the first two words of each Commandment elegantly scrolling against a pearly marbled tablet framed in yellow. The tablet is flanked by four Moorish archways. Rendered to give the impression of three-dimensionality, they pull the viewer into the bucolic landscape beyond, marked by rolling hills, sturdy cypress trees, a stylized Temple of Solomon, and a few humble buildings. We are in an idealized and abstracted landscape of Jerusalem. Above it all, a Star of David takes in the scene.

The window is fabricated from a varied and colorful palette of opalescent, iridescent, rolled, and textured glass and contained in a lead cane and copper foil matrix. Typically, Tiffany's stained-glass windows at this time were made with only two to three layers of glass. The May window has between two and an impressive six layers, which gives it a diversity of tone and deeply nuanced effect of shade, light, and perspective.[2] It is one of only a handful of liturgical stained-glass windows that Tiffany Studios was commissioned to produce for synagogues.[3] Given the relatively early date of the commission—Tiffany established his favrile glass technique in 1893—and the level of customized detail in the memorial window, there seems little doubt that Louis C. Tiffany and his workshop were intimately involved in the design.

Currently measuring 18 feet across and nearly 10 feet high, the window was once nearly 43 percent larger, at 20½ by 15½ feet.[4] Upon examination, one can easily discern that it was at some point divided into three segments, the wooden mullions between them concealing additional elements that were removed; less noticeable is the absence of the entire lower portion of the window. Looking more closely at the images in the window itself, one is also struck by the incongruence of the realistic architectural rendering of the Moorish archways with the romanticized symbols of Jewish faith and history. In fact, these archways take us back to the original setting of Tiffany's May Memorial Window, the long-gone Temple Emanu-El on Forty-third Street and Fifth Avenue. In order to truly understand the remarkable power and innovation of this piece, we need first to return to the mid-nineteenth century to see what Louis Comfort Tiffany saw when he undertook to incorporate his work of art into an existing structure.

In 1868, the board of Temple Emanu-El set out to build a new home for its growing congregation. Though the congregation had been formed twenty-three years earlier, the Temple's move for the first time into its own, purpose-built structure was an extraordinary testament to the development of a powerful and secure American

Fig. 61
Tiffany Glass and Decorating
Company, New York
May Memorial Window, 1899
10 × 18 feet (originally measured
15 ½ × 20 ½ feet)
Leaded glass
Temple Emanu-El, New York

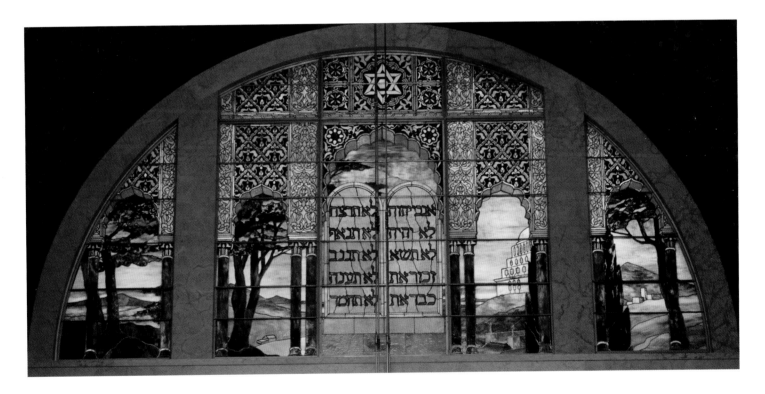

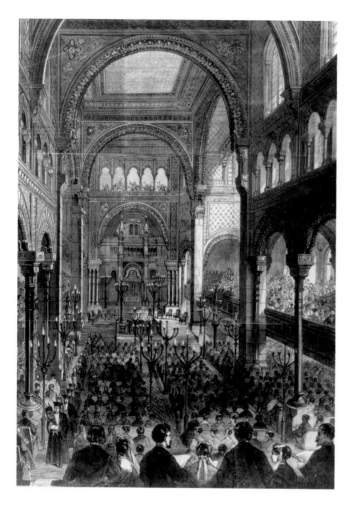

Fig. 62
Dedication of the Hebrew Temple Emanu-El, corner of Fifth Avenue and Forty-Third Street, New York City, Sept. 11, 1868
Published in *Frank Leslie's Illustrated Newspaper*, October 3, 1868, p. 41
Collection of Congregation Emanu-El of the City of New York

Fig. 63
Interior of Temple Emanu-El, Forty-third Street location, New York
Collection of Rabbi William A. Rosenthal

Perhaps the most informative description of the interior comes from the account of the dedication ceremony in *The American Israelite* of September 26, 1868:

> The walls are covered with arabesque patterns, the arches are notched in Byzantine style, the columns take to themselves Arabian heads and Moorish fillets… the colors in the decoration are red, blue, yellow, white and gold, arranged in such variety and continuation of style, as to produce a most brilliant effect. The gilding is very profuse, and the ceiling, in ultramarine blue, is set with constellations of stars and defined by borders of rich colors… The windows are all of ornamentally painted glass of a magnificent design.

At the eastern end stood the sanctuary's focal point, the ark holding the Torah scrolls. It was showcased by an elaborate vertical structure, drawing dramatic attention to the room's breathtaking dimensions. Above the ark a carved and painted Star of David, framed by the Hebrew prayer the *Shema* (Hear O Israel), was embedded in a recessed arch. Situated above this was a series of twelve lancets, dramatically lit from hidden openings which held the orchestra; crowning the arched niche were two glass Tablets of the Law, very possibly moved from the congregation's previous home at Twelfth Street, flanked by two gabled architectural elements (Figure 63).[7] This combination of elements created what the architectural historian and author Montgomery Schuyler begrudgingly admired as an "attempt to combine Gothic

Jewish community in the United States. Its dedication, on September 11, 1868, was accompanied by much public fanfare and acclaim (Figure 62). The architects, Leopold Eidlitz and Henry Fernbach, had created a monumental structure steeped in the Moorish vernacular that was the contemporary convention for synagogue architecture.[5] They also infused it with Gothic and Romanesque elements, creating a building simultaneously rooted in multiple historical narratives. From the street, passers-by took in an enormous rose window with Gothic tracery and a Star of David, and two minarets on Romanesque columns. The galleried interior seated 2,300 and was illuminated with more than 500 gas jet candelabra; the ceiling was a rich blue decorated with stars and diamond shapes.[6] As no color images exist of this space, contemporary press reports of the building's 1868 dedication provide the best descriptions of the jewel-toned sanctuary. They are also extremely useful in determining Tiffany's decorative intentions when he designed the May window some three decades later.

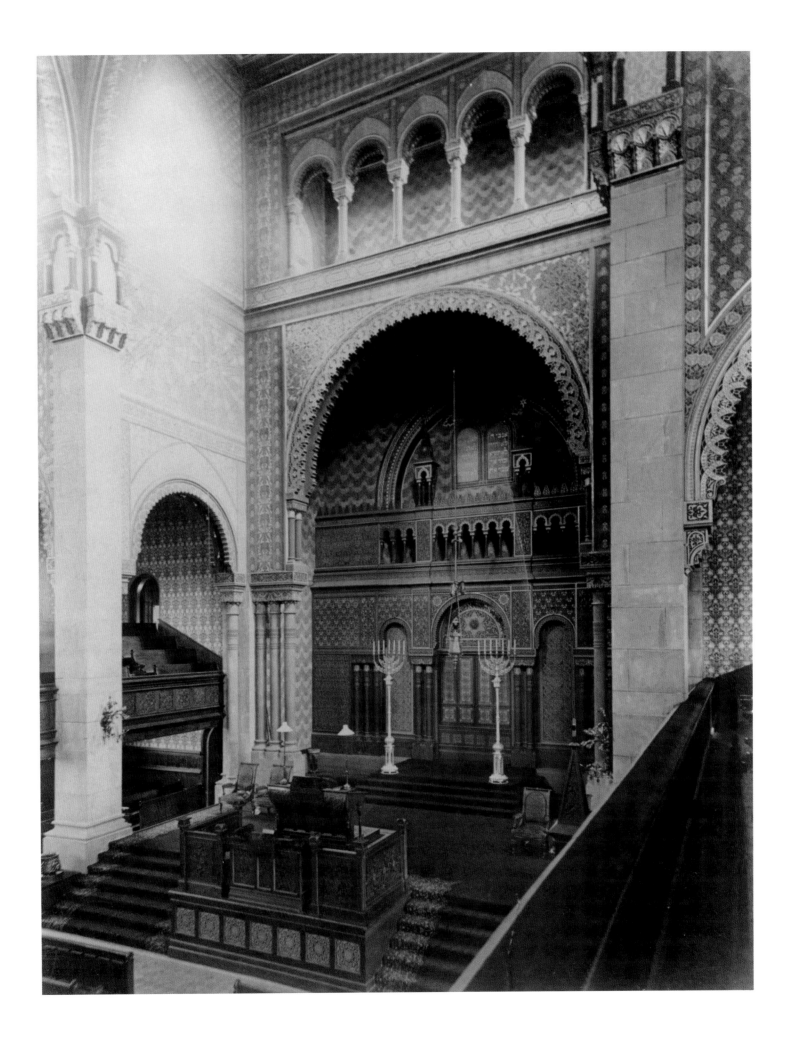

structure with Saracenic decoration… a bold attempt, but it was justified by the event."[8]

It was this section that, in 1899, was completely transformed into a stained-glass monument to Lewis May, the congregation's late president who had been so instrumental in bringing the temple's new home to fruition. May was a leading financier in nineteenth-century New York and a long-time director of the Mutual Life Insurance Company. He had a wide array of business interests, especially in real estate and street railways. Born in Worms, Germany, in 1823, May came to the United States when he was six years old, eventually landing in California, where, in 1850, he secured a controlling interest in a trading company. He then moved to New York to oversee purchasing, and later went on to form the banking firm of May & King.[9] He retired in 1884, devoting himself full-time to Jewish charities, and in particular to his role as president of Emanu-El, a position he had assumed in 1863.

To celebrate the twenty-fifth anniversary of May's presidency, in 1888, a commemorative silver vase was commissioned from Edward C. Moore at Tiffany & Co. The vase bore the image of the Forty-third Street building, a miniature replica of the eternal light which hung above the ark and the Hebrew passage from Deuteronomy, "A land of wheat and barley, of vines, figs and pomegranates, a land of olive trees and honey." A leather-bound volume with a gold imprint of the vase was published, extolling the virtues of the beloved president. It was perhaps this first encounter with Tiffany & Co. that led the directors of Temple Emanu-El to engage the services of Tiffany Studios. On

Thanksgiving Day in 1899, two years after May died, a magnificent stained-glass window was added above the ark and dedicated as a memorial to him.[10] When the temple moved uptown to Sixty-fifth Street in 1927, it was one of only three items to be relocated, the others being the ark doors donated by Jacob Schiff in 1910, and the eternal lamp.

We know that the base of the semicircular window, which has since been removed from the original, projected into the interior approximately five feet. However, the only known images of this portion are a very poor reproduction of the designer's rendering (Figure 64) in a biography of Isaac Mayer Wise, published shortly after the move to Sixty-fifth Street, and a 1920 photograph depicting the congregation's Seventy-fifth anniversary, in which the window is obscured by decorations. Fortunately, it is possible to reassemble the missing elements by culling from periodicals and newspapers that took note of the first installation of the window in 1899. For example, accounts in both *The American Hebrew* and the *New York Times* included references to images symbolizing the twelve tribes, the fruits and flowers of the Holy Land alluded to in Deuteronomy, the Song of Solomon, and the Ark of the Covenant. Tiffany Studios closely replicated twelve archways from the original, even reproducing the appearance of the carved wood. The six central panels were said to have contained Byzantine scrolls and vases filled with olives, figs, grapes, and pomegranates, as well as lilies and roses. In his Thanksgiving sermon, which also served as a dedication for the window, the Reverend Dr. Silverman credits his predecessor Dr.

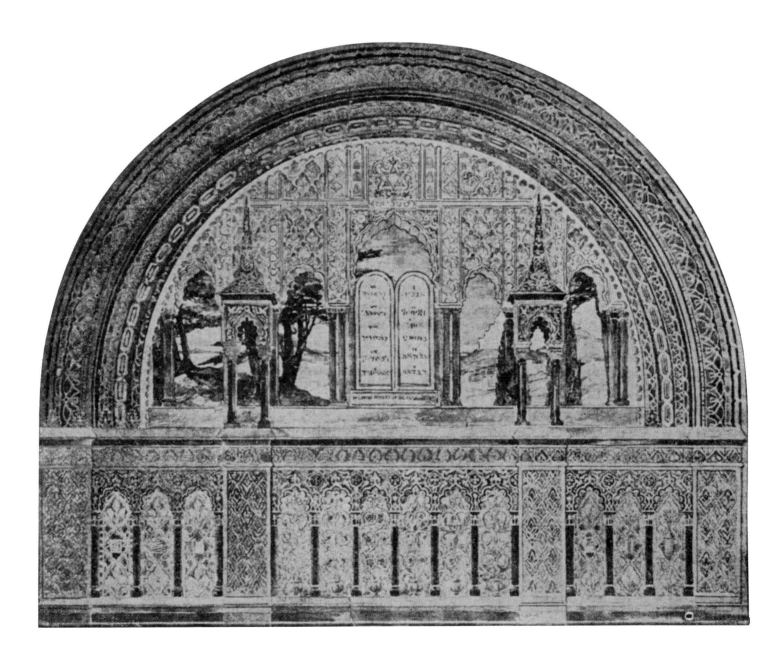

Gustav Gottheil with providing the symbolic imagery for the window (giving us additional clues as to its original construct).[11] However, given the appearance of traditionally Christian symbols such as the lily and rose, it seems more likely that Louis C. Tiffany had arranged most, if not all, aspects of the window's design.

The panels were likewise arranged thematically. The three to the left showed ears of wheat surrounding images of the High Priest's breast plate, a bee hive (not typically considered as a Jewish symbol), and a Torah scroll. The breast plate, described in the Bible as being adorned with twelve precious stones—cornelian, peridot, emerald, ruby, lapis lazuli, onyx, sapphire, banded agate, amethyst, topaz, beryl, and jasper—would have been an attractive subject for Tiffany to represent in stained glass. The three panels to the right contained images of the Ark of the Covenant, the Pillars of the Porch of the Temple, and the Tower of David. As Dr. Silverman noted in his dedicatory sermon, "[T]he three panels to the left reference the ministry of the Temple, the expounders of the law and its sweetness, and the representatives of the Tribes. Those to the right appertain more particularly to the people—to the covenant which is their guide, the pillars and the tower of the King, which stand for strength and stability of their faith."[12] There is also a dialogue between the upper, existing portion of the window, which speaks to Tiffany's engagement with the architecture of the space via the representation of the carved wood elements composed of columns surmounted by an arched pediment flanking the Ten Commandments, and this missing section, which articulated the congregation's religious and cultural identities. Where the top roots

worshipers to the building in which they worship— to a transformation of wood into glass, opacity into translucence—the bottom reminds them of their connection to history and law.

Particularly noteworthy in both of these sections is the middle road that Tiffany took in balancing realistic representation with abstracted landscape. In the first case, he recreated in glass the wooden Moorish and Romanesque architectural elements—carved, painted, gilded, and gabled—that flanked the original Ten Commandments above the ark, as well as the twelve carved lancet archways. The direct quotations of existing elements of the building allowed Tiffany to gently translate the architectural vernacular of the interior into a modernized form. Representing old technology with new was both a gracious nod of respect to the artistry of the building that Tiffany was entering, and a means to demonstrate his mastery in executing elaborate and complicated surface design. At the same time, setting the idealized landscape of Jerusalem in the background shows his interest in creating a more philosophical, aspirational, and meditative scene, less literal and not beholden to the physical space in which the congregants assembled.

A question remains, however. Why was the congregation willing so radically to alter its showpiece, the most visible and extravagant portion of its interior? An article in *The American Hebrew* in October 1899, approximately six weeks before the window was dedicated, sheds some light on the matter. In announcing the congregation's intention to honor Lewis May, it indicated that the function of this new addition was not only to memorialize a man, but also to reinforce

the mission of a movement beleaguered by the threat of societies that espoused a system of morality separate from theology. The window would serve as a beacon of "moderate reformers" and a symbolic statement against "non-sectarian societies"—a clear reference to the ethical culture movement taking root in their own backyard.[13]

> In the Temple Emanu-El a memorial window of unusual size and beauty is to be erected soon to Lewis May... As a mark of appreciation not only for services rendered by him, but because of the example he set to the rising generation, the trustees decided to erect this window to his memory. It was during the presidency of Mr. May that the extreme reform wave struck the Jewish community of New York, and in the time when it became popular to desert the congregation and join non-sectarian societies, when the existence of the temple was threatened, it was the moderate reformers of the stamp of Lewis May who turned the tide and through their efforts not only kept the congregation intact, but increased its membership and elevated its standing in the religious community. The window will occupy the most prominent place in the temple.[14]

In other words, by fashioning the existing decorative elements into a new format, one which both embraced new technological innovations and referenced their architectural and cultural histories, the congregation was able to modernize and reaffirm the value of maintaining its cultural and religious identities. Furthermore, the act of commissioning the window from Tiffany Studios publicly reinforced the worshipers' place as acculturated Americans, whose sermons were now delivered in English rather than German and whose spiritual decorations were produced by a prominent American artist, with a uniquely American artistic sensibility.

In a description of the May window dedication, the *New York Times* wrote that "the congregation felt that some lasting memorial should be devised to commemorate his name and his services, and as the Temple was the object of his deepest affection, it was thought best to make this a part of the edifice itself." The remarkable aspect of the installation of the window was that it reinterpreted the actual space of the building by morphing wood into glass, gilding into translucence. The decision to excise the existing architecture in order to set the Tiffany window above the ark was a grand gesture of devotion, of binding the man and his ideas to the building.

The Lewis May window is an excellent example of Louis Comfort Tiffany's personal skill and vision. It also shows how the decorative arts can shed light on the technology and aesthetics of the time, as well as the cultural and ideological contexts that created them. Stained glass at the turn of the nineteenth century could either be a conservative reflection of existing architecture or a new and visually independent element. The Tiffany window was an especially graceful compromise, making a powerful statement on the role of architecture and technologies in crafting a cultural, national, and religious identity.

ENDNOTES

Louis Comfort Tiffany's Gospel of Good Taste

1. For purposes of clarity, the succession of Louis Comfort Tiffany's businesses will be referred to throughout this catalog as Tiffany Studios.
2. Louis C. Tiffany, "The Gospel of Good Taste," *Country Life in America* 19, 2 (November 1910), 105.
3. Several thousand images known as the Tiffany Studios Study Photograph Collection are now in the collection of the Charles Hosmer Morse Museum of American Art, Winter Park, Florida.
4. From "an intimate associate" of Tiffany's. Quoted in Gertrude Speenburgh, *The Arts of the Tiffanys* (Chicago: Lightner Publishing Corp., 1956), 34.
5. Louis C. Tiffany, "Color and Its Kinship to Sound," *The Art World* 22, 2 (May 1917), 142. Robert Koch, *Louis C. Tiffany: The Collected Works of Robert Koch* (Atglen, PA: Schiffer Publishing Ltd., 2001), 169. From 1894 Tiffany consulted with two chemists on enamel, glass, and eventually jewelry. One was Dr. Charles Avery Doremus (1851–1925), "experimenting in dyes for colored glass, not for stained-glass windows, but for objects of use and decoration which are blown…" ("Pots and Flasks of Many Hues," *New York Times*, May 20, 1894, 17). The other was Dr. Parker Cairns McIlhiney (1870–1923; 1894 Ph.D. from Columbia University, NYC; 1894 associated with Tiffany in artistic glass, jewelry, and enamel manufacturing; Paris Exposition Universelle, 1900, awarded silver and bronze medals).
6. Tiffany, "Color and Its Kinship to Sound," 142. Tiffany Furnaces (first called Stourbridge Glasshouse) would not be opened in Corona until he recruited Arthur J. Nash in 1893.
7. Candace Wheeler, *Yesterdays in a Busy Life* (New York: Harper & Brothers, 1918), 236.
8. Stage-set designs for noted performances such as David Belasco's *Madame Butterfly* at the Herald Square Theatre in March 1900.
9. Tiffany, "Color and Its Kinship to Sound," 143.
10. Wheeler, *Yesterdays in a Busy Life*, 232.
11. William O. Stoddard, *Men of Business, Men of Achievement* (New York: Charles Scribner's Sons, 1893). One business manager was William Pringle Mitchell (1859–1900), vice-president and manager whose uncle Alfred (1832–1911) married Tiffany's elder sister Annie (1844–1937); he managed Tiffany's companies from 1881 until his death.
12. "Special Mention," *Building,* trade supplement in back of Vol. XI (August 31, 1889), 2.
13. Ibid.
14. *A Synopsis of the Exhibit of the Tiffany Glass and Decorating Company in the American Section of the Manufactures and Liberal Arts Building at the World's Fair, Jackson Park, Chicago, Illinois, 1893, with an Appendix on Memorial Windows* (New York: Tiffany Glass and Decorating Company, 1893), 8.
15. The chapel was later installed at the Cathedral of St. John the Divine, New York City, and at Laurelton Hall. It was reassembled in the 1950s and 1960s by Hugh and Jeannette McKean and permanently installed at the Morse Museum in 1999.
16. W.R., "Notes on Italian Paintings in Two Loan Exhibitions in New York," *American Journal of Archaeology and of the Fine Arts* 10, 2 (April–June 1895), 231.
17. In Chicago in 1893 and again at the Grafton Galleries in 1899.
18. Memorandum dated August 7, 1908 from the art director, Tiffany Studios, Archives of the Wayne County Historical Museum, Richmond, Indiana.
19. S. Bing, *Artistic America, Tiffany Glass, and Art Nouveau,* trans. by Benita Eisler (Cambridge, MA: MIT Press [1970]), 146.
20. Allied Arts Company, *The Exhibit of Louis C. Tiffany from the Tiffany Studios… Paris 1900*, 15.
21. Cecilia Waern, "The Industrial Arts of America: The Tiffany Glass and Decorative Co.," *The Studio* 2, XI (September 1879), 157.
22. Memorandum dated August 7, 1908 from the art director, Tiffany Studios, Archives of the Wayne County Historical Museum, Richmond, Indiana.
23. *Synopsis of the Exhibit.*
24. Polly King, "Women Workers in Glass at the Tiffany Studios," *The Art Interchange* XXXIII, 4 (October 1894), 87.
25. Ibid.
26. Ibid.
27. Waern, "The Industrial Arts of America," 157. Reference first made in "Louis C. Tiffany & Co. Associated Artists," *Harper's Bazaar*, July 23, 1881, 471.
28. Louis C. Tiffany, "American Art Supreme in Colored Glass," *The Forum* 15, 5 (1893), 626.
29. Christopher Gray, "Turn-of-the-Century HQ of Louis Comfort Tiffany," *New York Times* (October 4, 1998), RE5.
30. King, "Women Workers in Glass," 86.
31. Ibid., 87.
32. Ibid., 86.
33. Most of the mounts were marked with both a letter grouping (usually two letters in pencil) and a number (usually in blue pencil).
34. Companies include: L.C. Tiffany & Co., Tiffany Glass Company, Tiffany Glass and Decorating Company, Stourbridge Glass Company and the La Farge Decorative Art Company.
35. Many mounts are marked with more than one company stamp, updated as the piece transitioned between the Tiffany companies. It is presumed that the earliest company mark dates its entry into the Tiffany inventory.
36. Michael Burlingham in an e-mail dated March 10, 2004 says that notes made by Alfred Bingham tell of a letter borrowed from Louise Platt dated March 1876.
37. Visits from Agnes Northrop and Joseph Briggs in the Laurelton Hall Guest Book, Morse Museum, Winter Park, Florida, acc. no.1999-022.
38. Laurelton Hall Inventory, 1919, pages 3 and 7, Morse Museum Archives.
39. The photographic studios and image clearing houses often impressed their stamps upon the images. Stock images depicting England, France, Italy, India, Syria, and Turkey appear from studios such as C. Clifford, Bedford Lemere & Co., Joseph Tiator, Samuel Bourne (English, 1834–1912), Adolphe Braun (French, 1811–1898), Félix Bonfils (French, ca. 1830–1885), Francis Frith (English, 1822–1898).
40. Tiffany, "American Art Supreme in Colored Glass," 625.
41. Photographic print, Morse Museum, Winter Park, Florida, acc. no. 65-030:0823.
42. Photographic print, Morse Museum, Winter Park, Florida, acc. nos. 65-030:0816 and 65-030:0821 respectively.
43. Photographic print, Morse Museum, Winter Park, Florida, acc. no. 65-030:0821.
44. Letter dated September 4, 1908 from Edwin Stanton George, manager of Ecclesiastical Department, Tiffany Studios, to Mr. F. H. Glass, Second National Bank, Richmond, Indiana, in reference to Reid Memorial Church, Richmond, Indiana. Archives of the Wayne County Historical Museum, Richmond, Indiana.
45. Memorandum dated August 7, 1908 from the art director, Tiffany Studios, Archives of the Wayne County Historical Museum, Richmond, Indiana.
46. In Queens Historical Society and Kent State University.
47. January 9, 1902, Kent State University, cited in Martin Eidelberg, Nina Gray, and Margaret K. Hofer, *A New Light on Tiffany: Clara Driscoll and the Tiffany Girls* (New York: New-York Historical Society with Giles, 2007), 89.
48. Ibid.
49. Ibid.
50. *Synopsis of the Exhibit*, 16.
51. Ibid., 19.
52. Examples of Tiffany's personal works: his daughter claimed that the *Entombment* window's figure of Joseph of Arimathea was based upon the likeness of Charles Tiffany, Louis' father. The scene was reused in a small roundel window at the Madison Square Presbyterian Church in 1905 (now at the Mission Inn Museum in Riverside, California) and appears again in the *Tree of Life* window in 1932 (now at the Morse Museum, Winter Park, Florida.) Similarly, the *Four Seasons* window, celebrated at its showings in Paris in 1900, Buffalo in 1901, and Turin in 1902, was commemorated on an enamel box in 1916 most likely when the window was subdivided and reinstalled in sections at Laurelton Hall.
53. "Gorgeous Masque in Tiffany Studio," *New York Times*, February 20, 1916, 7.
54. Ibid.

Tiffany Studios' Business of Religious Art

1. This much quoted number was reported by Will H. Low who noted that this construction revival at the end of the nineteenth century was "more than curious; it becomes a question of eminent artistic importance." Will H. Low, "Old Glass in New Windows," *Scribner's Magazine* 4, 6 (December 1888), 675 quoted by J. B. Bullen, "Louis Comfort Tiffany and Romano-Byzantine Design," *The Burlington Magazine* 147, 1227 (June 2005), 397.
2. Ibid., 392. The full quotation as stated in this essay is from Candace Wheeler, *Yesterdays in a Busy Life* (New

York: Harper & Bros., 1918), 232–233.

3. "Chicago-American vs. Foreign Stained Glass," *The American Architect and Building News* XLII (November 1893), 75 as quoted in Patricia Pongracz Spicka, "The Chapel's First Installation and Move to Saint John the Divine," in *The Tiffany Chapel at the Morse Museum*, ed. by Nancy Long (Winter Park, FL: Charles Hosmer Morse Museum of American Art, 2002), 91. The Tiffany Chapel has a complex history. Though created as a marketing tool, an example of the finest work the firm had to offer, the installation proved so powerful that it was purchased in 1898 by Mrs. Hermione Whipple Wallace as a memorial chapel dedicated to her son. To this end, the Tiffany Chapel was installed from 1899 to 1911 as the primary consecrated space in the crypt of the cathedral church of St. John the Divine in New York City, while the church was under construction above ground. Once the structure above was complete, the crypt and the chapel that had served it for the preceding decade were closed. Tiffany petitioned St. John the Divine to return the work to him personally. He prevailed and, in 1915, it was relocated to Tiffany's Laurelton Hall in Oyster Bay, Long Island, where it remained until the estate was destroyed by a fire in 1957. Jeannette Genius and Hugh McKean brought the remaining components of the chapel and the estate back to Winter Park, Florida, where the collection became part of the Morse Museum. The chapel was restored and reinstalled in 1999.

4. See, for example, the *Tiffany Studios New York Ecclesiastical Department* brochure published between 1902 and 1905 when the firm had its showrooms at 335 Madison Ave. (The full chapel is illustrated on page 39 and a detail featuring just the lectern and candlesticks on page 32.)

5. *Lexicon and Catalogue of the Loan Exhibition for the Benefit of the Chapel at Saint Gabriel's, Peekskill, New York. Held in the Rooms adjoining the Tiffany Chapel at 335 to 341 Fourth Avenue, New York from March Twenty-fifth to April Sixth, 1895* (New York: James Pott and Company, March 23, 1895.)

6. *Lexicon and Catalogue*, 10, 78 respectively.

7. Bullen, "Louis Comfort Tiffany," 397.

8. *Lexicon and Catalogue*, 32, 52, 54, 62, and 70 respectively.

9. Tiffany Glass and Decorating Company, *Glass Mosaic* (New York: Tiffany Glass and Decorating Company, 1896), 3–4.

10. Ibid., 7–13.

11. Ibid., 14.

12. A photograph and discussion of the white marble baptismal font from St. Agnes's is published in *Glass Mosaic*, 5–6, photograph unpaginated, and again in the *Tiffany Studios New York Ecclesiastical Department* brochure. (The white marble baptismal font from St. Agnes's appears on page 30.)

13. Bullen, "Louis Comfort Tiffany," 390.

14. Barbara Veith, "Chronology," in Alice Cooney Frelinghuysen et al., *Louis Comfort Tiffany and Laurelton Hall: An Artist's Country Estate* (New York: Metropolitan Museum of Art with Yale University Press, 2006), 225. Veith notes that from November 1865 through March 1866 Tiffany traveled to England, Ireland, France, and Italy, spending time in the cities of Paris, Rome, Naples, Sorrento, and Florence and that

in 1870 he again spent time in London, Paris, Madrid, Malaga, Gibraltar, Tangier, Malta, Sicily, Naples, Amalfi, Sorrento, Alexandria, Cairo, Tunisia, Algeria, Rome, and Florence.

15. Siegfried Bing, "Louis C. Tiffany's Coloured Glass Work," in Bing, *Artistic America, Tiffany Glass, and Art Nouveau*, trans. by Benita Eisler (Cambridge, MA: MIT Press [1970]), 195. This article was originally published as "Die Kunstgläser von Louis C. Tiffany," *Kunst und Kunsthandwerk* I (1898), 105–11.

16. It is likely that Tiffany would have visited each of these churches as each town is within a day's travel of Rome: Tarquinia is approximately twenty-eight miles north and Terracina about thirty-five miles south-east of Rome. Cosmatesque pulpits in particular were increasingly well recognized during this period. A seminal study of such pulpits including excellent line drawings and descriptions was published by J. Tavenor-Perry in 1906. See J. Tavenor-Perry, "The Ambones of Ravello and Salerno," *The Burlington Magazine for Connoisseurs* 9, 42 (September 1906), 396–403.

17. For an excellent discussion of the Westminster Cosmati work see Paul Binski, "The Cosmati at Westminster and the English Court Style," *The Art Bulletin* 72, 1 (March 1990), 6–34.

18. I am grateful to Alice Cooney Frelinghuysen for alerting me to the sign now in the collection of the Metropolitan Museum of Art, MMA 2010.124.1,2.

19. Steven Wander, "The Westminster Abbey Sanctuary Pavement," *Traditio* 34 (1978), 142 and n. 14, 142–43.

20. Ibid., 143.

21. Dorothy Glass, "Papal Patronage in the Early Twelfth Century: Notes on the Iconography of Cosmatesque Pavements," *Journal of the Warburg and Courtauld Institutes* 23 (1969), 387.

22. Ibid., 388.

23. Tiffany Studios, *Memorials in Glass and Stone* (New York: Tiffany Studios, 1913).

24. The Presbyterian Church in Kingston counted among its decorations a figural window executed by Tiffany Studios. According to *A Partial List of Windows Designed and Executed by Tiffany Studios* published in 1910, the Teter Memorial Window on the subject of Christ Blessing the Children was made for the church before 1910. See Tiffany Studios, *A Partial List of Windows Designed and Executed by Tiffany Studios*, 2nd edition ed. by John H. Sweeney (Watertown, MA: Tiffany Press, 1973), 98. A second example of a Tiffany Studios pulpit inlaid with glass mosaic in wood is the pulpit that once graced the east end of All Hallows' Church in Wynecote, Pennsylvania. For another example of the execution of a similar design in various media see Jennifer Perry Thalheimer's discussion of the *Antependium* window in this volume.

25. I am grateful to Jeni Sandberg for alerting me to the candlesticks' production by Gorham.

26. Bullen, "Louis Comfort Tiffany," 395, image number 44.

"Unimaginable Splendours of Colour": Tiffany's Opalescent Glass

1. Period accounts of the development of opalescent glass for windows cite La Farge as the first to use this material, with Tiffany following suit almost immediately. These same accounts note that both men made significant contributions to the field of stained glass, working in different artistic directions, with different goals. Indeed, one author concedes that "it is safe to say that they have been mutually essential to it [the development of American stained glass]." Charles H. Caffin, "Decorated Windows," *The Craftsman* 3, 6 (March 1903), 357.

2. Caryl Coleman, "The Second Spring," *The Architectural Record* 2, 4 (April–June 1893), 485.

3. Cecilia Waern, "The Industrial Arts of America: II. The Tiffany or 'Favrile' Glass," *The International Studio* 14, 63 (June 1898), 17.

4. "A New Field for Artists," *New York Times*, April 5, 1891, 17.

5. Louis C. Tiffany, "American Art Supreme in Colored Glass," *Forum* 5, 15 (1893), 623.

6. C. Hanford Henderson, "Glass-Making," *Journal of the Franklin Institute* 124, 3 (September 1887), 214.

7. Thank you to conservators Susan Greenbaum, Mary Clerkin Higgins, and Marie-Pascale Foucault-Phipps for their insights into these techniques. For further information, see Mary Clerkin Higgins, "Origins, Materials, and the Glazier's Art," in *Stained Glass: From Its Origins to the Present* (New York: Harry N. Abrams, Inc., 2003), 32–55.

8. Louis C. Tiffany, "The Quest of Beauty," *Harper's Bazaar* 52, 12 (December 1917), 44.

9. Coleman, "The Second Spring," 485.

10. Charles de Kay, *The Art Work of Louis C. Tiffany* (1914; repr., Poughkeepsie, NY: Apollo Book, 1987), 20.

11. Antique glass is mouth-blown flat glass that is often transparent, single color. Cathedral glass is rolled in sheets and can be transparent or translucent, single or multicolored. Crown glass is glass that has been spun into flat, circular discs, or crowns. The center of the disc, or "bull's eye," is thick and nearly opaque but the disc becomes more translucent towards the thinner, outer edges. International Textbook Company, "Stained- and Leaded-Glass Designing," in *International Library of Technology* (Scranton, PA: International Textbook Company, 1916), 10–11.

12. Louis C. Tiffany, 1880, "Colored-Glass Window," U.S. Patent 237,417, filed October 25, 1880 and issued February 8, 1881.

13. I am grateful to Julie Sloan for bringing St. Stephen's Episcopal Church to my attention.

14. It is tantalizing to speculate whether the artists had a role in selecting these different methods for rendering flesh details. As a painter, Millet may have had an affinity for paint; as a sculptor, Saint-Gaudens might have been drawn to sculptural overlay; and Vedder, as an illustrator, may have preferred the bold outline necessary for glass inlay.

15. Will H. Low, "Old Glass in New Windows," *Scribner's Magazine* 4, 6 (December 1888), 682.

16. Samuel Howe, "The Making of the Glass," *The Craftsman* 3 (March 1903), 365.

17. William Griffith, "From Sand Bank to Stained-Glass Window," *New York Times*, May 21, 1905, X8.

18. For an excellent history of this glass company see William J. Patriquin and Julie L. Sloan, *The Berkshire Glass Works* (Charleston, SC: The History Press, 2011), especially pages 67–71.

19. Ibid., 75.

20. Francis Thill (b. Holland, ca. 1830 – d. New York, 1890) was a glassmaker and part or full owner of a number of different glasshouses between the 1860s through the late 1880s.

21. *The Engineering and Mining Journal* 28, 10 (September 6, 1879), 167.

22. James Baker, 1875, "Improvement in the Manufacture of Antique-Colored Glass," U.S. Patent 171,971, filed December 11, 1875 and issued January 11, 1876. Baker (1823–1883) was head of the firm James Baker and Sons, New York. Their colored glass disks were made under Baker's supervision at Thill's glasshouse and used by a number of glass artists including La Farge and Francis Lathrop. James W. Baker, "An Old-Timer," *The Ornamental Glass Bulletin* 12, 8 (September 1918), 8–9.

23. De Kay, *Louis C. Tiffany*, 19. Boldini remains something of a mystery. Martin Eidelberg posits that the spelling of "Boldini" may have been incorrectly recorded by de Kay; see *Tiffany Favrile Glass and the Quest of Beauty* (New York: Lillian Nassau, 2007), 13, 92, n. 8.

24. Tiffany and La Farge's relationship is discussed in Julie L. Sloan, "The Rivalry between Louis Comfort Tiffany and John La Farge," *Nineteenth Century* 17, 2 (Fall 1997), 27–34.

25. The historical context and terms of Tiffany and Heidt's agreement are explored in Jean-François Luneau, "Un document inédit sur les débuts du verre opalescent: l'accord entre Louis C. Tiffany et Louis Heidt," *Journal of Glass Studies* 50 (2008), 197–216. This article also provides the most comprehensive biographical sketch of Heidt's life to date.

26. De Kay, *Louis C. Tiffany*, 19.

27. Henderson, "Glass-making," 217.

28. "Memorial Windows," *The Critic* XI, 272 (March 16, 1888), v–vi.

29. For more information on this company see Paul Crist, "Kokomo Opalescent Glass Co., An Early History," formerly posted at http://www.kog.com/History/paulcristarticle.htm (updated on January 5, 1998).

30. For detailed information on Nash see Martin P. Eidelberg and Nancy A. McClelland, *Behind the Scenes of Tiffany Glassmaking: The Nash Notebooks* (New York: St. Martin's Press in association with Christie's, 2001).

31. Tiffany Studios, *Memorials in Glass and Stone*, 1913, n.p.

32. Advertisement, *Christian Work* 66, 1676 (March 30, 1899), 482.

33. The Neustadt Collection of Tiffany Glass is the repository of the glass left over from the closing of the Tiffany Studios in the late 1930s. Approximately 275,000 pieces of flat and pressed glass are in the museum's holdings. For additional information about the history of this glass and its makers see Lindsy Riepma Parrott, "Sheets and Shards, Gems and Jewels: The Glass Archive of the Neustadt Collection of Tiffany Glass," *Journal of Glass Studies* 51 (2009), 161–75.

34. "A New Invention in Glass," *Chicago Daily Tribune*, December 8, 1880, 3.

35. Howe, "The Making of the Glass," 365.

36. "Art in Stained Glass," *Washington Post*, September 1, 1895, 17.

37. Griffith, "From Sand Bank to Stained-Glass Window," X8.

38. Louis C. Tiffany, "American Art Supreme in Colored Glass," 44.

39. Tiffany Studios, *The Memorial Window and the Making Thereof* (New York: Tiffany Studios, 1903), courtesy of the Doros Collection.

40. Arthur John Nash and Leslie Hayden Nash Archives (relating to the Tiffany Studios), "Glass Formula L. H. Nash & Other," box 2, 32. Rakow Research Library, Corning Museum of Glass.

41. Nash Archives, box 1, 63.

42. Tiffany Glass and Decorating Company, 1894, "Trade-mark for Decorative Glass," U.S. Trademark 25,512, filed September 26, 1894 and issued November 13, 1894.

43. Nash Archive, box 1, 64.

44. Howe, "The Making of the Glass," 367–68.

45. Low, "Old Glass in New Windows," 675.

With Joyous Hope and Reverent Memory: The Patrons of Tiffany's Religious Art

1. Charles Winston, *An Inquiry into the Difference of Style Observable in Ancient Glass Paintings Especially in England, with Hints on Glass Painting, by an Amateur* (Oxford: John Henry Parker, 1847), 236–37.

2. Will H. Low, "Old Glass in New Windows," *Scribner's Magazine* 4 (December 1888), 675.

3. Rabbi Marc D. Angel, *Remnant of Israel: A Portrait of America's First Jewish Congregation, Shearith Israel* (New York: Riverside Book Company, Inc., 2004), 14, 110–14.

4. *Indoor Memorials* (New York: Tiffany Studios), 1913, n.p.

5. "Memorial Windows," *Century Advertising Supplement* (December 1888), 40. When the article reappeared six months later in *The Decorator and Furnisher*, it had shed any designation as an advertisement.

6. "Memorial Windows," 40.

7. *A Synopsis of the Exhibit of the Tiffany Glass and Decorating Company in the American Section of the Manufactures and Liberal Arts Building at the World's Fair, Jackson Park, Chicago, Illinois, 1893, with an Appendix on Memorial Windows* (New York: Tiffany Glass and Decorating Company, 1893), n.p.

8. Ibid.

9. *Memorial Windows* (New York: Tiffany Glass and Decorating Company, 1896), n.p.

10. The Camelot Project at the University of Rochester (http://www.lib.rochester.edu/camelot/), consulted November 21, 2011.

11. Calder Loth, *Windows of Grace, A Tribute of Love: The Memorial Windows of St. Paul's Episcopal Church* (Richmond, VA: St. Paul's Episcopal Church, n.d.), 16–19.

12. The earliest window commission from Tiffany Studios at St. Paul's was 1894. Prior to that date memorial windows had come from English firms. See ibid., 20.

13. Loth, *Windows of Grace*, 48.

14. http://www.tulane.edu/~latner/Davis.html, consulted November 20, 2011.

15. http://jeffersondavis.rice.edu/Imprisonment.aspx.

16. http://jeffersondavis.rice.edu/FAQs.aspx.

17. Loth, *Windows of Grace*, 48.

18. "Dr. Cuyler, His Recent Resignation at the Zenith of Pastoral Success," *Brooklyn Daily Eagle*, April 21, 1890, 1.

19. "His Farewell: Dr. Cuyler Leaves the Lafayette Avenue Church," *Brooklyn Daily Eagle*, April 7, 1890, 1.

20. Josiah Strong, *Our Country: Its Possible Future and its Present Crisis* (New York: Baker & Taylor Co., 1886, rev. ed. 1891), 227.

21. Ibid., 264.

22. I have relied on Edwin Gaustad and Leigh Schmidt, *The Religious History of America* (1996; rev. ed. New York: HarperOne, 2002) for the broad outlines of this argument. See especially pages 222–30.

23. "To Be Unveiled [*sic*] To-day", *Brooklyn Daily Eagle*, May 14, 1893, 2.

24. Ibid. and "The Cuyler Memorial Window," *Architecture and Building* XVIII, 21 (May 27, 1893), 252.

25. "The Cuyler Memorial Window," 252.

26. "To Be Unveiled [*sic*] To-day", 2.

27. Low, "Old Glass in New Windows," 675. By the late nineteenth century the terms "reverent memory" and "joyous hope" had become shorthand expressions for Jesus' death and resurrection and the promise of future resurrection for all believers.

28. The Jefferson Davis window, St. Paul's Episcopal Church, Richmond, Virginia, discussed earlier is a telling counterpoint to this theme.

29. See also the Tiffany design drawing (Metropolitan Museum of Art 67.654.96) which is a model for the Strother-Buford *Kiss of Charity* window at St. Paul's Episcopal Church, Richmond, Virginia, 1916.

30. http://www.lifespan.org/bradley/about/history/, consulted November 10, 2011.

31. Margaret Shippen Orr had been confirmed at Christ Church and her father had been a founder and donor of land for the building consecrated in 1842. *In Memory of Alexander Ector Orr, 1831–1914, and Margaret Shippen Orr, 1835–1913* (New York: self-published, 1917) 73.

32. Ibid., 8.

33. *In Memory of Alexander Ector Orr*, 8.

34. Ibid., 20. Ethel Syford, *Examples of Recent Work from the Studio of Louis C. Tiffany* (New York: Tiffany Studios, n.d.), repr. from *New England Magazine*, n.s. 45 (September 1911), 2 published the central lancet of the *Adoration of the Magi*.

35. *In Memory of Alexander Ector Orr and Margaret Shippen Orr*, 18.

36. For information about the Louis Comfort Tiffany Foundation established in 1918, see http://louiscomforttiffanyfoundation.org/about.html.

Innovation by Design: Frederick Wilson and Tiffany Studios' Stained-Glass Design

1. *New York Times*, November 13, 1880. For a discussion of the religious landscape windows by Tiffany Studios see Elizabeth Johnston De Rosa, "Louis Comfort Tiffany and the Development of Religious Landscape Memorial Windows," Ph.D. diss., Columbia University, 1995.

2. For an illustration of this Christmas card design see Regina Soria et al., *Perceptions and Evocations:*

The Art of Elihu Vedder (Washington, D.C.: National Collection of Fine Arts with the Smithsonian Institution Press, 1978), 178–79.

3. For an illustration of Blashfield and Lauber's collaborative mosaic see Tiffany Glass and Decorating Company, *Glass Mosaic* (New York: Tiffany Glass and Decorating Company, 1896).

4. Joseph Lauber, "European Versus American Color Windows," *Architectural Record* 31 (1912), 145.

5. This estimation of executed windows includes domestic and secular as well as religious windows. See Alice Cooney Frelinghuysen, "'A Glitter of Colored Light': Tiffany Domestic and Ecclesiastical Windows," in *Tiffany Glass: A Passion for Color*, ed. by Rosalind Pepall (Montreal, Quebec: Montreal Museum of Fine Arts, 2009), 74.

6. "Notes," *The Critic* V, 107 (January 16, 1886), 37.

7. See Alice Cooney Frelinghuysen's essay in this catalogue for a discussion of Northrop's work and Diane C. Wright, "Frederick Wilson: 50 Years of Stained Glass Design," *Journal of Glass Studies* 51 (Corning Museum of Glass, 2009) for a more in-depth look at Wilson's career, both during and beyond his years at Tiffany Studios.

8. "Unveil Memorial Window at All Saints' Church," *Atlanta Constitution*, April 12, 1908. There were variations on this phrase, including "Under the personal supervision of Louis C. Tiffany" and "Approved by Louis C. Tiffany."

9. For a discussion of the institutional use of reproductions of masterpieces and the use of print sources for stained glass see Virginia Chieffo Raguin, "Books, Prints, Stained Glass and the Purposes of Art," in *Glory in Glass. Stained Glass in the United States: Origins, Variety and Preservation* (New York: American Bible Society, 1998), 147–48.

10. Henry Turner Bailey's *The Great Painters' Gospel: Pictures Representing Scenes and Incidents in the Life of Christ* (Boston, MA: W.A. Wilde Co., 1900) and F. W. Farrar's *The Life of Christ as Represented in Art* (New York: Macmillan, 1894) were illustrated. I thank Lindsy R. Parrott for bringing Bailey to my attention.

11. Tiffany hired other experienced glassmakers and designers from abroad to work for him, notably Arthur and Douglas Nash who worked on the development of glass recipes.

12. See the 1871, 1881, and 1891 English censuses.

13. "Architectural League Exhibition," *The Art Amateur* 30, 2 (1894), 46. The South Kensington Museum later became the Victoria and Albert Museum, and its associated school the Royal College of Art.

14. The 1871 English census lists Wilson as a student but, by the time of the 1881 census, he was listed as "Artist in Stained Glass Mf," so it is assumed he began his professional career sometime between 1871 and 1881. One of the few known pre-Tiffany designs by Wilson was the Brown memorial window at Manchester Cathedral, executed by Wilson and Whitehouse, 1888 (destroyed during World War II).

15. Jean M. Farnsworth, Carmen R. Croce, and Joseph F. Chorpenning, eds., *Stained Glass in Catholic Philadelphia* (Philadelphia: Saint Joseph's University Press, 2002), 435–36. Alfred Godwin was an English immigrant from Manchester, and it is possible that Wilson had contact with him or other English stained-glass makers working in the United States before immigrating himself.

16. The work shown at the World's Fair was published by Tiffany as a "memorial window" and is comprised of a central Christ figure flanked by two angels. Tiffany Glass and Decorating Company, *A Synopsis of the Exhibit of the Tiffany Glass and Decorating Company in the American Section of the Manufactures and Liberal Arts Building at the World's Fair, Jackson Park, Chicago, Illinois, 1893, with an Appendix on Memorial Windows* (New York: Tiffany Glass and Decorating Company, 1893).

17. Jeffrey Rush Higgins Collection, Rakow Research Library, Corning Museum of Glass.

18. "The Church Art Department of the Tiffany Glass and Decorating Company," *New York Observer and Chronicle*, March 23, 1899 and "The Church Art Department of the Tiffany Glass and Decorating Company," *Christian Intelligencer*, March 29, 1899.

19. "The Te Deum, the Hymn and the Window," Jeffrey Rush Higgins Collection, Rakow Research Library, Corning Museum of Glass.

20. The cartoon is the life-size drawing used as a template for the glass cutters and for piecing the glass together into the final arrangement.

21. Letter from Wilson to his daughter, December 20, 1930. Jeanne P. and Edward Wilson Hewett Collection.

22. "Women Workers in Glass at the Tiffany Studios," *The Art Interchange* XXXIII, 4 (October 1894), 87. Agnes Northrop painted the floral background for the Jay Gould Memorial Window in the Reformed Church, Roxbury, New York.

23. Letter to Frederick Wilson from his four assistants, December 30, 1899, Jeffrey Rush Higgins Collection, Rakow Research Library, Corning Museum of Glass. Max Wieczorek would later join the California landscape movement on the West Coast. Robert L. Dodge was a muralist who worked on the Library of Congress murals.

24. This is an example of a secular window. Prints and Photographs Collection, Library of Congress.

25. Tiffany Glass and Decorating Company, *Memorial Windows* (New York: Tiffany Glass and Decorating Company, 1896).

26. Copyright records are individually dated but it appears that designs were often submitted in batches so the months and years recorded may not accurately reflect when the designs were actually finished.

27. *New York Observer and Chronicle*, January 30, 1908 and September 19, 1907.

28. "The Te Deum, the Hymn and the Window," Jeffrey Rush Higgins Collection, Rakow Research Library, Corning Museum of Glass.

29. "Church Life in Many Fields," *New York Observer and Chronicle*, December 12, 1907; "Advertisement," *New York Times*, December 17, 1907; "To Continue Wilson Exhibition," *New York Tribune*, December 15, 1907.

30. Wilson was a member of the Louis Comfort Tiffany Foundation Advisory Board from 1920 to 1924. Louis Comfort Tiffany Foundation minutes 1920–24, Morse Museum Archives.

31. This study depicts the figure of "Law" in a window executed for the Cleveland County Courthouse.

32. While there is no documentation giving the exact reasons why Wilson left Tiffany Studios, it is probable that a number of factors were at play. Wilson was sixty-five years old in 1923, and both he and several family members were ill at the time. The temperate climate of California may have been a considerable draw. Changing tastes in stained-glass design may have also been of interest to him. While in California he created designs for stained glass for the Judson Studios in a medieval revival style. His last designs for Judson were installed just after his death in 1932.

33. Frelinghuysen, "'A Glitter of Colored Light," 86–87.

34. Tiffany Studios, *A Partial List of Windows* (New York: Tiffany Studios, 1910).

35. There is no exact biblical verse stating "The Righteous Shall Receive a Crown of Glory," but this has a similar meaning to the verse in Peter 5:4.

36. This mosaic was eventually moved to the Lake Merritt United Methodist Church, Oakland, California.

Agnes Northrop: Tiffany Studios' Designer of Floral and Landscape Windows

1. Northrop's significance has been eclipsed in recent years by the attention given to Clara Driscoll. See Martin Eidelberg, Nina Gray, and Margaret K. Hofer, *A New Light on Tiffany: Clara Driscoll and the Tiffany Girls* (New York: New-York Historical Society and London: D. Giles, 2007).

2. Tiffany collector Bruce Randall had copies of two hand-written memoirs by Agnes Northrop. They were both written late in her life and are fairly close in terms of their content. One is titled "My Story by Agnes F. Northrop," and is dated 1952, by which time Northrop was ninety-five years old; it comprises eight pages but is unpaginated. The other, titled simply "Agnes F. Northrop," was written in a small notebook, paginated from pages 57 to 94, and is undated. I am most grateful to Bruce Randall's son, Bruce Randall Jr., for sharing these important documents with me.

3. Northrop's services were at times offered when Driscoll's "Tiffany girls" were short-staffed. One example is Northrop's aid to Driscoll in 1898 in the design of the Deep Sea lamp. That collaboration was short-lived for, the next month, Alice Gouvy, another Tiffany designer, took over. See Eidelberg, Gray, and Hofer, *A New Light on Tiffany*, 49–50, 190. Northrop was also said to have helped Driscoll with some small decorative bronze boxes based on the Queen Anne's lace flower. Driscoll Letters, Queens Historical Society. She worked on other decorative objects, contributing "original designs for carpets and silks." Polly King, "Women Workers in Glass at the Tiffany Studios," *The Art Interchange* XXXIII, 4 (October 1894), 87. Northrop designed silk panels decorated with stylized pinks for a lampshade, as seen in an extant design drawing signed by Northrop in the collection of the Metropolitan Museum of Art, New York (53.679.1810).

4. See "Life-Work of E. A. Fairchild Ended at 82," *Flushing Daily Times*, May 3, 1907.

5. Regrettably, the class rosters for the Flushing Institute 1860, the year he would have matriculated, are missing.

6. "Stained Glass Designer Dies," obituary, *Long Island Star-Journal*, September 15, 1953.

7. "Agnes F. Northrop," 87.

8. Louis Tiffany's companies were incorporated under various names at various times. When Northrop began

her tenure with Tiffany, she was working for the Tiffany Glass Company, which would later become Tiffany Glass and Decorating Company, and then Tiffany Studios. For the sake of clarity, I will refer to the firm as Tiffany Studios in keeping with the standard usage in this volume. Northrop was referring to A. D. F. Randolph & Company, a New York City publishing house printing primarily religious books.

9. See Alice Cooney Frelinghuysen, "A New Day: Women Book-Cover Designers and the Aesthetic and Arts and Crafts Movements," in Mindell Dubansky, Alice Cooney Frelinghuysen, and Josephine M. Dunn, *The Proper Decoration of Book Covers: The Life and Work of Alice C. Morse* (New York: The Grolier Club of New York, 2008), 22–28. Sarah Wyman Whitman and Helen Maitland Armstrong also worked designing trade bindings as well as stained glass.

10. "Agnes F. Northrop," 88.

11. "My Story," 5. Note that the "Renaissance Plates" probably refers to Tiffany's extensive collection of photographic plates of works of art from various parts of the world. Many of these plates from the Tiffany Studios are in the collection of the Morse Museum of American Art, Winter Park, Florida. William Pringle Mitchell was the major partner when Tiffany incorporated his firm as Louis C. Tiffany & Co., in 1881. Pringle's uncle was married to Tiffany's elder sister Annie.

12. For a thorough study on Anne Van Derlip, see Wade Allen Lawrence, "Tiffany in Duluth: The Anne Weston Connection," B.A. thesis, University of Minnesota, 1984.

13. It is possible that Northrop was referring to Edith Mitchell. See Eidelberg, Gray, and Hofer, *A New Light on Tiffany*, 175.

14. "My Story," 6.

15. For information on Tiffany Studios' designers please see Diane C. Wright's essay in this volume.

16. Northrop and Sperry were among the "local exhibitors" at an exhibition of the Flushing Art Club in December 1897. See "Art Exhibit," *Brooklyn Eagle*, December 13, 1897.

17. "My Story," 6.

18. Ibid.

19. John Du Fais (1855–1935), a Harvard-educated architect, worked for Tiffany's firm in its early years, becoming secretary of the newly formed Tiffany Glass Company in 1886, and worked at the firm until at least 1887. He was also president of the Architectural League of New York.

20. "My Story," 6.

21. Ibid.

22. *Catalogue of the Ninth Annual Exhibition of the Architectural League of New York* (New York, 1893), lxxiii. The cartoon, unfortunately, is not known to survive, but it may have been for a window in the Henry Field Memorial Gallery that Tiffany designed for the Art Institute of Chicago in 1893, the only art museum commission known to date. For an illustration, see Alice Cooney Frelinghuysen, *Louis Comfort Tiffany at the Metropolitan Museum of Art* (New York: Metropolitan Museum of Art, 1998), 22.

23. For more information on Wheeler and her role in the World's Columbian Exposition, see Amelia Peck and Carol Irish, *Candace Wheeler: The Art and Enterprise of American Design, 1875–1900* (New York: Metropolitan

Museum of Art, 2001), 63–71.

24. King, "Women Workers in Glass," 87.

25. Ibid.

26. For an illustration of the Gould window, see Eidelberg, Gray, and Hofer, *A New Light on Tiffany*, 28. See also ibid.

27. "My Story," 5.

28. The window was made for Walter Jennings' Long Island mansion, Burrwood, across Cold Spring Harbor from Tiffany's country estate, Laurelton Hall. Jennings, a founder of Standard Oil, commissioned the window for the landing of a grand staircase, above the front entrance (a typical location for Tiffany windows). The border is not known to survive. The figural panels are illustrated in Alastair Duncan, Martin Eidelberg, and Neil Harris, *Masterworks of Louis Comfort Tiffany* (London: Thames and Hudson, 1989), figs. 25, 26.

29. Gardner Teall, "Artistic American Wares at Expositions," *Brush and Pencil*, July 1900 (illustrated), 176–79. The window was purchased by the State Hermitage Museum, St. Petersburg, in 1901 (NB 349).

30. For an illustration, see Alastair Duncan, *Tiffany Windows* (New York: Simon and Schuster, 1980), 72. (Now at the Morse Museum of American Art.)

31. Gertrude Speenburgh, *The Arts of the Tiffanys* (Chicago: Lightner Publishing Corp., 1956), 8.

32. Ibid.

33. Clara Driscoll correspondence, June 15, 1898, Queens Historical Society. Driscoll expressed concern over the expense, suggesting that the cost only begins when the camera is bought. Thereafter, each photograph costs something.

34. Typescript journal by Louis C. Tiffany, July 7, 1907, Collection of the Morse Museum of American Art, Winter Park, Florida.

35. Ibid., January 3, 1907.

36. Clara Driscoll correspondence, December 4, 1904, Kent State University Library, Kent, Ohio.

37. Typescript journal by Louis C. Tiffany, January 20, 1907, Collection of the Charles Hosmer Morse Museum of American Art, Winter Park, Florida. While Driscoll would have provided female companionship for Northrop, Parker McIlhiney, chemist at the Studios, would have been male companionship for Tiffany (by that time, Tiffany was widowed for the second time, his wife having died in 1904).

38. Ibid., July 31, 1907. In a photograph preserved in the collection of Tiffany's great grandson, Michael Burlingham, is depicted Tiffany, with Clara Driscoll on his right, and Agnes Northrop on his left, all sketching on a sidewalk in Quimper. Northrop returned with Tiffany from Cherbourg, France, on September 14, 1907, Passenger Records, Liberty Ellis Island Foundation, Inc.

39. Ibid., August 1, 1907.

40. Ibid., August 10, 1907.

41. "My Story," 6–7.

42. "Agnes F. Northrop," 89.

43. King, "Women Workers in Glass," 86.

44. "My Story," 7.

45. King, "Women Workers in Glass," 87.

46. The church, now known as New York City Church of Christ, is located at Sixth Avenue and Second Street in Brooklyn.

47. The Dutch Reformed Church in Flushing merged with

the First Congregational Church of Flushing in 1974, forming the Bowne Street Community Church, as it remains today.

48. Contract between the Reformed Church and the Tiffany Glass and Decorating Company, March 22, 1892, Bowne Street Community Church Archives.

49. See "Queensborough Notes," *Brooklyn Eagle*, March 30, 1899.

50. Baker was manager of the Parsons Nurseries, and served as secretary and treasurer of the Kissena Nurseries, both in Flushing.

51. "Prof. Allen Parkhill Northrop's Memory," unidentified newspaper, taken from a clipping pasted into a scrapbook kept by the alumni of the Flushing Institute, Queens Historical Society, page 10.

52. Ibid.

53. For a thorough analysis of this window in the context of landscape as a subject for memorial windows, see Elizabeth J. De Rosa, "Louis Comfort Tiffany and the Development of Religious Landscape Memorial Windows," Ph.D. dissertation, Columbia University, 1995, 61–104.

54. "Will Be Dedicated To-Day," *Brooklyn Daily Eagle*, December 5, 1895, quoted in De Rosa, "Louis Comfort Tiffany," 64.

55. This could be due in part to the manner in which Tiffany Studios crafted its press release and may underscore the firm's ambivalence towards assigning and inconsistency surrounding attribution and credit to particular designers.

56. "Agnes F. Northrop," 93.

57. The window is currently owned by Southern Connecticut State College. A drawing for the Trowbridge memorial is in the collection of the Garden Museum, Matsue, Japan. See Alastair Duncan, *Louis C. Tiffany: The Garden Museum Collection* (Easthampton, MA and Woodbridge: Antique Collectors' Club, 2004), 167.

58. "Agnes Northrop," 93 . For an illustration of the Gould window, see Duncan, Eidelberg, and Harris, *Masterworks of Louis Comfort Tiffany*, fig. 1.

59. "New Glass in Old Windows," *The Independent* 77 (January 5, 1914), p. 9. The window ultimately ended up in the Headquarters of the Carnegie Trust in Dunfermline.

60. For an image of the Skinner window, see Frelinghuysen, *Tiffany at the Metropolitan Museum of Art*, 39.

61. "My Story," 6.

62. Edward Stanton George, head of Tiffany Studios' Ecclesiastical Department to Fletcher D. Proctor, Proctor, Vermont, May 18, 1909, Proctor Family Papers, collection of Proctor Free Library, Proctor, Vermont. For further discussion of the Tiffany Studios windows for Union Church in Proctor, Vermont, see Alice Cooney Frelinghuysen, "Glass in the Green Mountains: Tiffany Windows and Vermont," in Alice Cooney Frelinghuysen, Lindsy R. Parrott, and Jean Burks, *Louis Comfort Tiffany: Nature by Design* (Shelburne, VT: Shelburne Museum, 2009), 47–53.

63. In late April 1910, Edward Stanton George acknowledged the receipt of photographs Proctor had sent to Tiffany Studios, informing him that he had "turned [them] over to Miss Northrop." Edward Stanton George, Tiffany Studios, to Fletcher Proctor, Proctor, Vermont, April 26, 1910, Proctor Family Papers, collection of Proctor Free

Library, Proctor, Vermont.

64. "Memorial Window Given to Presbyterian Church," *Knickerbocker Press* (Albany), December 7, 1914.

65. *The Argus* (Albany), December 5, 1914.

66. The attribution to Northrop is based on a letter from Northrop, writing from her apartment at the Hotel Gramercy Park to Mr. Eadie of the Reformed Church, dated April 10, 1940, where she says she has "a large Memorial window on Exhibition for a few days— which will be placed in St. Jude's Episcopal Church in Seal Harbor—a companion to one I designed in 1912—a landscape." Bowne Street Community Church Archives.

67. "My Story," 7–8.

68. Letter from Agnes F. Northrop, Hotel Gramercy Park, to Mr. Eadie, pastor of Flushing Reform Church, April 10, 1940, Bowne Street Community Church Archives.

69. Ibid.

70. Emily Genauer, "Utility is Stressed in Objects for Home," *New York World Telegram*, March 10, 1934.

71. Agnes F. Northrop, "Tiffany Lamps are Still in 'Current Scene,' [Letter to the Editor]," *New York World Telegram*, March 26, 1934.

Translations in Light: The May Memorial Window at Temple Emanu-el, New York

1. For discussions on ornamentation in European synagogues see Carol Herselle Krinsky, *Synagogues of Europe: Architecture, History, Meaning* (New York: Dover Publications Inc., 1985), 44–46, and for a full discussion on rabbinic attitudes toward synagogue decoration see Vivian Mann, *Jewish Texts on the Visual Arts* (Cambridge: Cambridge University Press, 2000), 71–76.

2. Plating, the hallmark of a Tiffany window, is a process whereby multiple layers of glass are mechanically placed in the window to achieve a desired artistic effect. When transmitted light passes through the window, the textures and colors of all the layers are blended together to provide an amazing artistic effect, one that is further modulated by the intensity and color temperature of the light present. In his essay "Louis C. Tiffany's Coloured Glass Work," Siegfried Bing described the results of the new plating process: "By the blending of colour he caused the sheet of glass to convey the effect of the cloudy sky, or of rippling water, or again the delicate shades of flowers and foliage." From *Kunst und Kunsthandwerk*, 1898, reprinted in S. Bing, *Artistic America, Tiffany Glass, and Art Nouveau* (Cambridge, MA: MIT Press [1970]), 201. The Lewis May Memorial Window underwent a restoration by Femenella and Associates in 2005. I am indebted to Arthur Femenella for his detailed analysis and description.

3. The known others being Temple Shearith Israel, New York; Temple Shaaray Tefila, New York; Temple Israel, Brooklyn; Temple Beth Zion, Buffalo (seven memorial windows were destroyed in a fire in 1961); Beth Emeth Synagogue, Albany; and Temple Oheb Shalom, Baltimore. See *The American Hebrew* advertisement, December 8, 1899 which lists all of the above synagogue commissions with the exception of Temple Israel. Also see Tiffany Studios, *A Partial List of Windows* (New York: Tiffany Studios, 1910).

4. *The American Hebrew*, October 1899, 747.

5. In 1847, Eidlitz received $60 for drawing and supervising the execution of the ark, the reader's platform and two small pulpits for the congregation's place of worship from 1848 to 1854 located on Christie Street. A Mr. Jones received $20 for glass Tablets of the Law. *Minutes* of February 13, 1848 and March 10, 1848.

6. Isador Lewi, *Isaac Mayer Wise and Emanu-El* (New York: Bloch Publishing Co., 1930), 93–96 and Rachel Wischnitzer, *Synagogue Architecture in the United States* (Philadelphia: Jewish Publishing Society of America, 1955), 72–76.

7. In a 1908 article on Eidlitz, Montgomery Schuyler described the interior of the Forty-third Street Temple, but does not mention the Tiffany window. His description of the eastern wall reads, "What was meant to be its culminating feature, the light gallery over the ark at the east end, lighted from invisible openings at its ends, is now marred of its original effect, being filled with organ pipes, which also produce a pretty effect, though by no means the effect the designer intended." Montgomery Schuyler, "Leopold Eidlitz: A Great American Architect," *Architectural Record* XXIV, 3 (September 1908), 179.

8. Ibid.

9. Lewis May obituary, *New York Times*, July 23, 1897 and the marriage announcement of Lewis May's widow Emita to Isador Lewi in the home of Dr. Gustav Gottheil, *New York Times*, November 27, 1902 .

10. The Board Minutes are strangely laconic on the commission of the window for Lewis May. In 1897, shortly after May's death, a resolution was passed to honor him (*Minutes* of July 22, 1897). Two years later, in the minutes of November 6, 1899 an expenditure of $2,000 for the window appears and all mention of the window concludes on December 4, 1899 with the following succinct passage: "The work was universally admired, and the committee itself was entirely satisfied with the results achieved."

11. "Memorial to Lewis May," *New York Times*, December 1, 1899

12. Ibid.

13. The ethical culture movement was founded by Felix Adler, the son of Rabbi Samuel Adler, a rabbi at Temple Emanu-El. He preached a sermon laying out his intellectual platform to the congregation in 1873 and was met with a hostile response. In 1877, he founded the New York Society for Ethical Culture.

14. *The American Israelite*, 47:5 (October 1899), 2.

EXHIBITION CHECKLIST

This checklist is organized according to lender. Catalog numbers for the illustrated objects appear in parentheses.

Institutional lenders

1. Tiffany Studios, New York
 Frederick Wilson, designer
 Suggested design for *Blessed are the Persecuted* window (not executed), copyrighted 1905
 Watercolor, gouache, pen and brown ink, and graphite, mounted in portfolio
 10 ¼ × 5 ¼ inches
 Arlington Street Church, Boston, Massachusetts (Catalog 52)

2. Tiffany Studios, New York
 Frederick Wilson, designer
 Suggested design for *Blessed are the Merciful* window, copyrighted 1905
 Watercolor, gouache, pen and brown ink, and graphite, mounted in portfolio
 10 ¼ × 5 ¼ inches
 Arlington Street Church, Boston, Massachusetts (Catalog 54)

3. Tiffany Studios, New York
 Pulpit from South Presbyterian Church, Syracuse, New York, 1907
 Oak and glass mosaic
 39 ½ × 69 × 23 ½ inches
 The Charles Hosmer Morse Museum of American Art, Winter Park, Florida
 (Catalog 20)

4. Tiffany Studios, New York
 Altar cross, ca. 1916
 Silver-plated brass, enamel, and glass
 21 ½ × 40 × 9 inches
 Christ Church Cobble Hill, Brooklyn, New York
 (Catalog 21)

5. Tiffany Studios, New York
 Pair of candlesticks, ca. 1916
 Silver-plated brass and enamel
 27 ⅝ inches; widest dimension: 10 ¾ inches
 Christ Church Cobble Hill, Brooklyn, New York
 (Catalog 2)

6. Tiffany Studios, New York
 Pair of vases, ca. 1916
 Silver-plated brass and enamel
 13 ⅝ inches; widest diameter: 6 inches
 Christ Church Cobble Hill, Brooklyn, New York
 (Catalog 22)

7. Tiffany Studios, New York
 Book stand, ca. 1916
 Silver-plated brass and enamel
 13 ½ × 12 ½ × 13 ½ inches
 Christ Church Cobble Hill, Brooklyn, New York

8. Mary Moore Orr
 Commemorative Presentation Book: In Memory of Alexander Ector Orr, 1831–1914, and Margaret Shippen Orr, 1835–1913, 1917
 9 × 6 ½ inches (closed)
 Christ Church Cobble Hill, Brooklyn, New York

9. Tiffany Studios, New York
 Baptismal font, Memorial to George Bradley and Emma Pendleton Bradley, 1908
 Marble and glass mosaic
 46 ½ inches
 (floor to top of basin);
 68 ½ inches
 (floor to top of cover);
 widest diameter: 58 inches
 Christ Church, Pomfret, Connecticut (Catalog 10)

10. Tiffany Glass and Decorating Company or Tiffany Studios, New York
 Sample of a mosaic column possibly for St. Michael's Episcopal Church, New York, ca. 1900–20
 Glass tesserae and plaster
 63 ½ × 8 ½ inches
 Museum purchase, Gift of Mr. and Mrs. Arnold B. McKinnon; Mr. and Mrs. Richard Barry III; Mr. and Mrs. Thomas L. Stokes, Jr.; Mr. and Mrs. James Summar, Sr. in honor of Mr. and Mrs. Richard Waitzer and Mr. and Mrs. Malcolm P. Branch; Mr. and Mrs. John Shannon; Leah and Richard Waitzer; Nancy and Malcolm Branch; Mr. Jim Hixon; Mrs. Martha Stokes; Mr. and Mrs. Stuart Katz; Paramount Bedding Corporation Fund; By exchange Walter P. Chrysler, Jr.
 Chrysler Museum of Art, Norfolk, Virginia (2007.19) (Catalog 38)

11. Alice Cordelia Morse (American, 1863–1961)
 Design for stained-glass window for Beecher Memorial Church, Brooklyn, New York, 1889–90
 Brush and watercolor, graphite on off-white wove paper, mounted to paperboard
 7 ¹³⁄₁₆ × 5 ⅝ inches
 Cooper-Hewitt, National Design Museum, Smithsonian Institution, New York, Gift of Alice C. Morse (2009-6-9) (Catalog 35)

12. Alice Cordelia Morse (American, 1863–1961)
 Alternate design for stained-glass window for Beecher Memorial Church, Brooklyn, New York, 1889–90
 Brush and watercolor, graphite on off-white wove paper, mounted to paperboard
 8 ⅛ × 3 ³⁄₁₆ inches
 Cooper-Hewitt, National Design Museum, Smithsonian Institution, New York, Gift of Alice C. Morse (2009-6-10) (Catalog 36)

13. Tiffany Studios, New York
 Frederick Wilson, designer
 Design drawing for *Death of Monica at Ostia: A.D. 387*,
 Signed and dated
 "United States, New York, Tiffany Studios, 1896"
 Watercolor, ink, and pencil on paper
 21 ¼ × 21 ¼ inches
 (54 × 54 cm)
 Jeffrey Rush Higgins collection, the Rakow Research Library of the Corning Museum of Glass, Corning, New York (126597) (Catalog 49)

14. Tiffany Studios, New York
 Frederick Wilson, designer
 The Righteous Shall Receive a Crown of Glory, Brainard Memorial Window for Methodist Church, Waterville, New York, ca. 1901
 Leaded glass
 151 × 92 inches
 Marked "Tiffany Studios /New York"
 Corning Museum of Glass, Corning, New York
 (Catalog 44)

15. Tiffany Studios, New York
Altar cross, Memorial to Lewis
Mayer Hamilton, 1905
Gilt bronze with turquoise
26 3⁄8 × 11 7⁄8 × 6 1⁄2 inches
Emmanuel Parish of the Episcopal
Church, Cumberland, Maryland
(Catalog 23a)

16. Tiffany Studios, New York
Pair of vesper lights, Memorial to
Lewis Mayer Hamilton, 1905
Gilt bronze
14 3⁄8 × 10 1⁄4 × 5 1⁄2 inches
Emmanuel Parish of the Episcopal
Church, Cumberland, Maryland
(Catalog 23b)

17. Tiffany Studios, New York
Sketch for altar cross, ca. 1905
Graphite on paper
28 1⁄2 × 13 1⁄2 inches
Emmanuel Parish of the Episcopal
Church, Cumberland, Maryland
(Catalog 24)

18. Tiffany Studios, New York
Sketch for processional cross (not
executed), ca. 1905
Graphite on paper
38 1⁄2 × 18 5⁄8 inches
Emmanuel Parish of the Episcopal
Church, Cumberland, Maryland

19. Tiffany Studios, New York
Sketch for vase (not executed),
ca. 1905
Graphite on paper
17 5⁄8 × 12 1⁄2 inches
Emmanuel Parish of the Episcopal
Church, Cumberland, Maryland
(Catalog 25)

20. Tiffany Studios, New York
Sketch for eucharistic light
(not executed), ca. 1905
Graphite on paper
17 5⁄8 × 12 1⁄2 inches
Emmanuel Parish of the Episcopal
Church, Cumberland, Maryland

21. Tiffany Studios, New York
Sketch for vesper lights, ca. 1905
Graphite on paper
26 1⁄4 × 13 1⁄2 inches
Emmanuel Parish of the Episcopal
Church, Cumberland, Maryland
(Catalog 26)

22. Tiffany Studios, New York
Sketch for eucharistic light (not
executed) for Emmanuel Parish of
the Episcopal Church, Cumberland,
Maryland, ca. 1905
Graphite on paper
20 5⁄8 × 12 3⁄8 inches
Private Collection

23. Tiffany Glass and Decorating
Company, New York
Electrolier, ca. 1897
Metal and glass (shade likely
20th-century replacement)
6 feet high (including chain)
× 16 inches (diameter)
First Presbyterian Church, Bath,
New York (Catalog 28)

24. Tiffany Glass and Decorating
Company, New York
Frederick Wilson, designer
Copyright design for *Salve Regina*
window, 1898
Photographic print: platinum
8 1⁄2 × 4 1⁄4 inches
Prints and Photographs Division,
Library of Congress, Washington,
D.C. (Catalog 51)

25. Tiffany Glass and Decorating
Company, New York
Agnes Northrop, designer
Copyright design for ornamental
chancel window, Schieren Memorial
Window, 1896
Photographic print: platinum
6 5⁄16 × 5 13⁄16 inches
Prints and Photographs Division,
Library of Congress, Washington,
D.C. (Catalog 63)

26. Tiffany Glass and Decorating
Company, New York
Agnes Northrop, designer
Copyright design for
window, 1898
Three photographic
prints: platinum
3 3⁄4 × 5 7⁄8 inches
(three photos)
Prints and Photographs Division,
Library of Congress, Washington,
D.C. (Catalog 64)

27. Tiffany Glass and Decorating
Company, New York
Mary E. McDowell, designer
Copyright design for
The Valiant Woman, 1898
Photographic print: platinum
7 15⁄16 × 3 inches
Prints and Photographs Division,
Library of Congress, Washington,
D.C. (Catalog 56)

28. Tiffany Glass and Decorating
Company, New York
Mary E. McDowell, designer
Copyright design for
The Valiant Woman, 1898
Photographic print: platinum
7 15⁄16 × 5 5⁄8 inches
Prints and Photographs Division,
Library of Congress, Washington,
D.C. (Catalog 57)

29. Tiffany Glass and Decorating
Company, New York
Joseph Lauber, designer
Copyright design for *Easter Angel*,
1895
Photographic print: platinum
8 1⁄8 × 2 7⁄8 inches
Prints and Photographs Division,
Library of Congress, Washington,
D.C. (Catalog 46)

30. Tiffany Glass and Decorating
Company, New York
J. A. Holzer, designer
Copyright design for *Angel
of Knowledge*, 1897
Photographic print: platinum
6 1⁄8 × 7 5⁄8 inches
Prints and Photographs Division,
Library of Congress, Washington,
D.C. (Catalog 47)

31. Tiffany Glass and Decorating
Company, New York
Edward P. Sperry, designer
Copyright design for *St. Paul
Preaching at Athens*, 1894
Photographic print: platinum
9 1⁄4 × 5 7⁄8 inches
Prints and Photographs Division,
Library of Congress, Washington,
D.C. (Catalog 43)

32. Tiffany Glass and Decorating
Company, New York
Edward P. Sperry, designer
Copyright design for *Job*, 1897
Photographic print: platinum
8 1⁄2 × 5 5⁄16 inches
Prints and Photographs Division,
Library of Congress, Washington,
D.C. (Catalog 59)

33. Tiffany Glass and Decorating
Company, New York
Edward P. Sperry, designer
Copyright design
for *Moses*, 1897
Photographic print: platinum
8 1⁄2 × 5 5⁄16 inches
Prints and Photographs Division,
Library of Congress, Washington,
D.C. (Catalog 5)

34. Tiffany Glass and Decorating
Company, New York
Antependium window,
ca. 1892–93
Colored glass
and acid-washed glass
108 × 48 inches
Courtesy of Lillian Nassau LLC,
New York (Catalog 7)

35. Tiffany Glass and Decorating
Company, New York
Head of St. Andrew, detail
for a *Last Supper* composition,
ca. 1897
Glass mosaic
49 × 30 inches
Collection of Allen Michaan,
courtesy of Lillian Nassau LLC,
New York (Catalog 48)

36. Tiffany Glass and Decorating
Company, New York
"Chi Rho" mosaic sample, ca. 1900
Favrile and iridescent favrile glass
set in plaster
16 ¼ × 12 ½ inches
Courtesy of Lillian Nassau LLC,
New York

37. Tiffany Glass and Decorating
Company, New York
"Sacred John" mosaic
sample, ca. 1900
Iridescent favrile glass
set in plaster
11 × 9 inches
Courtesy of Lillian Nassau LLC,
New York

38. Tiffany Glass and Decorating
Company or Tiffany Studios,
New York
Sample of mosaic patterning and
borders, n.d.
Favrile glass set in plaster
53 ½ × 18 ½ inches
Courtesy of Lillian Nassau LLC,
New York

39. Louis Comfort Tiffany
(1848–1933)
Design for baptismal font, late
19th–early 20th century
Graphite on paper mounted
on board in original mat
Overall: 16 ½ × 13 inches;
design: 9 ¹⁄₁₆ × 5 ⅜ inches
Purchase, Walter Hoving and Julia
T. Weld Gifts and Dodge Fund,
1967 (67.654.271)
The Metropolitan Museum
of Art, New York (Catalog 15)

40. Louis Comfort Tiffany
(1848–1933)
Design for baptismal font,
late 19th–early 20th century
Pen and ink on paper mounted on
board in original mat
Overall: 14 ¹³⁄₁₆ × 9 ¹⁵⁄₁₆ inches;
design: 5 ¹⁵⁄₁₆ × 8 inches
Purchase, Walter Hoving and Julia
T. Weld Gifts and Dodge Fund,
1967 (67.654.270)
The Metropolitan Museum of Art,
New York (Catalog 18)

41. Louis Comfort Tiffany
(1848–1933)
Design for baptismal font, late
19th–early 20th century
Watercolor and graphite on paper
mounted on board in original mat
Overall: 16 ¼ × 11 ¾ inches;
design: 7 ⅞ × 5 ⅛ inches
Purchase, Walter Hoving and Julia
T. Weld Gifts and Dodge Fund,
1967 (67.654.267)
The Metropolitan Museum
of Art, New York (Catalog 14)

42. Louis Comfort Tiffany
(1848–1933)
Design for baptismal font for
Presbyterian Church in Kingston,
Pennsylvania, late 19th–early
20th century
Watercolor and graphite on paper
mounted on board
Overall: 21 ¾ × 14 ¾ inches
Purchase, Walter Hoving and Julia
T. Weld Gifts and Dodge Fund,
1967 (67.654.203)
The Metropolitan Museum
of Art, New York (Catalog 17)

43. Louis Comfort Tiffany
(1848–1933)
Design for a window for All Saints
Church, Atlanta, Georgia, late
19th–early 20th century
Watercolor, ink, and graphite on
artist board in original shaped mat
Overall: 17 ½ × 10 ⅞ inches;
design: 11 ⁷⁄₁₆ × 5 ¹⁵⁄₁₆ inches
Purchase, Walter Hoving and Julia
T. Weld Gifts and Dodge Fund,
1967 (67.654.77)
The Metropolitan Museum of Art,
New York (Catalog 4)

44. Louis Comfort Tiffany
(1848–1933)
Design for cope for the Reverend
Edward McCurdy [McCarty], St.
Augustine's Church, Brooklyn,
New York, ca. 1890–1915
Watercolor, metallic ink, and
graphite on paper-faced artist board
Overall: 20 ½ × 13 ⅞ inches;
design: 8 ½ × 11 ⁹⁄₁₆ inches
Purchase, Walter Hoving and Julia
T. Weld Gifts and Dodge Fund,
1967 (67.654.427)
The Metropolitan Museum of Art,
New York (Catalog 9)

45. After Joseph Lauber (1855–1948)
*Chapel Exhibit by Tiffany Glass
and Decorating Company, 1893
World's Columbian Exposition in
Chicago, Illinois*, ca. 1893
Chromolithograph
10 × 8 inches
Purchase, Walter Hoving and Julia
T. Weld Gifts and Dodge Fund,
1967 (67.654.232)
The Metropolitan Museum
of Art, New York (Catalog 1)

46. Louis Comfort Tiffany
(1848–1933)
Design for marble baptismal font,
ca. 1902–20
Watercolor, gouache, pen and ink,
and graphite on off-white wove
paper (or artist board) in original
warm gray window mat-overmatted
with an archival mat
16 ½ × 12 inches
Purchase, Walter Hoving and Julia
T. Weld Gifts and Dodge Fund,
1967 (67.654.269)
The Metropolitan Museum of Art,
New York (Catalog 16)

47. Louis Comfort Tiffany
(1848–1933)
Design for baptismal font,
ca. 1902–20
Watercolor, brown wash, and
graphite on off-white wove paper
(or artist board) in original
warm gray mat
Overall: 15 ¹¹⁄₁₆ × 12 ¾ inches;
design: 6 ⅞ × 4 ⁹⁄₁₆ inches
Purchase, Walter Hoving and Julia
T. Weld Gifts and Dodge Fund,
1967 (67.654.266)
The Metropolitan Museum
of Art, New York (Catalog 13)

48. Louis Comfort Tiffany
(1848–1933)
Design for marble pulpit,
ca. 1895–1900
Watercolor, glazing media, pen
and inks, including brown ink and
bronze metallic ink, and graphite
on off-white wove paper
9 ¹³⁄₁₆ × 14 ⅞ inches, recto
The Elisha Whittelsey Collection,
The Elisha Whittelsey Fund, 1953
(53.679.1814)
The Metropolitan Museum of Art,
New York (Catalog 11)

49. Louis Comfort Tiffany
(1848–1933)
I am the Resurrection and the Life,
ca. 1907
Artist board with original dark gray
window mat
14 × 10 ½ inches, recto
Purchase, Walter Hoving and Julia
T. Weld Gifts and Dodge Fund,
1967 (67.654.230)
The Metropolitan Museum of Art,
New York (Catalog 41)

50. Louis Comfort Tiffany
(1848–1933)
Design for figural window,
ca. 1910–20
Gouache and watercolor over silver
gelatin photograph collage and
watercolor, pen and black India ink,
and graphite on wove paper support
16 ⁹⁄₁₆ × 11 ¹³⁄₁₆ inches, new mat
Purchase, Walter Hoving and Julia
T. Weld Gifts and Dodge Fund,
1967 (67.654.463)
The Metropolitan Museum of Art,
New York (Catalog 45)

51. Louis Comfort Tiffany
(1848–1933)
Design for baptismal font, late
19th–early 20th century
Watercolor and graphite on paper
mounted on board
Overall: 16 ⅞ × 12 ¼ inches;
design: 7 ⅞ × 6 ⅜ inches
Purchase, Walter Hoving and Julia
T. Weld Gifts and Dodge Fund,
1967 (67.654.277)
The Metropolitan Museum of Art,
New York (Catalog 12)

52. Tiffany Studios, New York
Frederick Wilson, designer
Design for *Beatitude* window for
Arlington Street Church, Boston,
Massachusetts, 1905
Watercolor, gouache, pen and
brown ink, and graphite, mounted
in portfolio
10 ½ × 5 ½ inches
Purchase, Walter Hoving and Julia
T. Weld Gifts and Dodge Fund,
1967 (67.654.398)
The Metropolitan Museum of Art,
New York (Catalog 53)

53. Tiffany Studios, New York
Frederick Wilson, designer
Salve Regina window for chapel
at Stony Wold Sanatorium, Lake
Kushaqua, New York, after 1910
Leaded glass
29 ½ × 28 inches
The Neustadt Collection of Tiffany
Glass, Long Island City, New York
(Catalog 55)

54. Tiffany Studios, New York
Design attributed to
Edward P. Sperry
*Lydia Entertaining Christ and the
Apostles*, Griffin Memorial Window
for Centennial Baptist Church,
Chicago, Illinois, before 1910
Leaded glass
89 ½ × 69 inches
The Neustadt Collection of Tiffany
Glass, Long Island City, New York
(Catalog 30)

55. Tiffany Glass and Decorating
Company, New York
Joseph Lauber, designer
Fathers of the Church, ca. 1892
Exhibited at the 1893 World's
Columbian Exposition in Chicago,
Illinois
Glass and plaster
97 ¾ × 58 ½ inches
The Neustadt Collection of Tiffany
Glass, Long Island City, New York
(Catalog 6)

56. Tiffany Studios, New York
Design attributed to Agnes
Northrop
Vine-Covered Cross window,
after 1900
Leaded glass
66 × 31 inches
The Neustadt Collection of Tiffany
Glass, Long Island City, New York
(Catalog 33)

57. Tiffany Studios Ecclesiastical
Department
Pamphlet, n.d.
7 × 10 ½ inches (open)
The Neustadt Collection of Tiffany
Glass, Long Island City, New York,
Gift of Fred and Nancylee Dikeman

58. Tiffany Studios Ecclesiastical
Department
Pamphlet, n.d.
7 × 10 ½ inches (open)
The Neustadt Collection of Tiffany
Glass, Long Island City, New York,
Gift of Fred and Nancylee Dikeman

59. Tiffany Studios Ecclesiastical
Department
Pamphlet, n.d.
7 × 10 ½ inches (open)
The Neustadt Collection of Tiffany
Glass, Long Island City, New York,
Gift of Fred and Nancylee Dikeman

60. Tiffany Studios Ecclesiastical
Department
Booklet, n.d.
8 ½ × 11 ½ inches (open)
The Neustadt Collection of Tiffany
Glass, Long Island City, New York

61. Tiffany Studios, New York
Memorials in Glass and Stone
booklet, 1913
9 ¾ × 13 ¼ inches (open)
On long-term loan to the Neustadt
Collection of Tiffany Glass, Long
Island City, New York

62. Tiffany Glass and Decorating
Company, New York
Glass Mosaic booklet, 1896
6 ¼ × 10 inches (open)
The Neustadt Collection of Tiffany
Glass, Long Island City, New York

63. Tiffany Studios, New York
Mausoleums booklet, 1914
9 × 13 inches (open)
The Neustadt Collection of Tiffany
Glass, Long Island City, New York,
Gift of Fred and Nancylee Dikeman

64. Tiffany Studios, New York
Character and Individuality in Decorations and Furnishings
booklet, 1913
8 ¾ × 12 ½ inches (open)
The Neustadt Collection of Tiffany Glass, Long Island City, New York

65. *The Decorator and Furnisher*,
October 1893
The Tiffany Glass and Decorating Company's Exhibit at the Columbian Exposition
13 ¾ × 20 ¾ inches (open)
The Neustadt Collection of Tiffany Glass, Long Island City, New York

66. Tiffany Glass Company, New York
Design attributed to Francis D. Millet
Brooke Memorial Window for St. Michael's Episcopal Church, Birdsboro, Pennsylvania, ca. 1886
Leaded glass
134 × 72 inches (excluding bottom memorial panel)
Smith Museum of Stained Glass Windows, Chicago, Illinois
(Catalog 29)

67. Tiffany Studios, New York
Sir Galahad, Cryder Memorial Window, before 1910
Leaded glass
45 × 27 ¼ inches
St. Andrew's Dune-by-the-Sea Church, Southampton, New York
(Catalog 42)

68. Tiffany Studios, New York
Landscape window, Betts Memorial Window, before 1910
Leaded glass
76 ½ × 51 ½ inches
St. Andrew's Dune-by-the-Sea Church, Southampton, New York
(Catalog 37)

69. Tiffany Studios, New York
Ornamental window with Alpha and Omega, Curtis Memorial Window, after 1910
Leaded glass
42 ¾ × 31 ¼ inches
St. Andrew's Dune-by-the-Sea Church, Southampton, New York
(Catalog 32)

70. Tiffany Glass and Decorating Company, New York
Electrolier, ca. 1900
Metal and glass
United Presbyterian Church of Binghamton, New York
(Catalog 27)

Private Lenders

71. Tiffany Studios, New York
Pair of candlesticks, after 1902
Metal with glass
12 ¾ inches (height)
Doros Collection (Catalog 3)

72. Tiffany Studios, New York
Frederick Wilson, designer
Te Deum, suggestion for Harrison Memorial Window, Germantown, Pennsylvania (not executed)
Watercolor and ink on paper (original matting)
45 ½ × 27 ½ inches
Doros Collection (Catalog 60)

73. Tiffany Studios, New York
I am the Resurrection and the Life, 1902
Leaded glass
50 ¼ × 29 ⅛ inches
The Collection of Richard H. Driehaus, Chicago, Illinois (40058)
(Catalog 61)

74. Tiffany Glass and Decorating Company, New York
The Soldier of the Lord, ca. 1900
Leaded glass
29 ⅜ × 22 ¾ inches
The Collection of Richard H. Driehaus, Chicago, Illinois (40161)
(Catalog 34)

75. Tiffany Glass and Decorating Company, New York
Frederick Wilson, designer
Suggestion for a window for First Congregational Church, Ansonia, Connecticut, ca. 1900
Watercolor and gouache on paper
20 ½ × 10 ¾ inches
Collection of Eric Streiner
(Catalog 31)

76. Tiffany Studios, New York
Design for St. Paul's Episcopal Church, Paterson, New Jersey, n.d.
Watercolor
25 ¼ × 21 ¾ inches (matted)
Allen Michaan, Michaan's Auctions, Alameda, California
(Catalog 8)

77. Tiffany Studios, New York
Design attributed to Frederick Wilson
Design for *Christ Blessing the Children* mosaic, n.d.
Watercolor and pencil on board
16 × 11 ½ inches (matted)
Allen Michaan, Michaan's Auctions, Alameda, California
(Catalog 58)

78. Tiffany Studios, New York
Design for an altar and rose window, n.d.
Watercolor
26 × 32 inches (matted)
Allen Michaan, Michaan's Auctions, Alameda, California
(Catalog 40)

79. Tiffany Studios, New York
Design attributed to Agnes Northrop
Design for landscape memorial window, n.d.
Watercolor
11 ½ × 7 ½ inches (matted)
Allen Michaan, Michaan's Auctions, Alameda, California
(Catalog 65)

80. Tiffany Studios, New York
Suggestion for chancel decorations, n.d.
Watercolor
28 ¼ × 20 inches (matted)
Allen Michaan, Michaan's Auctions, Alameda, California
(Catalog 39)

81. Tiffany Studios, New York
Design attributed to Agnes Northrop
Design for landscape window in a church, n.d.
Watercolor
19 ¾ × 30 inches (matted)
Allen Michaan, Michaan's Auctions, Alameda, California
(Catalog 62)

82. Tiffany Studios, New York
Frederick Wilson, designer
Cartoon for *Christ Blessing the Children* window, 1904
Watercolor, pencil, and pastel on paper
40 ½ × 28 ½ inches (unframed)
Allen Michaan, Michaan's Auctions, Alameda, California
(Catalog 50)

83. Tiffany Studios, New York
Suggestion for a marble altar for
Archbishop Thomas Lynch, Church
of the Resurrection, Greensburg (?),
Pennsylvania, n.d.
Watercolor
18 × 21 ¾ inches (matted)
Allen Michaan, Michaan's
Auctions, Alameda, California
(Catalog 19)

84. Author unknown
*Lexicon and Catalogue of the Loan
Exhibition for the Benefit of the
Chapel at Saint Gabriel's, Peekskill,
New York. Held in the Rooms
adjoining the Tiffany Chapel at 335
to 341 Fourth Avenue, New York
from March Twenty-fifth to April
Sixth, 1895*
New York: James Pott and
Company, March 23, 1895
6 × 9 ¾ inches (closed)
Private Collection

85. Tiffany Studios
Wade Memorial Chapel booklet,
Cleveland, Ohio, ca. 1900
10 ⁵⁄₁₆ × 14 ⁷⁄₁₆ inches (open)
Private Collection

BIBLIOGRAPHY

A Synopsis of the Exhibit of the Tiffany Glass and Decorating Company in the American Section of the Manufactures and Liberal Arts Building at the World's Fair, Jackson Park, Chicago, Illinois, 1893, with an Appendix on Memorial Windows (New York: Tiffany Glass and Decorating Company, 1893).

"Advertisement." *New York Times*, December 17, 1907.

The Argus (Albany), December 5, 1914.

"Art Exhibit." *Brooklyn Eagle*, December 13, 1897.

Ancestry.com. *1871 England Census* [database on-line]. Provo, UT, USA: Ancestry.com Operations Inc, 2004.

Ancestry.com. *1881 England Census* [database on-line]. Provo, UT, USA: Ancestry.com Operations Inc, 2004.

Ancestry.com. *1891 England Census* [database on-line]. Provo, UT, USA: Ancestry.com Operations Inc, 2004.

"A New Field for Artists." *New York Times*, April 5, 1891, 17.

"A New Invention in Glass." *Chicago Daily Tribune*, December 8, 1880, 3.

Angel, Rabbi Marc D. *Remnant of Israel: A Portrait of America's First Jewish Congregation, Shearith Israel* (New York: Riverside Book Company, Inc., 2004).

"Architectural League Exhibition." *The Art Amateur* 30, 2 (1894), 46.

"Art in Stained Glass." *Washington Post*, September 1, 1895, 17.

Bailey, Henry Turner. *The Great Painters' Gospel: Pictures Representing Scenes and Incidents in the Life of Christ* (Boston: W. A. Wilde Co., 1900).

Baker, James W. "An Old-Timer." *The Ornamental Glass Bulletin* 12, 8 (September 1918), 8–9.

Beer, Thomas. *The Mauve Decade*. (New York: Garden City Publishing Co., 1926).

The Bible. King James Version.

Bing, Siegfried. *Artistic America, Tiffany Glass, and Art Nouveau*, trans. by Benita Eisler (Cambridge, MA: MIT Press [1970]).

Binski, Paul. "The Cosmati at Westminster and the English Court Style." *The Art Bulletin* 72, 1 (March 1990), 6–34.

Bolgia, Claudia. "An Engraved Architectural Drawing at Santa Maria in Aracoeli, Rome." *Journal of the Society of Architectural Historians* 62, 4 (2003), 436–47.

Bullen, J. B. "Louis Comfort Tiffany and the Romano-Byzantine Design." *The Burlington Magazine* 147, 1227 (June 2005), 390–98.

Caffin, Charles H. "Decorated Windows." *The Craftsman* 3, 6 (March 1903), 350–60.

Carter, Paul A. *The Spiritual Crisis of the Gilded Age* (DeKalb: Northern Illinois University Press, 1971).

Catalogue of the Ninth Annual Exhibition of the Architectural League of New York (New York, 1893), lxxiii.

"Chicago-American vs. Foreign Stained Glass." *The American Architect and Building News* XLII (November 1893), 75.

"The Church Art Department of the Tiffany Glass and Decorating Company." *Christian Intelligencer*, March 29, 1899.

"The Church Art Department of the Tiffany Glass and Decorating Company." *New York Observer and Chronicle*, March 23, 1899.

"Church Life in Many Fields." *New York Observer and Chronicle*, December 12, 1907.

Coleman, Caryl. "The Second Spring." *The Architectural Record* 2, 4 (April–June 1893), 473–92.

"To Continue Wilson Exhibition." *New York Tribune*, December 15, 1907.

"The Cuyler Memorial Window." *Architecture and Building* XVIII, 21 (May 27, 1893), 252.

Crist, Paul. "Kokomo Opalescent Glass Co., An Early History," formerly posted at http://www.kog.com/History/paulcristarticle.htm (updated on January 5, 1998).

Cross, Robert D. *The Church and the City 1865–1910* (Indianapolis: Bobbs-Merrill, 1967).

De Kay, Charles. *The Art Work of Louis C. Tiffany* (Garden City, NY: Doubleday, 1914; repr. Poughkeepsie, NY: Apollo Books, 1987).

De Quelin, René. "A Many Sided Creator of the Beautiful." *Arts and Decoration* 17 (July 1922), 176–77.

De Rosa, Elizabeth Johnston. "Louis Comfort Tiffany and the Development of Religious Landscape Memorial Windows." Ph.D. dissertation, Columbia University, 1995.

"Dr. Cuyler. "His Recent Resignation at the Zenith of Pastoral Success." *Brooklyn Daily Eagle*, April 21, 1890, 1.

Duncan, Alastair. *Tiffany Windows* (New York: Simon and Schuster, 1980).

Eidelberg, Martin, and Harris, Neil. *Masterworks of Louis Comfort Tiffany* (London: Thames and Hudson, 1989).

Louis C. Tiffany: The Garden Museum Collection (Easthampton, MA and Woodbridge: Antique Collectors' Club, 2004).

Eidelberg, Martin. *Tiffany Favrile Glass and the Quest of Beauty* (New York: Lillian Nassau, 2007).

Nina Gray, and Margaret K. Hofer. *A New Light on Tiffany: Clara Driscoll and the Tiffany Girls* (New York: New-York Historical Society with Giles, 2007).

and Nancy A. McClelland. *Behind the Scenes of Tiffany Glassmaking: The Nash Notebooks* (New York: St. Martin's Press in association with Christie's, 2001).

The Engineering and Mining Journal 28, 10 (September 6, 1879), 167.

Farnsworth, Jean M., Carmen R. Croce, and Joseph F. Chorpenning, eds. *Stained Glass in Catholic Philadelphia* (Philadelphia: Saint Joseph's University Press, 2002).

Farrar, F. W. *The Life of Christ as Represented in Art* (New York: Macmillan, 1894).

Faude, Wilson H. "Associated Artists and the American Renaissance in the Decorative Arts." *Winterthur Portfolio* 10 (1975), 101–30.

Frelinghuysen, Alice Cooney. *Louis Comfort Tiffany at the Metropolitan Museum of Art* (New York: Metropolitan Museum of Art, 1998).

"A New Day: Women Book-Cover Designers and the Aesthetic and Arts and Crafts Movements," in Mindell Dubansky, Alice Cooney Frelinghuysen, and Josephine M. Dunn, *The Proper Decoration of Book Covers: The Life and Work of Alice C. Morse* (New York: The Grolier Club of New York, 2008), 22–28.

"'A Glitter of Colored Light': Tiffany Domestic and Ecclesiastical Windows," in *Tiffany Glass: A Passion for Color*, ed. by Rosalind Pepall (Montreal, Quebec: Montreal Museum of Fine Arts, 2009).

"Glass in the Green Mountains: Tiffany Windows and Vermont," in Alice Cooney Frelinghuysen, Lindsy Parrott, and Jean Burks, *Louis Comfort Tiffany: Nature by Design* (Shelburne, VT: Shelburne Museum, 2009), 47–53.

Frelinghuysen, Alice Cooney, et al. *Louis Comfort Tiffany and Laurelton Hall: An Artist's Country Estate* (New York: Metropolitan Museum of Art with Yale University Press, 2006).

Gaustad, Edwin, and Leigh Schmidt. *The Religious History of America* (1966; rev. ed. New York: HarperOne, 2002).

Genauer, Emily. "Utility is Stressed in Objects for Home." *New York World Telegram*, March 10, 1934.

Glass, Dorothy. "Papal Patronage in the Early Twelfth Century: Notes on the Iconography of Cosmatesque Pavements." *Journal of the Warburg and Courtauld Institutes* 32 (1969), 366–90.

Gray, Christopher. "Turn of the Century HQ of Louis Comfort Tiffany." *New York Times*, October 4, 1998, RE5.

Griffith, William. "From Sand Bank to Stained-Glass Window." *New York Times*, May 21, 1905, X8.

Hartley, Alfred. "Some Views on Photography. By a Painter." *The Studio* 4, 20 (November 1894), 63.

Henderson, C. Hanford. "Glass-Making." *Journal of the Franklin Institute* 124, 3 (September 1887), 199–224.

Higgins, Mary Clerkin. "Origins, Materials, and the Glazier's Art," in *Stained Glass: From Its Origins to the Present* (New York: Harry N. Abrams, Inc., 2003), 32–55.

"His Farewell: Dr. Cuyler Leaves the Lafayette Avenue Church." *Brooklyn Daily Eagle*, April 7, 1890, 1.

Howe, Samuel. "The Making of the Glass." *The Craftsman* 3 (March 1903), 361–68.

"Imprisonment 1865–67." *The Papers of Jefferson Davis*. Rice University. Accessed November 21, 2011. http://jeffersondavis.rice.edu/Imprisonment.aspx.

International Textbook Company. "Stained- and Leaded-Glass Designing." International Library of Technology (Scranton, PA: International Textbook Company, 1916).

Kilde, Jeanne Halgren. *When Church Became Theatre: The Transformation of Evangelical Architecture and Worship in the Nineteenth Century* (New York: Oxford University Press, 2001).

King, Polly. "Women Workers in Glass at the Tiffany Studios." *The Art Interchange* XXXIII, 4 (October 1894), 87.

Krinsky, Carol Herselle. *Synagogues of Europe: Architecture, History, Meaning* (New York: Dover Publications Inc., 1985).

Koch, Robert. *Louis C. Tiffany: The Collected Works of Robert Koch* (Atglen, PA: Schiffer Publishing Ltd., 2001).

Latner, Richard B. "Jefferson Davis." Tulane University Department of History. Accessed November 21, 2011. http://www.tulane.edu/~latner/Davis.html.

Lauber, Joseph. "European Versus American Color Windows." *Architectural Record* 31(1912), 145.

Lawrence, Wade Allen. "Tiffany in Duluth: The Anne Weston Connection." B.A. thesis, University of Minnesota, 1984.

Lewi, Isador. *Isaac Mayer Wise and Emanu-El* (New York: Bloch Publishing Co., 1930).

Lexicon and Catalogue of the Loan Exhibition for the Benefit of the Chapel at Saint Gabriel's, Peekskill, New York. Held in the Rooms adjoining the Tiffany Chapel at 335 to 341 Fourth Avenue, New York from March Twenty-fifth to April Sixth, 1895 (New York: James Pott and Company, March 23, 1895).

Log of the Good Ship Molly-Polly-Chunker: Showing Forth the Perilous and Thrilling Adventures of her Company in a Voyage through Strange Countries never before Visited by any Similar Expedition (New York: privately printed, 1887).

Loth, Calder. *Windows of Grace, A Tribute of Love: The Memorial Windows of St. Paul's Episcopal Church* (Richmond, VA: St. Paul's Episcopal Church, n.d.).

"Louis C. Tiffany & Co. – Associated Artists." *Harper's Bazaar*, July 23, 1881, 471.

"Louis C. Tiffany's Window." *Bulletin of the Metropolitan Museum of Art* 20, 12 (December 1925), 287–88.

Low, Will H. "Old Glass in New Windows." *Scribner's Magazine* 4, 6 (December 1888), 675–86.

Luneau, Jean-François. "Un document inédit sur les débuts du verre opalescent: l'accord entre Louis C. Tiffany et Louis Heidt." *Journal of Glass Studies* 50 (2008), 197–216.

Mann, Vivian. *Jewish Texts on the Visual Arts.* (Cambridge: Cambridge University Press, 2000).

May, Henry. *Protestant Churches and Industrial America* (New York: Harper, 1949).

McKean, Hugh F. *The "Lost" Treasures of Louis Comfort Tiffany* (Garden City, NY: Doubleday, 1980).

McShane, Kara L. "Malory's Morte d'Arthur." Rossell Hope Robbins Library. The Camelot Project at the University of Rochester. Accessed November 21, 2011. http://www.lib.rochester.edu/camelot

"Memorial Windows." *Century Advertising Supplement*, December 1888, 40.

"Memorial Windows." *The Critic* XI, 272 (March 16, 1888), v–vi.

"Memorial Window Given to Presbyterian Church." *Knickerbocker Press* (Albany), December 7, 1914.

Morselli, Piero. "A Project by Michelangelo for the Ambo(s) of Santa Maria del Fiore, Florence." *Journal of the Society of Architectural Historians* 40, 2 (1981), 122–29.

"New Glass in Old Windows." *The Independent* 77 (January 5, 1914), 9.

New York Observer and Chronicle, January 30, 1908 and September 19, 1907.

Northrop, Agnes. "Agnes F. Northrop," undated, paginated from pages 57– 94, unpublished.

"Tiffany Lamps are Still in 'Current Scene,' [Letter to the Editor]," *New York World Telegram*, March 26, 1934.

"My Story by Agnes F. Northrop," dated 1952, unpaginated, unpublished.

"Notes." *The Critic* V, 107 (January 16, 1886).

Orr, Mary Moore. *In Memory of Alexander Ector Orr, 1831–1914, and Margaret Shippen Orr, 1835–1913* (New York: self-published, 1917).

"Our History: A Glimpse of the Past." Bradley Hospital, East Providence, RI. Accessed October 1, 2011. http://www.lifespan.org/bradley/about/history/.

Patriquin, William J., and Julie L. Sloan, *The Berkshire Glass Works* (Charleston, SC: The History Press, 2011).

Parrott, Lindsy Riepma. "Sheets and Shards, Gems and Jewels: The Glass Archive of the Neustadt Collection of Tiffany Glass." *Journal of Glass Studies* 51 (2009), 161–75.

Peck, Amelia, and Carol Irish. *Candace Wheeler: The Art and Enterprise of American Design, 1875–1900* (New York: Metropolitan Museum of Art, 2001).

Pongracz Spicka, Patricia. "The Chapel's First Installation and Move to Saint John the Divine," in *The Tiffany Chapel at the Morse Museum*, ed. by Nancy Long (Winter Park, FL: Charles Hosmer Morse Museum of American Art, 2002), 86–95.

Price, Joan Elliott. "Louis Comfort Tiffany: The Painting Career of a Colorist." Ph.D. dissertation, University of Wisconsin-Madison, 1991.

"Prof. Allen Parkhill Northrop's Memory," unidentified newspaper, taken from a clipping pasted into a scrapbook kept by the alumni of the Flushing Institute, Queens Historical Society, page 10.

"Queensborough Notes." *Brooklyn Eagle*, March 30, 1899.

Raguin, Virginia Chieffo. "Books, Prints, Stained Glass and the Purposes of Art," in *Glory in Glass. Stained Glass in the United States: Origins, Variety and Preservation* (New York: American Bible Society, 1998), 147–48.

Stained Glass: From Its Origins to the Present (New York: Harry N. Abrams, Inc., 2003).

Schaefer, Herwin. "Tiffany's Fame in Europe." *The Art Bulletin* 44, 4 (1962), 309–28.

Schuyler, Montgomery. "Leopold Eidlitz: A Great American Architect." *Architectural Record* XXIV, 3 (September 1908).

Sloan, Julie L. "The Rivalry between Louis Comfort Tiffany and John La Farge." *Nineteenth Century* 17, 2 (Fall 1997), 27–34.

Soria, Regina, et al. *Perceptions and Evocations: The Art of Elihu Vedder* (Washington, D.C.: National Collection of Fine Arts with the Smithsonian Institution Press, 1978).

Smith, Ryan K. *Gothic Arches, Latin Crosses: Anti-Catholicism and American Church Design in the Nineteenth Century* (Chapel Hill: University of North Carolina Press, 2006).

"Special Mention." *Building* XI, trade supplement, August 31, 1889, 2.

Speenburgh, Gertrude. *The Arts of the Tiffanys* (Chicago: Lightner Publishing Corp., 1956).

"Stained Glass Designer Dies." Obituary, *Long Island Star-Journal*, September 15, 1953.

Stirling, A. M. W. *The Richmond Papers* (London: William Heinemann, 1926).

Stoddard, William O. *Men of Business, Men of Achievement* (New York: Charles Scribner's Sons, 1893).

Strong, Josiah. *Our Country: Its Possible Future and its Present Crisis* (New York: Baker & Taylor Co., 1886, rev. ed. 1891).

Syford, Ethel. *Examples of Recent Work from the Studio of Louis C. Tiffany* (New York: Tiffany Studios, n.d.), repr. from *New England Magazine*, n.s. 45 (September 1911), 97–108.

Tavenor-Perry, J. "The Ambones of Ravello and Salerno." *The Burlington Magazine for Connoisseurs* 9, 42 (September 1906), 396–403.

Teall, Gardner. "Artistic American Wares at Expositions." *Brush and Pencil*, July 1900 (illustrated), 176–79.

Tiffany Glass and Decorating Company. *Glass Mosaic* (New York: Tiffany Glass and Decorating Company, 1896).

Memorial Windows (New York: Tiffany Glass and Decorating Company, 1896).

Tiffany Studios. *The Memorial Window and the Making Thereof* (New York: Tiffany Studios, 1903).

A Partial List of Windows (New York: Tiffany Studios, 1910).

Indoor Memorials (New York: Tiffany Studios, 1913).

Memorials in Glass and Stone (New York: Tiffany Studios, 1913).

Tiffany, Louis Comfort. "American Art Supreme in Colored Glass," *The Forum* 15, 5 (1893), 621–28.

"The Gospel of Good Taste." *Country Life in America* 19, 2 (November 1910), 105.

"The Tasteful Use of Light and Color in Artificial Illumination." *Scientific American* 104 (April 1911), 373.

"What is the Quest of Beauty?" *The International Studio* 58, 230 (April 1916).

"Color and Its Kinship to Sound." *The Art World* 22, 2 (May 1917), 142–43.

"The Quest of Beauty." *Harper's Bazaar* 52, 12 (December 1917), 43–44.

"To Be Unvailed [*sic*] To-day." *Brooklyn Daily Eagle*, May 14, 1893, 2.

"Unveil Memorial Window at All Saints' Church." *Atlanta Constitution*, April 12, 1908.

W.R. "Notes on Italian Paintings in Two Loan Exhibitions in New York." *American Journal of Archaeology and of the Fine Arts* 10, 2 (April–June 1895), 231.

Waern, Cecilia. "The Industrial Arts of America: The Tiffany Glass and Decorative Co." *The Studio* 2, XI (August 1897), 156–65.

"The Industrial Arts of America: II, The Tiffany or 'Favrile' Glass." *The Studio* 14, 63 (July 1898), 16–21.

Wander, Steven H. "The Westminster Abbey Sanctuary Pavement." *Traditio* 34 (1978), 137–56.

Wheeler, Candace. *Yesterdays in a Busy Life* (New York: Harper & Brothers, 1918).

"Will Be Dedicated To-Day." *Brooklyn Daily Eagle*, December 5, 1895.

Williams, Peter W. *Houses of God: Region, Religion and Architecture in the United States* (Urbana: University of Illinois Press, 1997).

Wilson, Richard Guy. "Architecture and the Reinterpretation of the Past in the American Renaissance." *Winterthur Portfolio* 18 (1983), 69–87.

Winston, Charles. *An Inquiry into the Difference of Style Observable in Ancient Glass Paintings Especially in England, with Hints on Glass Painting, by an Amateur* (Oxford: John Henry Parker, 1847).

Wischnitzer, Rachel. *Synagogue Architecture in the United States* (Philadelphia: Jewish Publishing Society of America, 1955).

Wright, Diane C. "Frederick Wilson: 50 Years of Stained Glass Design." *Journal of Glass Studies* 51 (Corning Museum of Glass, 2009).

PHOTO CREDITS

All rights are reserved. Most photographs were provided by the institutions owning the works; their courtesy is gratefully acknowledged. Since certain copyright holders could not be traced, we would appreciate notification of additional credits, which will be included in future editions.

COLLECTIONS AND ARCHIVES

Arthur John Nash and Leslie Hayden Nash Archives (relating to the Tiffany Studios), Rakow Research Library, Corning Museum of Glass.

Clara Driscoll correspondence, Queens Historical Society.

Contract between the Reformed Church and the Tiffany Glass and Decorating Company, March 22, 1892, Bowne Street Community Church Archives.

Jeffrey Rush Higgins Collection, Rakow Research Library, Corning Museum of Glass.

Charles Hosmer Morse Museum of American Art Archives.

"The Te Deum, the Hymn and the Window." Jeffrey Rush Higgins Collection, Rakow Research Library, Corning Museum of Glass.

Letter from Agnes F. Northrop, Hotel Gramercy Park, to Mr. Eadie, pastor of Flushing Reform Church, April 10, 1940, Bowne Street Community Church Archives.

Letter to Frederick Wilson from his four assistants, December 30, 1899, Jeffrey Rush Higgins Collection, Rakow Research Library, Corning Museum of Glass.

Letter from Frederick Wilson to his daughter, December 20, 1930. Jeanne P. and Edward Wilson Hewett Collection.

Passenger Records, Liberty Ellis Island Foundation, Inc.

Proctor Family Papers, collection of Proctor Free Library, Proctor, Vermont.

Typescript journal by Louis C. Tiffany, July 7, 1907. Collection of the Morse Museum of American Art, Winter Park, Florida.

Front Cover:
Corning Museum of Glass, Corning, New York
 Courtesy of the Collection of the Corning Museum of Glass, Corning, NY, gift of Mr. and Mrs. Bruce Randall
Back Cover:
Chrysler Museum of Art, Norfolk, Virginia
 Courtesy of the Chrysler Museum of Art

Allen Michaan, Michaan's Auctions, Alameda, California
 Courtesy of Allen Michaan, Michaan's Auctions (Pages 52, 76, 112, 113, 130, 148, 156, 173, 181)
Arlington Street Church, Boston, Massachusetts
 Courtesy of Arlington Street Church, Boston; Photo by David Bohl (Pages 150, 151)
Art Resource, New York
 Adoc-photos/Art Resource, NY (Page 13)
 Alinari/Art Resource, NY (Page 14)
 Art Resource, NY (Pages 10, 17)
 Scala / Art Resource, NY (Pages 65, 80)
 Image copyright © The Metropolitan Museum of Art. Image source: Art Resource, NY (Pages 29, 43, 58, 60, 61, 64, 66, 67, 68, 69, 71, 73, 74, 75, 117, 151, 170, 172, 177)
 Cooper-Hewitt, National Design Museum, Smithsonian Institution / Art Resource, NY (Page 108)
Bowne Street Community Church (previously Reformed Church), Flushing, New York
 Courtesy of Bowne Street Community Church; Photo by Richard Goodbody, Inc. (Pages 102, 162)
Carnegie Dunfermline Fund Trust, Dunfermline, Scotland
 Copyright Andrew Carnegie Dunfermline Trust; Photo by 13hundred (Page 180)
Charles Hosmer Morse Museum of American Art, Winter Park, Florida
 Image copyright © The Charles Hosmer Morse Foundation, Inc. (Pages 22, 26, 30, 31, 32, 34, 38, 39, 41, 44, 46, 47, 49, 55, 57, 65, 77)
 Image copyright © The Charles Hosmer Morse Foundation, Inc.; Photo courtesy of Louis Lusk (Page 25)

Christ Church Cobble Hill, Brooklyn, New York
 Courtesy of Christ Church Cobble Hill, Brooklyn; Photo by Richard Goodbody, Inc. (Pages 40, 50, 63, 78, 79, 132, 135)
Christ Episcopal Church, Pomfret, Connecticut
 Courtesy of Christ Episcopal Church, Pomfret; Photo by James H. Goodwin (Pages 62, 86, 93)
Chrysler Museum of Art, Norfolk, Virginia
 Courtesy of the Chrysler Museum of Art (Page 110)
Collection of Eric Streiner, New York
 Courtesy of the Collection of Eric Streiner; Photo by Gina Fuentes Walker (Page 99)
Collection of Richard H. Driehaus, Chicago
 Courtesy of the Collection of Richard H. Driehaus (Pages 106, 169, 200)
Corning Museum of Glass, Corning, New York
 Courtesy of the Collection of the Corning Museum of Glass, Corning, NY, gift of Mr. and Mrs. Bruce Randall (Page 128)
 Courtesy of the Jeffrey Rush Higgins Collection, Rakow Research Library of the Corning Museum of Glass, Corning, NY (Pages 136, 147)
Doros Collection
 Courtesy of the Doros Collection; Photo by Gina Fuentes Walker (Pages 42, 159)
Doug Major Collection
 Courtesy of the Doug Major Collection (Pages 171, 177)
Emmanuel Parish of the Episcopal Church, Cumberland, Maryland
 Courtesy of Emmanuel Parish of the Episcopal Church; Photo by Bruce Vartan Boyajian (Pages 81, 82, 83, 141)
First Church, Albany, New York
 Courtesy of the First Church in Albany (Page 178)
First Presbyterian Church, Bath, New York
 Courtesy of First Presbyterian Church; Photo by Lindsy R. Parrott (Page 84)
First Presbyterian Church, Syracuse, New York
 First Presbyterian Church; Photo by Harry Littell (Page 154)
First Unitarian Church, Baltimore, Maryland
 Courtesy of First Unitarian Church; Photo by Michael Koryta (Pages 100, 142, 143)

First Unitarian Congregational Society, Brooklyn, New York
Courtesy of First Unitarian Congregational Society; Photo by Richard Goodbody. Inc., (Page 176)

Harvard Art Museums/Fogg Museum, Cambridge, Massachusetts
Katya Kallsen © President and Fellows of Harvard College (Page 120)

Lake Merritt United Methodist Church, Oakland, California
Courtesy of Lake Merritt United Methodist Church; Photo by Dana Davis (Pages 160, 161)

Library of Congress, Washington, D.C.
Courtesy of the Prints and Photographs Division, Library of Congress (Pages 45, 126, 139, 140, 149, 153, 157, 174, 179)

Lillian Nassau LLC, New York
Courtesy of Lillian Nassau LLC, New York (Pages 48, 144, 158)

Metropolitan Museum of Art, New York, New York
Courtesy of the Metropolitan Museum of Art (Pages 164, 167, 168)

Michael John Burlingham, New York
Image courtesy of Michael John Burlingham (Page 24)

Neustadt Collection of Tiffany Glass, Long Island City, New York
Courtesy of the Neustadt Collection of Tiffany Glass; Photo by Richard Goodbody, Inc. (Pages 4, 89, 94, 103, 119, 152)
Photo by Neustadt Collection (Page 72)

New York Public Library, New York
Courtesy of the New York Public Library; Photo by (Page 21)

New York City Church of Christ, Brooklyn, New York
Courtesy of New York City Church of Christ; Photo by Richard P. Goodbody, Inc.(Page 175)

Smith Museum of Stained Glass Windows, Chicago
Courtesy of the Smith Museum of Stained Glass Windows (Page 97)

State Hermitage Museum, St. Petersburg, Russia
Photograph © The State Hermitage Museum / photo by Yuri Molodkovets (Page 171)

St. Andrew's Dune Church, Southampton, New York
Courtesy of St. Andrew's Dune Church; Photo by Richard Goodbody, Inc. (Pages 6, 101, 104, 109, 114, 121)

St. Paul's Episcopal Church, Richmond, Virginia
Courtesy of St. Paul's Episcopal Church; Photo by Cyane Lowden (Pages 123, 124)

St. Stephen's Episcopal Church, Lynn, Massachusetts
Courtesy of St. Stephen's Episcopal Church; Photo by Rick Cloran (Pages 90, 92)
Courtesy of St. Stephen's Episcopal Church; Photo by Marilyn Cloran (Page 91)

Temple Emanu-El, New York
Courtesy of Femenella & Associates, Inc.; Photo by Sam Calello of Calello Photography (Pages 184, 187)
Collection of Congregation Emanu-El of the City of New York (Pages 188, 189, 191)

The Union Church of Proctor, Proctor, Vermont
Courtesy of the Union Church of Proctor (Page 183)

United Presbyterian Church of Binghamton, New York
Courtesy of United Presbyterian Church of Binghamton; Photo by Lindsy R. Parrott (Pages 84, 111)

Walters Art Museum, Baltimore, Maryland
Courtesy of the Walters Art Museum (Page 78)

Westminster Abbey, London, United Kingdom
© Dean and Chapter of Westminster (Page 62)

Yale University Art Gallery
Courtesy of the Yale University Art Gallery (Page 37)

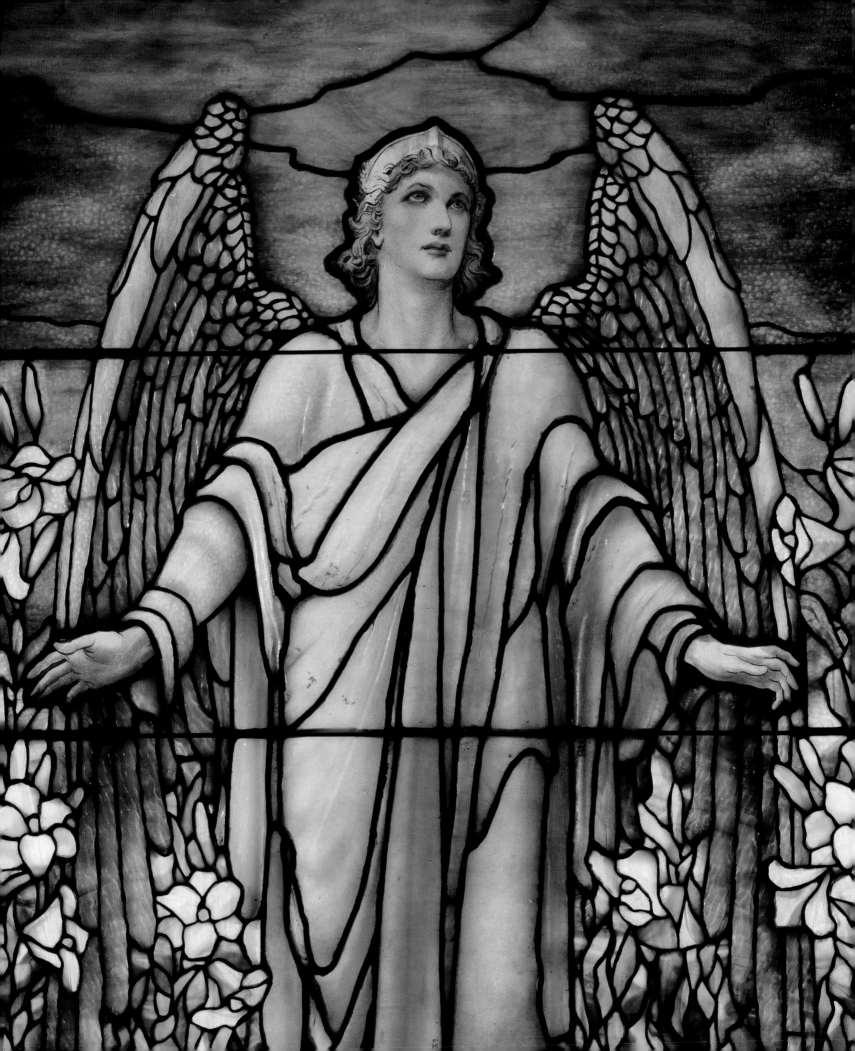

INDEX

Note: page numbers in *italics* refer to illustrations.